The Turner Prize

Bambarina,

Ti Amo Molto

Venezia feb 14th 2000

Tiggerio

Xx

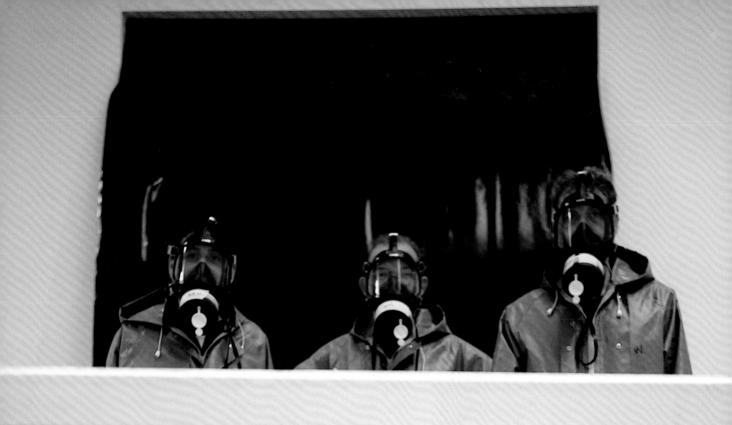
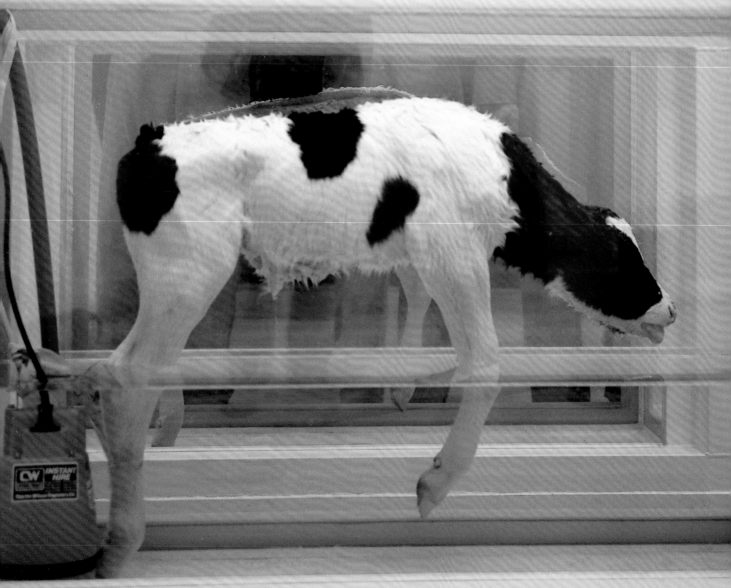

The Turner Prize

Virginia Button

Tate Gallery Publishing

Updated edition 1999

Published by
Tate Gallery Publishing Ltd
Millbank
London SW1P 4RG

ISBN 1 85437 221 1

A catalogue record for this book is
available from the British Library

The moral rights of the author
have been asserted

Designed by Esterson Lackersteen
Printed in Great Britain by
Balding + Mansell, Norwich

Front cover:
Chris Ofili,
No Woman, No Cry 1998
(detail)

Frontispiece: Installing Damien
Hirst's *Mother and Child, Divided* for
the Turner Prize exhibition in 1995
Photo: Philip Pestell

Dedication

I would like to dedicate this book
to my daughter Marina, born on
3 February 1997

Contents

Author's Note

My essay on the history of the Turner Prize draws heavily on Tate Gallery Records, and all unfootnoted letters, minutes and background information come from this source. But institutional records, however informative, cannot tell the whole story and I am most grateful to those who have been candid with me concerning their involvement with the Turner Prize and its evolution. I am particularly indebted to Sir Alan Bowness, Oliver and Nyda Prenn and Waldemar Januszczak, who gave generously of their time, and without whom it would have been difficult to write a balanced account of the early history of the prize. My warmest thanks also extend to Richard Cork who, in the late stages of production, kindly agreed to preface this book with a fascinating personal account of the importance of the prize.

I would also like to thank artists and their representatives for generously supplying information and many of the illustrations for the year-by-year survey. The essays on each artist in this section aim to provide a basic introduction to the artist's work, with an emphasis on the time of their association with the prize. For the period 1991–8 I have edited the existing Turner Prize exhibition broadsheets which were written by me, with the exception of the years 1991–3, when the authors were my colleagues Sean Rainbird and Simon Wilson, and 1998, when Michela Parkin contributed two essays. After 1998 I ceased to be curator of the Turner Prize exhibition. Contributors in 1999 are Mary Horlock, Sean Rainbird and Simon Wilson.

Any project of this kind is by its nature collaborative, and I would like to acknowledge all those colleagues at the Tate who have in some way contributed to this book. Special thanks go to Brenda Brinkley, Celia Clear, Tim Holton, Mary Horlock, Jane Ruddell, and my indefatigable editor, Sarah Derry. Finally, the need for this book was suggested to me by Penny Alexander, formerly the Tate Gallery's Information Officer, whose team fields enquiries about the Turner Prize throughout the year. Although my account is not exhaustive, I hope some questions are now answered for her, and for all those who are interested to know more about the prize and its development.

Virginia Button

Preface

Richard Cork

Nobody could have imagined, when the Turner Prize made a hesitant debut in the autumn of 1984, that it would burgeon into the fiercely debated, headline-spawning brouhaha of today. After all, Britain spent a large part of the twentieth century pretending that adventurous developments in modern art did not exist. At the Tate Gallery, where the Turner Prize was bravely launched by Alan Bowness and the recently formed Patrons of New Art, successive early directors had for too long balked at acquiring the artists we now regard as the outright masters of modernism. Even in 1928 the Tate was so opposed to Matisse that it rejected his mild-mannered *Reading Woman with Parasol*, a painting purchased by the admirable Contemporary Art Society as a gift to the nation. As for Picasso, the Tate only got around to buying his work for the first time in 1949, when the artist was nearly seventy years old.

Would such a hidebound culture ever warm to the notion of honouring contemporary artists' achievements? The prospect seemed dubious. Having struggled as a critic to foster a more vigorous involvement with new art ever since my career began at the *Evening Standard* in 1969, I knew how oppressively the odds were heaped against such a venture. In 1984 Britain still seemed far too willing to lapse into a nostalgia fit for devotees of 'heritage' alone. While its appetite for the past swelled to addictive proportions, the nation's response to the modern invariably seemed grudging. There was a widespread mistrust of the unfamiliar, and a preference for art safely sanctified by time. It was as if the crisis afflicting Britain's post-imperial identity had made us seek reassurance in history, and shun contact with the more disconcerting products of our own age. Instinctive, knee-jerk condemnation was levelled at work that refused to provide the consoling toeholds offered by older art. This chronic evasion and intolerance mirrored our plight as a beleaguered island, forever looking back at an era of greater confidence rather than coming to terms with the challenges of today.

Convinced that no good would come of ruminating on Britain's past glories, and that we must rid ourselves of this disabling tendency to shy away from the present, I gave a guarded welcome to the Turner Prize. True, the anonymity of the sponsor bred paranoid and, as it turned out, groundless suspicions about corrupt manipulation by hidden commercial interests. The award ceremony was plagued by malfunctioning microphones, grotesquely scrambled in the swimming-pool acoustics of the Duveen Gallery. And the bestowal of the prize failed to ignite any subsequent desire on the part of the US-based winner, Malcolm Morley, to exhibit in his native country more frequently than he had done over the previous quarter of a century. But there was no denying that an unexpected amount of media interest had already been generated by the event. It succeeded in enlarging a general awareness of modern art, even if the most popular newspapers vied with each other to hurl the most virulent abuse and dismiss the whole enterprise as a farce. At least the tabloid press was deigning to admit the existence of contemporary artists, and tempting readers to discover for themselves the work on view in the Tate's special exhibition.

As the prize developed over the next few years, its merits and shortcomings emerged with increasing clarity. By 1987, when it was given to Richard Deacon, I had unreservedly

decided that there was nothing wrong with the principle of giving a prize for 'an outstanding contribution to art in Britain'. If it benefited individuals as impressive as Deacon, and gained a wider audience for his work, the idea was worth supporting. Turner himself thought well enough of prizes to try instigating one himself, even though his good intentions (as in so many other matters) were never implemented.

But a paramount issue still had to be confronted. Was the prize really arousing *worthwhile* interest in the art of our time? The problem centred on its identity as a race. Announcing a six-person shortlist was tantamount to setting up five unlucky candidates as fall-guys for the eventual winner. And it was difficult for the judges to arrive at a choice that did not seem arbitrary. With the Booker Prize, its nearest equivalent in the literary field, attention is focused on each contender's latest novel, newly published and clearly assessable. The yardstick for the Turner Prize is altogether more generalised. Without a particular work to focus on, many observers wondered how the six names on the shortlist were arrived at in any given year.

Brief reasons were given in the catalogue of the 1987 exhibition, but in some cases they only compounded the confusion. Patrick Caulfield, who had been painting distinguished pictures for well over twenty years and held a much-admired Tate retrospective in 1981, was included for selecting a show of old masters at the National Gallery. Why should he have been chosen for that event, rather than for a survey of his own work? We did not know, and a similar mystery hung over two of the other candidates. Thérèse Oulton, justly praised by the Turner judges for her 'fresh contribution to the tradition of oil painting', first excited wide attention with her *Fool's Gold* exhibition three years before. It would have been more timely to single her out then, and the reason for Declan McGonagle's presence on the shortlist was equally unclear. He had been running the Orchard Gallery in Derry with great flair since 1978. The best moment to single him out would have been in 1984, when he left Ireland (temporarily, as it turned out) to become Exhibitions Director at the ICA. Why was 1987 his special year?

The other three contestants had, by contrast, enjoyed unusual attention over the previous twelve months. Helen Chadwick's *Of Mutability*, a sensual yet poignant meditation on transience, was a highlight of the ICA's 1986 season. Richard Long's retrospective at the Guggenheim Museum in New York saluted a career that began with precocious confidence over twenty years before. As for Richard Deacon, his touring show *For Those Who Have Eyes* confirmed his status as an outstanding young sculptor, flamboyant and yet incisively disciplined. He was an excellent winner; and yet I remember feeling unhappy that Deacon's current work triumphed over Long's Guggenheim exhibition, a high point for an artist who had done so much to transform our ideas about sculpture's relationship with the land.

If the Tate wanted convincingly to fulfil its desire 'to increase public interest in contemporary art', the gallery should have allotted a great deal more space to all the artists involved. Only then would the visitor have been able to encounter their work in a powerful way, and treat the exhibition as a major occasion rather than a sideshow. Perhaps acknowledging that more could be done, the 1987 catalogue revealed that 'we hope in future to be able to offer the winner a small exhibition at the Tate Gallery in the summer after the award has been made'. The word 'small' still sounded half-hearted, however, and the timing of the promised show far too tardy. If the public were to understand why the winners' work was so significant, they should be granted a substantial exhibition as soon after the award ceremony as possible, before memories grew cold. 'The whole exercise needs to be carried out on a grander scale,' I wrote at the time, 'so that the Tate's own belief in the prize is manifested with overwhelming conviction in the rooms of the gallery itself.'

The following year, an invitation from Alan Bowness to join the 1988 Turner judges gave me the opportunity to suggest changes. Deciding in particular that the disadvantages

of the shortlist outweighed any virtues it may have possessed, I argued that it ought to be dispensed with. Instead, the prize should go to a single artist, who would benefit from the space now available for a substantial one-person show when the award was announced. To my delight, the other members of the jury – Carmen Gimenez, Henry Meyric-Hughes, Jill Ritblat and the Tate's newly-appointed director Nicholas Serota – shared my views.

We also had little hesitation in choosing Tony Cragg for the prize. After a number of years when the same names recurred in the shortlists time and again, it was heartening to realise that he had never been an official contender before. His British pavilion at the 1988 Venice Biennale was outstanding; and after Alan Yentob presented him with the award, Cragg went on to stage a superb exhibition at the Tate. In my eyes, it was the first display to do full justice to a Turner Prize winner. I also felt relieved that the other artists discussed by our jury had not suffered the chagrin of public rejection on the night. Moreover, our decision to restrict the prize to artists alone, rather than remaining open to writers and curators as well, seemed absolutely right. Now, in its fifth year of existence, the whole event had gained an appropriate sense of dignity and focus at last.

But I reckoned without the Turner Prize's apparently limitless capacity to raise a hullabaloo. The abandonment of the shortlist stirred up ferocious dissent. To many commentators, it robbed the enterprise of the gossip, razzmatazz and sheer betting-shop excitement to be gained from speculating on the winner. Critics who had previously been withering in their disapproval of the shortlisted names now found, perhaps to their own surprise, that they missed the contentiousness and gladiatorial brutality involved in pitting artists against each other. So the 1989 jury decided to 'commend' seven names before awarding the prize, on his third shortlisted appearance, to Richard Long. The perennial human love of a public tussle had triumphed. The Turner extravaganza was once again capable of wounding its contestants, most of whom agree to participate in the shortlist shenanigans only with understandable misgivings.

When the sponsors' bankruptcy forced it to take a sabbatical in 1990, everyone supposed that the prize had vanished for ever. The following year, though, it bounced back with the money doubled to a mighty £20,000. Now that the once-inflated market for art had declined into a slump, the cash benefits appeared even more desirable. Backed by Channel 4, the Turner Prize had a new upper age-limit of fifty. But the judges interpreted the rule as a charter for the under-thirties. Three of the four shortlisted artists – Ian Davenport, Fiona Rae and Rachel Whiteread – had only left college in recent years. Anish Kapoor was alone in belonging to an older generation, and found himself cast in an unenviable role. If he won, plenty of voices would have been ready to deplore the 'predictability' of the choice and argue that younger artists needed the prize-money far more. If he lost, however, Kapoor would have quite unfairly taken on a 'yesterday's man' stigma compared with the successful Young Turk. And in view of the exceptional promise shown by the other shortlisted names, he could easily have been humiliated by an artist armed with a fraction of his sustained output over the previous decade.

In the event, Kapoor managed to avoid Richard Long's fate in 1987 and beat off the challenge posed by his younger rivals. I was even more pleased when he announced that the £20,000 award would be devoted to helping artists who need money to continue their work. Furthermore, Channel 4's involvement guaranteed that all four artists received serious, prime-time exposure in an hour-long programme about their work. The Tate now devoted three rooms to a clearly laid-out Turner Prize show. It was still insufficient, but at least a video and information panels about the artists prefaced their work, helping to introduce them to a broader public.

The dilemma posed by setting middle-generation artists against their younger counterparts resurfaced, in an equally painful form, the subsequent year. David Tremlett and Alison Wilding, both artists in their forties with distinguished track records, found

themselves pitted against the thirty-one-year-old Grenville Davey and Damien Hirst, at twenty-seven the acknowledged *enfant terrible* of new British art. Although the fashionable bets went on Hirst, the judges finally resisted his claims. They were just as unwilling, however, to let the quieter merits of Tremlett or Wilding triumph. The vote went instead to Davey – an unexpected choice, but one that identified the Turner Prize firmly with the younger generation. The decision would prove prophetic. In 1993 Rachel Whiteread carried off the award at the age of only thirty.

I was hugely impressed by Whiteread's elegiac *House*, the most resonant and moving public sculpture produced in Britain for many years. The vituperation aimed at this blanched, melancholy memorial was so relentless, and the local council's determination to knock it down so enraging, that I felt elated when Whiteread emerged as the winner. The astounding notoriety of *House* ensured that the Turner Prize became a far more high-profile affair than before. Even so, the extent of the hatred generated by Whiteread's sculpture was disturbing. Over the tragically few months that *House* existed, the game of ridiculing modern art as often as possible seemed to have grown into a national pastime. Focusing on what artists do, and never bothering to ask themselves why, many scaremongering articles targeted the Turner Prize simply to claim that contemporary work suffered from terminal cynicism or idiocy. A lot of the journalists who reviled the 1993 shortlist had probably not even gone to Millbank and seen the exhibition for themselves. Their narrow-mindedness was deplorable, for anyone who took the trouble to visit the Tate might well have ended up with a very different view.

A week before the winner was announced, I gave a lunchtime talk about the shortlisted artists in front of the exhibits. A substantial number of people turned up, and they listened with attentiveness. Far from sensing antipathy or scorn, I was conscious of their desire to look, ponder and arrive at an independent assessment of the show. Their openness was enormously encouraging. I came away gratified by the realisation that an unprejudiced attitude to modern art does exist, waiting for the chance to discover more about work that often seems bewildering or perverse at first glance.

Bilious commentators protest, with wearisome frequency, that the Prize automatically favours 'conceptual' or 'anti-art' manifestations at the expense of more 'traditional' work. The fact is, though, that the line-up usually encompasses a greater diversity of work than its enemies claim. The selection for the 1994 shortlist seemed well-rounded to an almost programmatic degree. Sculpture, painting and alternative media were all strongly represented, and the success of Antony Gormley ensured that the Turner Prize had not yet become a wunderkind ghetto. Perhaps Willie Doherty was sidelined a little, in a room that visitors might have overlooked as they passed through the handsome spaces devoted to Shirazeh Houshiary's planetary sculptures and dark, rigorous pencil-pictures, Peter Doig's bleak yet lyrical paintings based on complex memories of his Canadian boyhood, and Gormley's rusted-iron body-casts *in extremis*. But the show as a whole was stimulating, and the television coverage had undergone an improvement as well.

I remember participating in an earlier Channel 4 discussion, broadcast live from the dinner held at the Duveen Gallery. The guests had been obliged to eat their meal in strangely crepuscular conditions, barely able to see each other or their food. And when we gathered round a table for the post-presentation debate, the murky lighting did not improve. But the 1994 programme was more sensibly arranged. This time the discussion was held in the Clore Gallery, where a luminous set had been installed. Although one of our number, Gerald Kaufman, rushed off for a Commons vote only minutes before the winner was announced, the rest of us managed to pretend that we had not noticed his absence during our subsequent round of quick-fire final comments.

I still felt that the Turner exhibition should be further expanded. The overwhelming response to the 1994 exhibition, running alongside an equally popular Rebecca Horn

exhibition, attracted Sunday afternoon crowds that sometimes forced the gallery to close its doors. The public appetite for contemporary art at its most adventurous was increasing dramatically, and I maintained in *The Times* that the Turner Prize provided an ideal opportunity to feed this hunger. Bringing the shortlisted artists into greater contact with the widest possible audience ought to be seen as the main objective of the event.

My argument was bolstered by the ebullience of new British art. Against all expectations, homegrown contemporary work began to experience a boom. The tired idea that the nation's cultural strength lay mainly in its literary and theatrical talents had faded at last. Defying our supposed prejudice against the visual, the audience for art grew apace. In 1995 the Tate notched up over two million visitors, suggesting that the titanic new Bankside gallery should prove irresistible when it opens in 2000. The intense interest centred on the Turner Prize was only the most spectacular manifestation of a growing fascination with young British artists, not only here but across the world. They had never been in more demand, and when I co-organised the 1995 *British Art Show* with Rose Finn-Kelcey and Thomas Lawson it attracted record-breaking attendances during a national tour.

The Tate reacted to this developing sense of excitement by producing the most rewarding Turner Prize exhibition I had yet seen. The confidence, inventiveness and subversive humour of the new art was energetically conveyed, despite an initial press kerfuffle over the delayed appearance of Damien Hirst's principal exhibit *Mother and Child, Divided*. Visiting the show with my children during its packed run, I was impressed not only by the quantity of visitors but by the quality of their responses. Queuing to see Hirst's sliced cow and calf eerily suspended in formaldehyde, or Mona Hatoum's visceral *Corps Etranger* projected onto the circular floor of a claustrophobic chamber, they scrutinised the work with fascination. Sniggers played no part in their engagement, and the felicitous fact that Mark Wallinger's horse paintings shared Hirst's kinship with Stubbs gave the show an unexpected sense of unity. Even Callum Innes's uncompromisingly abstract paintings, depending for their impact on his provocative decision to wash away the colour already applied to the canvas, commanded widespread respect.

Inexplicably, the 1996 shortlist turned out to be an all-male affair. Since the twenty-six artists chosen for *The British Art Show* included sixteen women, I was shocked by the Turner line-up. Why had none of the women making such an impressive contribution to the current vitality of British art been deemed worthy of the prize? The jury's selection gave the exhibition a narrow, retrograde air, stiflingly akin to the bad old days when women artists so often endured a state of near-invisibility.

It was a pity, because in every other respect the 1996 Turner contenders were carefully balanced in terms of vision and working methods alike. They encompassed painting at one extreme and video installation at the other, with photography, film, wall-drawing and multi-media strategies persuasively represented as well. Unlike the previous year's contest, when Hirst's victory was almost a foregone conclusion, none of the selected artists wallowed in a super-star status. It was a wide-open race, and for the first time in years a painter stood a generally predicted chance of ending as the winner.

In the end, despite his limpid room of sensuous yet disquieting paintings, Gary Hume did not carry off the prize. It went, unprecedentedly, to an artist who concentrates on film and video. Douglas Gordon's macabre, twin-screen *Confessions of a Justified Sinner* occupied its space with even greater assurance than Willie Doherty's installation had displayed two years earlier. Craigie Horsfield's quieter and more redemptive photographs looked impressive, too, and several of them had the dignity of monumental paintings. Only Simon Patterson's offerings seemed cramped. He had to sandwich a large, maritime sculpture with three sails between a wall-work and the familiar, anarchic wit of *The Great*

Bear. New art is often space-hungry, and the Tate may well find that the shortlisted artists of the future need even more room before their work can be displayed to full advantage.

Since the 1997 exhibition has yet to be staged, I cannot tell how memorable it will be. But the debate has been dominated, so far, by suspicions that the four selected women were singled out merely to make amends for last year's male bias. While I understand why such speculation has occurred, it plays into the hands of those who still consider the finest art to be a male preserve. Christine Borland, Angela Bulloch, Cornelia Parker and Gillian Wearing deserve to be shortlisted for their work alone, not on account of their gender. However much some journalists may protest that the judges' all-female line up smacks of political correctness, the list primarily celebrates four individuals who should be considered on their own merits.

I hope that the 1997 debate goes beyond the predictable press attempts, when the shortlist was published, to deplore the absence of painters and dismiss the Turner Prize as 'the usual freak show'. Artists have every reason to explore new ways of working, and nobody should vilify them for using unorthodox materials as well. The truth is that the makers of the most nourishing art have never been prepared to rest on the examples set by their forerunners. However closely they studied the past, they were determined to contest the solutions arrived at even by their most admired predecessors. In his day, Michelangelo proved no more ready to reiterate his seniors' achievements than Picasso, whose scrutiny of art history was second to none. Every outstanding artist has developed a singular vision by departing, often with outright defiance, from the supposed norm. Western art since the Renaissance has rarely stood still, and during the twentieth century this fundamental dynamic quickened to an unprecedented degree.

The upheaval undergone by modern art is an authentic reflection of larger forces, which have themselves overthrown many assumptions taken for granted in the previous century. If artists had ignored the galvanic changes of our own era, the work they produced would soon have ossified. We cannot expect the vital art of today simply to offer a reassuring sense of continuity, when the world itself is assailed by so much turbulence and doubt. I expect the best work to stimulate, catch me off-balance, and even redefine my ideas about what art can be, not act as a sedative. If artists want to deploy rice rather than pigment, or dispense with bronze in order to spray a reinforced concrete lining inside the empty walls of an East End house, then their willingness to experiment should be respected.

An unconventional material or strategy is no guarantee of a memorable outcome. Much depends on the intensity and coherence of the artist's imagination, and critics must be prepared to distinguish between the potent and the meretricious. Sometimes, a painter as penetrating as Francis Bacon can renew the language of art by adhering to brush, canvas and the figurative image. When a new way of working can produce a sculpture as haunting as Rachel Whiteread's *House*, however, its departure from precedent is entirely justified. We may not, initially, realise that *House* is a sculpture, or feel willing to regard it as a work of art. But if we are prepared to shed our preconceptions, stop legislating about what artists 'ought' to do, and acknowledge that they have a fundamental right to explore new methods of making, then this austere yet oddly resilient *memento mori* can end up touching all our lives. To the extent that the Turner Prize helps us overcome our prejudices and confront us with the most challenging art of today, it deserves to startle, infuriate and enlighten for many years to come.

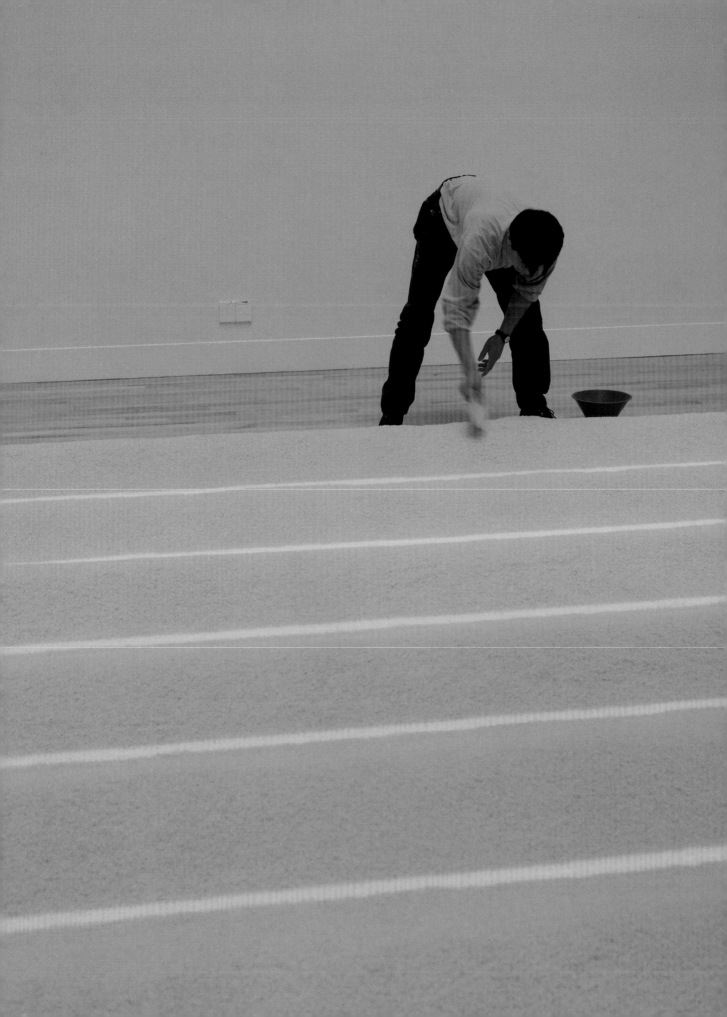

A History of the Turner Prize

It has often been said that the Turner Prize deliberately courts controversy. Without doubt, the success of the prize in drawing contemporary British art to the attention of a wider audience owes a huge debt to media-generated outrage. One history of the prize certainly features offended art-lovers, alienated art-world professionals and cyclical periods of a tabloid feeding frenzy. But the 'shock-horror' headlines that the prize continues to provoke are surely more revealing of an endemic resistance to the 'new' in British culture, particularly in the visual arts, than of the radicalism of contemporary art. Many of the shortlisted artists have established reputations abroad, where their work has been admired and collected without sparking national scandal. And given that the history of art in the twentieth century is in part defined by a non-traditional or non-hierarchical use of materials, it seems curious that a piece such as Vong Phaophanit's *Neon Rice Field* should so confound the British press when exhibited in 1993.

The Turner Prize was not set up to attract controversy, but it has always actively sought publicity. In its infancy, public debate around the event centred on serious questioning of its purpose and format, and the terms and conditions of the prize have evolved in response to such criticisms. Although its format has not altered since 1991, the earlier chameleon-like identity of the prize fostered its contentious reputation which, sadly, has often been the focus of attention at the expense of the artists' work. This said, the prize is, without question, now established as an event on the national and international calendar. As such, it is partly responsible for the apparent surge of interest in contemporary British art over the last decade.

The Turner Prize exhibition, established on a firm footing in 1991, has stimulated an enormous audience response. In recent years the prize has spawned undergraduate dissertations determined to unravel its miasmic history and assess its implications for British art. The main purpose of this book is to give an account of the development of the prize, not least to answer the many enquiries received by the Tate Gallery throughout the year. More importantly, it documents the artists who have been shortlisted over the past twelve years, and in so doing pays tribute to those who instigated the prize in order to promote and foster a greater understanding of contemporary British art.

The Patrons of New Art

The Turner Prize was founded by the Patrons of New Art (PNA) in 1984. Its genesis is inextricably linked to the early history of this group, established in 1982 under the directorship of Alan Bowness to assist in the acquisition of new art for the Tate Gallery's collection, and to encourage a wider interest in contemporary art.

The early 1980s marked a sea change in the status of national museums as publicly funded institutions. Under the Thatcher government, elected in 1979, it soon became clear that such institutions would need increasingly to rely on entrepreneurial endeavour and private sources to finance many of their activities. This shift was summed up by Alan Bowness in 1986:

Political decisions have been taken to give the museums greater independence, and much is being done to stimulate an increase in private giving in order to reduce the

Vong Phaophanit at work on *Neon Rice Field* at the Tate Gallery in 1993

financial dependence on Government-provided funds. All this involves a new status for the museums: instead of being institutions in receipt of a directly provided parliamentary vote, they are to become grant-assisted bodies ... it signifies a fundamental shift of responsibility for the financial well-being of the museum from Government to Trustees.[1]

Bowness arrived as director of the Tate in 1980. He had belonged to the existing support group, the Friends of the Tate, for many years. Although he admired what the Friends were doing he felt there was room for a smaller, high-powered group particularly interested in contemporary art. In establishing the patrons he hoped to foster a cluster of enthusiastic collectors who would support the British art of their own time, thus helping to enrich the nation's future heritage. Charles and Doris Saatchi, two of the most important collectors of contemporary art, were living in London, and the time seemed ripe to encourage others to follow their example in collecting contemporary work.[2] It was part of the Gallery's remit to acquire contemporary British art, but there was a need to avoid the furore caused in the 1970s by the purchase of Carl Andre's *Equivalent VIII* (dubbed 'the bricks'). In purchasing contemporary work for the Gallery, with money raised annually through subscriptions, the patrons could usefully assist the Tate in acquiring difficult or controversial new work without the need for 'public' expenditure.

The founding of the PNA also dovetailed with the Gallery's existing plans to develop the site at Millbank which had begun with the Clore Foundation's donation in 1980 for a gallery to house the Turner Bequest. Central to these plans was the creation of a 'Gallery of New Art', along with a gallery dedicated to sculpture and a study centre. A press release announcing the aims of the patrons anticipated that acquisitions made by the group would 'eventually become the nucleus of a Museum of New Art, devoted exclusively to recent developments, which will become an integral, but distinct, part of the Tate Gallery'.

The early 1980s witnessed a shift in the aesthetic climate of international modernism,

1 *The Tate Gallery Illustrated Biennial Report 1984–6*, p.17. In 1980 the traditional annual increase in the level of grant-in-aid ceased.
2 Charles Saatchi, with his brother Maurice, founded the advertising agency Saatchi & Saatchi in 1970. Charles's interest in contemporary art began in the 1960s and later, with the encouragement of his first wife, Doris Lockhart, he became a serious collector. In 1985 he opened a gallery in Boundary Road, St John's Wood, London, as a public showcase for his collection.

Daily Express, 19 February 1976

DAILY EXPRESS Thursday February 19 1976

"The repose and calm of this work of art reflects the simplicity and restraint of my earlier period, the symbolism remains personal and eludes exact interpretation."

which during the 1970s had been dominated by minimal and conceptual art. The return of a more expressive and figurative style of painting seemed symptomatic of this change. Variously described as 'new painting', 'new image painting', 'new expressionist', 'wild painting' or '*heftige malerei*' this emergent tendency was perhaps most clearly defined by *A New Spirit in Painting*, an exhibition organised by Christos M. Joachimides, Norman Rosenthal and Nicholas Serota for the Royal Academy of Arts in London at the beginning of 1981. In their selection, including thirty-eight artists from three generations, the organisers attempted to 'discover ... common threads which cross national boundaries and which can be related to the great traditions of European and American painting. By doing so we hope that we might help regain for painting that wide audience which it has always claimed, but which it has recently lost'.[3] The 'New Spirit' was passionate. Unlike the cool and apparently cerebral art of the 1970s, much of which had notoriously alienated audiences, this 'new' art, with its reassessment of traditional values and emphasis on 'subjective vision', seemed less forbidding. It thrived on the cult of artistic personalities such as Georg Baselitz, Francis Bacon and Julian Schnabel. By promoting a universal expressionist style, the new painting also encouraged and celebrated the revival of specifically national schools.

Inspired by such developments and a new generation of emerging British artists, the Patrons of New Art aimed to help the Tate record the moment for the future and to bring new developments in art to the attention of a wide audience. A number of critics, however, could only view the 'New Painting' as evidence of the art world's need to reinvent itself, to keep art markets buoyant. This view was particularly attractive to British critics, who felt uneasy about the presence of Charles and Doris Saatchi, collectors whose taste could sway the international market. Saatchi & Saatchi had, after all, helped the Tories sweep to power with their 'Labour isn't Working' advertising campaign. Charles Saatchi's enthusiasm for 'New Painting' accrued notoriety in the summer of 1982 when the Tate held a small exhibition of paintings by the young American artist Julian Schnabel. The fact that nine of the eleven pictures were lent by the Saatchis sparked a fit of critical rage. In a country unused to blatant consumption of contemporary art, and amidst fears that private sponsors would soon be calling the shots in public spaces, such a hostile response might seem inevitable. Saatchi had been on the founding committee of the PNA with Felicity Whaley-Cohen and Max Gordon, but curtailed his involvement shortly after this incident.[4]

3 *A New Spirit in Painting*, Royal Academy of Arts (15 January–18 March 1981) 1981, p.12.
4 Despite Saatchi's withdrawal from the patrons he was again accused of pulling strings when Malcom Morley won the first Turner Prize, as he was a keen collector of Morley's work (see Peter Fuller, *New Society*, 15 November 1984, p.249).

A Glittering Prize

Administered under the umbrella of the Friends of the Tate Gallery, the PNA were keen to establish their own identity and to find ways of actively extending their support for the Tate. On 30 November 1982 at the second meeting of the New Art Committee (the executive committee of the PNA), the architect Max Gordon suggested the idea of an annual prize.[5] He proposed – prophetically, as it turned out – that such an event should be 'sponsored by a large company, possibly in collaboration with Channel 4 Television, for achievement in the visual arts'. At the first formal general meeting of the PNA, held on 17 October 1983, Alan Bowness announced outline plans for a scholarship or prize similar in status to the Booker Prize. The following month he reported to the New Art Committee that an anonymous sponsor had offered to fund the prize for three years at £10,000 per year. This sponsor was Oliver Prenn, a founder member of the PNA, who with his wife Nyda had been collecting modern art since the early 1970s. Prenn had attended the general meeting and, after giving the matter some thought, approached Bowness with an offer of sponsorship. Prenn had enjoyed business success in the 1970s and had set up a charitable fund, but sponsoring the Turner Prize represented his first charitable support for the visual arts. He was anxious to avoid any kind of national newspaper story at the time, and asked that anonymity be the only condition of his sponsorship. Such terms suited the needs of the institution and Bowness was extremely grateful to Prenn for stepping forward. Although he had successfully worked with sponsors for exhibitions, the director was against the idea of attaching a sponsor's name to the prize: 'that was the risk, the "Polo-Mint" Turner Prize, or something similar, whereas Oliver was generous enough to say it was a good idea and he would just supply the cash'. Although he was personally enthusiastic about the prize, Prenn was a model sponsor and respected the hands-off policy adopted by the Tate Gallery. Ironically, against a backdrop of conspiracy theories, the secrecy surrounding his sponsorship led to wild accusations about the source of funding.[6]

Now that the prize had secured tangible means of financial support, the next step was to find an appropriate name.

In the Name of Turner

Critics have frequently speculated as to whether the prize would have had Turner's personal blessing. Reporting on the first award ceremony, Marina Vaizey wrote: 'I can't help feeling that Turner, a dab hand at making an impact, in his top hat with brush at the ready on Varnishing Day at the Royal Academy, would have taken to it no end'. But Peter Fuller stated: 'I am sure that, like me, Turner would have boycotted the goings on at the Tate'.[7]

Whatever Turner's view, the naming of the prize has proved as provocative as any other aspect of its history. What they perceived as the hijacking of Turner's name for an upstart contemporary prize incensed Turner's supporters, as did the fact that the gallery at the Tate designated to house Turner's bequest was to be called the 'Clore Gallery for the Turner Collection', not simply 'Turner's Gallery', as had been stipulated in his will. It seemed that sponsors or donors were again to blame.

When the prize was first announced, the chief complaint was that there appeared to be no connection between Joseph Mallard William Turner and the newly launched prize. As one writer inveighed:

> What, one might wonder, has all this got to do with Turner? The simple answer is nothing. Not one of the judges has any particular connection with Turner and any connections between the artists' work and that of Turner are remote in the extreme.

Worse still was that Turner himself had left provision for a young artists' prize, which had been ignored along with other wishes expressed in his will. In his first codicil of August

5 In 1981, after a distinguished career in various architectural partnerships, Max Gordon (1931–1990) set up an independent practice and consultancy devoted to art-related architecture. Writing Gordon's obituary for the *Independent* 27 August 1990, Michael Craig-Martin commented: 'Gordon was a true internationalist ... A distinguished art collector himself ... He used his professional connections to bring together people in the art world from both sides of the Atlantic. He was discreetly but significantly helpful in internationalising the reputations of many British artists over the past twenty-five years'. Gordon was also widely praised for his conversion of a paint warehouse in Boundary Road into a gallery for the Saatchi Collection.

The original members of the New Art Committee were Penny Allen, Cherry Barnett, Max Gordon, Patrick Rodier, Charles Saatchi, Felicity Samuel (Mrs Whaley-Cohen), Alan Bowness, Michael Compton and Richard Francis.
6 See, for example, Peter Fuller, *Art Monthly*, no.82, Dec.–Jan. 1984–5, pp.2–6, p.4; *Turner Society News*, no.33, Summer 1984, p.7.
7 Marina Vaizey, *Sunday Times*, 11 November 1984, p.40; Peter Fuller, *Art Monthly*, no.82 Dec.–Jan. 1984–5, pp.2-6, p.2.

1832 he gave money to the Royal Academy so that they might have a dinner to celebrate his birthday and award 'a Medal called Turner's Medal' together with a prize of about £20, 'for the best Landscape every two years'. In the fifth codicil of 1 February 1849, he made 'a Medal for Landscape Painting and marked with my name upon it as Turner's Medal silver or gold on their discretion' the condition of their receiving any money at all. Despite the fact that the Academy got £20,000 out of Turner's estate, neither the medal nor the prize were given in perpetuity as he had clearly intended.[8]

Waldemar Januszczak was among the critics angered by the handling of the Turner Bequest, and against this background he too questioned the propriety of attaching Turner's name to the prize. However, years later, as Commissioning Editor for Arts at Channel 4, he argued cogently in favour of retaining the name in the sponsor's forword to the 1991 Turner Prize exhibition pamphlet. His defence pivoted around the fact that Turner, widely recognised as Britain's greatest artist, had been dismissed in his own day as a fraud: 'We now know that these angry contemporaries of Turner were wrong, and guilty of massive misunderstanding. Which is why it is so appropriate that Turner should have given his name to an award whose ambition is to look at, encourage and champion new art in Britain'.

Considerable debate took place before the name of the new prize was announced. Indeed, the first jury had already been appointed before it had even been decided. In January 1984 Alan Bowness reported to the New Art Committee that he had discussed their suggestions with the Trustees. The Trustees were opposed to the name 'Tate', unenthusiastic about 'Turner', and preferred 'New Art' or 'Millbank'. But in May, at the tenth meeting of the New Art Committee, Bowness confirmed that the annual award was to be called the Turner Prize, having in the intervening months convinced the Trustees that it deserved a name that would stand for great achievement in British art, as well as appealing to a wider audience. Bowness knew of Turner's desire to establish a prize for younger artists, and felt it was legitimate to appropriate Turner's name. He had served on panels for a number of prestigious foreign prizes in the 1970s (among them the Rembrandt Prize), and was convinced that Britain should have its own illustrious award. Most countries honour the achievements of their living artists. In France, for example, the Ministry of Culture awards the Grand Prix National des Arts annually to a French artist for outstanding work in one of the fine arts. In Holland, the Amsterdam Prizes, awarded by the Amsterdam Foundation for the Arts, are given every two to three years, the individual prizes bearing the names of great Dutch artists.

The PNA's prize would need to distinguish itself from existing awards, such as the John Moores Prize for painting and the Hunting Group Art Prizes, and from a flurry of more recently established arts prizes such as the Imperial Tobacco Portrait Awards at the National Portrait Gallery. However, it was not a visual arts prize that the Turner was set up to rival, but a literary one – the Booker Prize for Fiction sponsored by Booker McConnell Ltd.

A Novel Idea

The Booker Prize, administered by the National Book League, was established in 1968 for the best full-length novel written in English by a citizen of the United Kingdom, Commonwealth, Eire or South Africa. Bowness recalls being impressed with the way in which the Booker had become a household name: 'The first ten years of the Booker were not much publicised, but suddenly – in the 1980s particularly when people like Anita Brookner won the Booker Prize for *Hotel du Lac* ... everybody but everybody was talking about it'. He made no secret of the fact that this sure-footed literary prize had been consciously emulated. For the Booker, publishers are invited to submit entries from which a shortlist is chosen, the winner being selected by a panel of jurors and announced at a televised award ceremony in the autumn. Each year this format brings a handful of novels

8 *Turner Society News*, no.33, Summer 1984, p.7.

under public scrutiny. The competitive edge seems to encourage people to buy and read the books, and to make up their own minds about the novelists under consideration.

Bowness, Prenn and Gordon hoped that contemporary art would attain a position in British cultural life on a par with that of the 'English' novel. But during the first few years of the Turner Prize, as it gradually muscled its way into the spotlight, the pertinence of a literary model for a visual arts prize was questioned. Commenting on the advent of the first Turner Prize, Laurence Marks reported: 'The idea ... is to do for new art what the Booker Prize has done for new fiction: generate a great cloud of fuss, feuding, gossip, theatrical controversy, dismissive remarks about the great modernists, and so forth, that will focus public attention on what artists are up to.' But he doubted whether the Turner could outstrip the success of the Booker. The prize money of £10,000 was a paltry sum compared with the cost of some contemporary art. Was it thus worth winning? Another problem was the gulf between contemporary art and levels of critical understanding:

> Most novelists who reach the Booker shortlist are writing within a recognisable narrative tradition. Anyone who is even casually interested in contemporary fiction can express a reasonably confident personal opinion as to their literary value, however fallible ... Nothing like the same exists in relation to 1980s visual art, whose frontiers seem to change every time you look up.[9]

The Booker, he concluded, was worth winning, as it could significantly enlarge an author's readership. But how could the Turner possibly swell the number of an artist's collectors?

A 'Knees-up at Aunt Tate'?

A 'razzmatazz knees-up' at stuffy aunt Tate was how Grey Gowrie, Minister for the Arts, described the first Turner Prize award ceremony, as he declared Malcolm Morley the winner: 'It is a credit to Alan Bowness', he concluded, 'that he has allowed the Tate to let her hair down'.[10] In the early 1980s this descent from Mount Olympus into the machiavellian world of the media offended several sensibilities. Many critics objected to the close relationship between the Turner Prize and the media, arguing that the highbrow aims of art are inevitably tarnished by the lowbrow mechanisms of mass communications. But such channels of communication and information are a requisite for raising awareness of contemporary art. Since 1991 the prize has enjoyed guaranteed annual television coverage from its Channel 4 sponsors. Such, indeed, is its media status that since 1991 various groups have cruised into the public eye on the back of it, often staging protests at Millbank on the evening of the award ceremony. These have included the pressure group Fanny Adams, protesting against the male domination of the art world, the K Foundation (formerly the pop band KLF, who awarded £40,000 to Rachel Whiteread as the 'worst' shortlisted artist in 1993), and FAT (Fashion Architecture and Taste) who have also objected to the 'cultural élitism' of the art establishment.

From its inception, the organisers of the prize concurred that publicity was crucial if the prize was to succeed in its aims. But arousing media interest wasn't altogether easy. On 1 June 1984 a patron wrote to Felicity Whaley-Cohen of his concern at the lack of press response to the announcement of the prize, which had been widely publicised in March:

> It is extraordinary that as far as I am aware, this [publicity] has produced no editorial whatsoever. I consider the Turner Prize to be one of the most significant events that has happened in the contemporary art world and I am astonished that the art critics, who so often complain about the lack of interest in contemporary art in the UK (compared with the USA) should have ignored it so totally.

In the run up to the first prize Gordon Burn reported John McEwan as remarking: 'It's all really rather English ... It's a bit like the election of a new Conservative Prime Minister in the good old days. All done with a couple of telephone calls'. Burn went on to observe that:

9 Laurence Marks, *Observer Review*, 4 Nov. 1984, p.23.
10 *PNA Newsletter*, no.6, Spring 1985, p.6.

'Good taste and discretion, for all the talk of upsetting applecarts and setting cats upon pigeons, is what has typified the Turner Prize so far'.[11] But BBC2's *Omnibus* programme agreed to cover the event, marking the beginning of the mediation of the prize to an audience far beyond the immediate environs of the capital. Since then the media's love affair with the Turner Prize has, as Robert Hughes commented when awarding the prize to Anish Kapoor in 1991, 'rattled the teacups'.

Turn-about Terms

In the mid-to-late 1980s the terms of the prize were redefined, particularly those relating to the shortlist and the shortlist exhibition. The jury, which selects the shortlist and awards the prize, is appointed annually by the Patrons in consultation with the Tate, thereby bringing a fresh set of enthusiasms and prejudices to the shortlist each year. Although public nomination for the prize itself has always been encouraged and is valued by the jury, the jury has always reserved the right to add its own nominations to those received. Initially the prize was given to 'the person who, in the opinion of the Jury, "has made the greatest contribution to art in Britain in the previous twelve months"'. Thus artists, critics and arts administrators alike were eligible and there was no imposed age limit. However, over the years the rubric of the Turner Prize has undergone several modifications. In 1987, for example, the phrase 'greatest contribution' was altered to 'outstanding contribution'. The word greatest had proved contentious, implying that the rightful winner should be the greatest living British artist: why, indeed, under these terms had Henry Moore, Francis Bacon and Lucian Freud never won the prize? The main aim of the prize needed to be publicly acknowledged rather than implied: it was not to honour a lifetime's achievement, but rather to celebrate younger talent and focus on recent developments.

That the terms of the prize have been subject to such unrelenting critical comment has much to do with the jury's choice of winner in 1984, viewed by many as wilful misinterpretation of the rules. The winner, Malcolm Morley, had enjoyed a successful exhibition at the Whitechapel Art Gallery. But as he had not lived in Britain since 1958 his contribution to art in this country seemed dubious. Scenting a story, the press seized onto the fact that he had served a short prison sentence in his youth, revelling in the implications this might have for his art practice.

The level of critical dissatisfaction with the prize continued unabated over the next few years, and even Patrons queried its efficacy. In the *PNA Newsletter* of spring 1986 (no.7) the director was forced to address the membership on the issue of the Turner Prize, to convince them of its merits:

> Such events are controversial, and I know that some Patrons have not been happy about the decision, nor about the conditions of the Prize ... The reason for the Turner Prize is the same as that which lay behind the setting up of the Patrons – namely, to enlarge the audience for contemporary art, and to increase public understanding and awareness ... I have always thought that this is more important than whoever actually wins the prize each year. We do need an award however, to ensure both media and public attention, and the Turner Prize has proved to be most successful in both respects.

Harping against the prize did not deter Drexel Burnham Lambert International Inc., an American investment company, from taking over the sponsorship at the end of Prenn's three-year term in 1987. Drexel was new to sponsorship, but Roger Jospé, the company's senior officer in Europe, was keen to support the Turner Prize. On top of the £10,000 prize money, Drexel promised to provide an extra £10,000 annually for the next three years in order to boost publicity, the exhibition, educational publications and events surrounding the prize. A report by DBL published in the *PNA Newsletter* of spring 1987 (no.9) explained the thrust of the company's sponsorship:

11 Gordon Burn, *Sunday Times Magazine*, 4 November 1984, pp.44–8, p.46.

The sponsors feel it is to everyone's benefit if British art is recognised. Tedious arguments in the press are disabling and will not be understood. People should not quaff champagne and complain. The British love debunking but they need to facilitate in a constructive way as well. The learning process takes a long time and the resources are now available for improving the perception of the prize.[12]

DBL's support won them an award from the Association for Business Sponsorship of the Arts under the government's Business Sponsorship Incentive Scheme, thus making a further £5,000 available to the Tate for the first year of their sponsorship. Yet the 'Drexel years', from 1987 to 1989, though full of promise, proved to be the most turbulent.

Prize Fighters v. Also-Rans

The competitive nature of the prize has always been a bone of contention. The terms of the shortlist seemed increasingly inappropriate as they placed artists of varying age and distinction in the same competition. Writing to Alan Bowness on 1 February 1988 to accept his place on the jury, critic Richard Cork nevertheless felt compelled to express widely held reservations about the nature of the shortlist:

I am happy to accept although I would welcome the chance to discuss with the other jurors the whole question of the shortlist. There is a widespread feeling, which I tend to share, that the shortlist sets very disparate artists up in competition with each other, with rather invidious results. Are you thinking of changing the shortlist arrangements in any way?

A few weeks earlier Bowness had received a letter from director-designate of the Tate, Nicholas Serota, who already had the question of the shortlist on his mind.

Although he admired Bowness's initiative, Serota was anxious to address aspects of the prize that he and others in the wider art community felt were unsatisfactory. Many found the unequal weighting of the shortlist particularly offensive. Writing in the *Financial Times* in November 1987, William Packer, for example, though praising the choice of Richard Deacon as winner, declared that the prize had lost its way:

Each year, and this is no exception, we have been presented with a choice that is no choice, a race in which any winner would be unthinkable – or at best bizarre – but for two or three, with the rest nowhere. This is demeaning for the also-rans – who had not asked to be entered – and infuriating to those left out yet with a far better claim.[13]

On the same day Richard Dorment, writing in the *Daily Telegraph,* opined:

The exhibition in the Central Hall of the Tate Gallery – of one work each of the artists on the shortlist – makes such depressing viewing that one wonders what purpose it serves. Perhaps in future these unsatisfactory shortlists should be dispensed with and the winner announced outright. Then, in addition to the prize money, he or she should automatically be given a one-man show at the Tate, and leave it at that.[14]

Taking such criticisms on board, Serota's main aims were to eliminate the combative selection process and to improve the presentation of work in the Gallery. Writing to Bowness on 21 January 1988 he suggested that in following the Booker model too closely, the prize had not yet found a format appropriate to the visual arts. Serota felt the time had come to restrict the shortlist to artists alone, and that a better exhibition would be possible if the shortlist comprised fewer candidates. He later sent a more detailed list of proposals culled from discussions with various people including artists, critics, curators and former jurors. Of most concern was the public nature of the shortlist:

The announcement of a shortlist causes anguish to artists without giving compensating

12 *PNA Newsletter*, no.9, Spring 1987. Drexel Burnham Lambert had at the time $1.8 billion in capital, 10,000 employees and more than fifty offices in the United States, Europe, South America and Asia.
13 William Packer, *Financial Times*, 26 Nov. 1987, p.25.
14 Richard Dorment, *Daily Telegraph*, 26 Nov. 1987, p.8.

edification to the public. There is a sense of a horse race between unevenly handicapped mounts and disappointment and embarrassment at being a senior artist who is good enough to run, but not to win.

A case in point, perhaps, was Richard Long who had failed to win the prize in 1984. He was considered yet again in 1987 and 1988, finally winning the award in 1989, just as Serota had initiated changes to avoid such embarrassing circumstances. By the time he was awarded the prize, Long's disaffection was such that he turned down his invitation to the award cermony at which the result was announced.

Serota also expressed misgivings about the exhibition:

> The shortlist and its accompanying catalogue lack impact, largely because of the short notice at which the exhibition is mounted. Furthermore, the public is confused because they believe that the quality of the work on view has some influence on the final choice.

As a result of Serota's consultations it was decided that from 1988 the shortlist would be agreed by the jury, but would not be made public. Resources that would have been used on the shortlist exhibition were to be diverted to fund a proper show for the winner of the prize, with an accompanying catalogue, the following year. Serota's justification for these changes was prepared in advance for the critics:

> It was felt that the publication of the shortlist, including both well-known names and 'unknowns' led to confusion about the scope of the prize, as well as making it difficult for the jury to award the prize to a younger artist without appearing to snub a major figure like Bacon, Freud or Auerbach.[15]

But although this revised format focused more successfully on the achievements of a British artist in one particular year, it completely failed to convey those achievements effectively to a wider public. The event had gained in dignity, but its edge had been dulled, as had the opportunity to draw attention to a broader spectrum of activity in contemporary art practice. There was also a minor point that had been overlooked: in 1987 a rule had been added to the prize, that artists shortlisted for two years would not be eligible for nomination in the following two years. Without a publicised shortlist it would be impossible to monitor adherence to this rule.

On 10 January 1989, Prenn wrote to Serota to express his feeling that the prize had lost some of its earlier impetus: 'The shortlist system was good because it enabled a great deal of public debate to take place, and because it enabled juries to draw attention to artists who

15 Tate Gallery Archive: 121, Nicholas Serota, unpublished statement, 9 Oct. 1988.

might not yet be likely to win'. In a letter to Prenn some months later, Serota confided his intention to rethink the procedure:

> This year, without introducing a formal shortlist I am considering the possibility of publishing a short 'review of the year', highlights which will indicate the field considered by the jury without placing such a focus on six names, five of whom must be 'losers' in a race that they have not chosen to enter.[16]

That year the jury publicised, not a shortlist, but a much longer list of 'commended' artists, alongside the name of the winner, Richard Long. This still proved unsatisfactory, as the director implied to Judith Bumpus of the BBC, in a letter following the award ceremony: 'I am glad that Richard has won but we obviously need to give further thought to the way in which we promote the work of the winner to a general audience'.[17]

Press curiosity in the Tate had escalated during the late 1980s owing to the arrival of a new director, and excitement surrounded the proposed rehang of the Collection. However, the unusual level of critical displeasure with the prize after the announcement in 1989 was such that the director and curators of the Tate's Modern Collection had already met on 20 December to studiously reconsider all aspects of the prize. A shortlist, they agreed, was unavoidable since any publicised list of names would assume this status. Clearly, an effective shortlist should comprise no more than three or four artists, all of whom should be strongly supported by the jury, so that each would have an equal chance of winning the prize. It was also agreed that there should be no bar on the number of times an artist could be shortlisted.

Several of the curators present had been involved in organising the Turner Prize exhibition and the meeting questioned the feasibility of mounting a successful show given the restrictions on space, time and availability of suitable work. They were also keen to explore other ways of promoting the artists' work such as videos, lectures and publications.

Many of these reforms were to come into play at a future date (see p.28–9). But the prevalent cynicism towards the prize at this time found a natural rather than administered cure. Disaffection centred, understandably, on what appeared to be the rule of Buggin's turn. With the exception of Tony Cragg, all winners of the prize (Morley, Hodgkin, Gilbert and George, Deacon and Long) had been on the very first shortlist in 1984. The winner of the prize seemed to be predetermined each year and the principle of fair competition undermined as a result. The formative period of the prize, committed to honouring a generation of established British artists, had run its course.

Onsite Insight: The Turner Prize Exhibition

The exhibition, which opens about a month before the winner is selected, plays a crucial role in achieving the main aim of the Turner Prize. Its primary function is to give a non-specialist art audience the opportunity of seeing work by the shortlisted artists. It also provides a focus for both formal and informal discussion about contemporary art as a whole. In one sense the success of the Turner Prize has depended on the success of the exhibition. As one critic noted in the aftermath of the first prize:

> Though this rush of prizes may seem to be inspired by the hoo-ha surrounding the Booker, and the consequent increase in novel sales, the most important thing about art prizes is that so many of the entrants have their work hung in exhibitions, with all attendant publicity, where public, critics and dealers can see them.[18]

But the exhibition has had a troubled history. Until recently, difficulties over timing, lack of space and a limited budget dogged the organisation of a satisfactory display. Richard Francis, at the time a curator at the Tate, wrote to the shortlisted artists on 30 July 1985 asking them to consider suitable works for the exhibition that was to open in just over two months' time. The criteria for appropriate works illustrates the particular

16 TGA.121 Letter from Nicholas Serota to Oliver Prenn, 15 May 1989.
17 TGA.121 Letter from Nicholas Serota to Judith Bumpus, 1 Dec. 1989 in reply to her congratulatory note of 22 November 1989. See also Marina Vaizey, *Sunday Times*, 27 Nov. 1988, p.8.
18 Liz Jobey, *The Times*, 18 Nov. 1984, p.41.

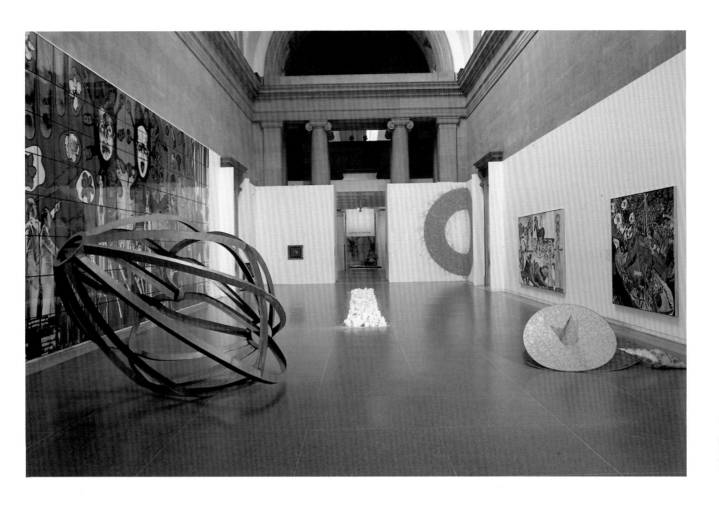

The Turner Prize exhibition in 1984

problems of organising such an exhibition: 'It [the work] should be easily available, in your collection with your dealer or in a London private collection, and have been made in the last year.'

In 1986, juror Michael Newman, upset by criticisms of the panel's choice of artists, emphasised the important role of the exhibition in a letter to Bowness, dated 10 July:

> Although controversy is bound to raise interest, I think we do have a problem with the negative criticism ... people will come to the exhibition ... to find out what it is all about, and I think their attitude will be almost to want to have the negative view confirmed. This means that presentation at that stage will be very important. Therefore I am disturbed to learn that the artists have been offered 11 ft of wall space, again in the rather gloomy rotunda, to be approached by a tunnel through a building site. This is bound to put the display at a disadvantage, particularly since we have some difficult work which needs adequate representation and possibly some explanation. To counter the response to the list so far I think we need to have a spectacular presentation in which the work will be seen in its best light. Each artist should have adequate space to make a good account of themselves.

Bowness reassured Newman that he would look into the possibility of a more extensive exhibition and catalogue, but explained that practicalities and cost would make this prohibitive. He later outlined the difficulties of the Turner Prize exhibition to the patrons in their newsletter of spring 1987 (no.9):

> People never quite realise that it takes eighteen months to two years to plan a big show and we can have, at the moment, a limited number of large shows in any one year ... We can make quite an impact with a group of ten or twelve works ... People are critical of

our exhibitions for shortlisted artists, but I remain unapologetic about them ... The time between the shortlist announcement and the exhibition of nominees is not very long and it is not always possible to make a satisfactory exhibition ...

In 1988 the shortlist exhibition was abandoned completely in favour of a winner's exhibition in the following year. But the idea of giving the winner a show twelve months later also proved problematic. Richard Deacon, for example, declined this proposal as a Tate exhibition would have conflicted with his previously scheduled solo exhibition at the Whitechapel Art Gallery. Instead he chose to install a large sculpture, *Like a Snail (A)*, in the garden at the front of the Tate from July to November 1988.

A Year of Suspension

In 1990, as if to give the prize time to heal its wounds, the Turner Prize was given an 'unsought, but not perhaps unwelcome' year's sabbatical. On 7 March 1990 Serota announced that Drexel Burnham Lambert had gone bankrupt, and had been forced to discontinue their sponsorship. They also withdrew financial support for the winner's exhibition of 1989. In July Serota gave a statement to the press that the Trustees had decided to suspend the prize for 1990, but that negotiations with a potential new sponsor were under way. The new sponsor was Channel 4 and in 1991 the prize was relaunched in its current format.

1990s Make-Over: The Turner Prize and Channel 4

As art critic of the *Guardian* in the 1980s, Waldemar Januszczak had often fiercely objected to aspects of the Turner Prize. As the Commissioning Editor for Arts at Channel 4, he saw an opportunity to facilitate change and give the prize the kind of boost it needed. A few weeks after Serota announced the withdrawal of Drexel's sponsorship, Januszczak made enquiries at the Tate. A series of exchanges followed. On 22 June 1990 he wrote to Serota:

There is no doubt that the Turner Prize is Britain's most prestigious art award. But there is no doubt that the prize has never fully realised its potential as whipper-up of enthusiasm and understanding for new art. To be perfectly honest there have been years when it has hardly seemed worth going to the trouble of having the prize at all.
And yet even in these bad years when mouthy young critics like myself sounded off against it ... there is no doubt that something important about the Turner Prize survived the attacks and confusions. It's not perfect – but it's the best there is. And because it's not perfect it has, in my opinion, a future full of potential.

Once Januszczak knew that the Gallery was prepared to consider a sponsorship proposal, he approached Michael Grade, the Chief Executive of Channel 4, who fully supported his initiative.

The Booker Prize had been successfully publicised by BBC2 and Januszczak was convinced that Channel 4 could do the same for the Turner Prize – it could guarantee television exposure, and offer expanded coverage, including profile films on the artists and live transmission of the award ceremony. He felt that the prize had previously lacked coherence and gravitas. The latter could be attained by improving the media presentation of the prize, and more importantly, by raising the prize money. But the pinnacle of his wish-list was an extensive exhibition for the shortlisted artists. With the demise of the Hayward Annual in the mid-1980s, London lacked a consistent focus for public discussion of contemporary art. Januszczak believed that a substantial exhibition at the Tate would provide such a platform and encourage further public interest in the event.

Replying to Januszczak's robust suggestions, in a letter dated 17 July 1990, Serota identified the key areas of the prize which needed attention, and in doing so indicated his own enthusiasm for a potential partnership with Channel 4:

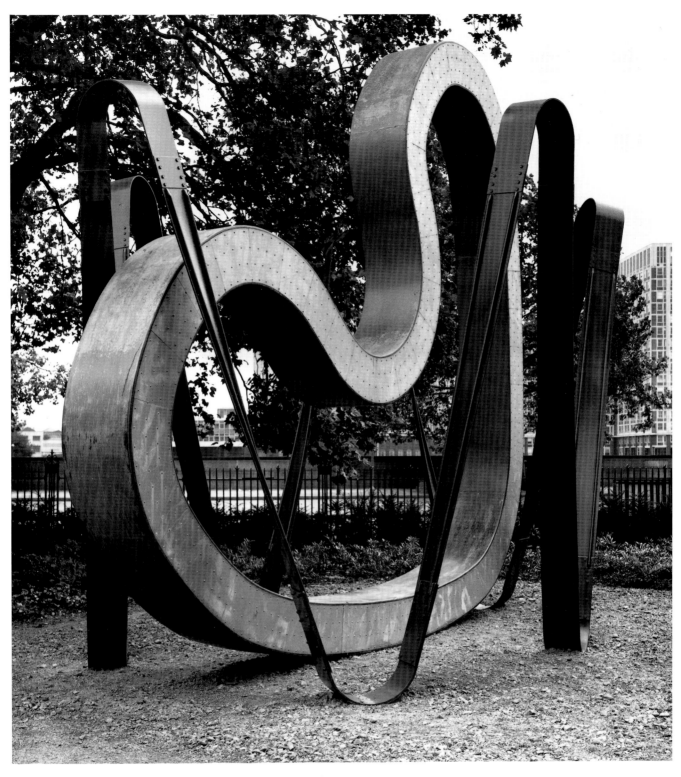

Richard Deacon, *Like a Snail (A)*
1987

two philosophical difficulties have vexed judges, artists, critics and public alike. First the impossibility of comparing artists of established practice and reputation with those only recently emerged into prominence, and second the continuing difficulty of achieving the first objective of the Prize – to make new art interesting and accessible to the Tate Gallery's own mixed-interest public, and to the public at large. In this objective the model of the Booker is of course axiomatic, and a primary purpose of the Turner Prize must be to attract sympathetic media attention for the artists selected by the jury and so to raise awareness and understanding of contemporary art.

The information area for the Turner Prize exhibition, first introduced in 1995

The Tate was confident that a more successful format could be established and maintained under this new sponsor. During discussions, the idea of an age limit was suggested as a solution to ignominious comparisons between artists at different stages in their careers. Initially, Januszczak was keen to set the limit at forty years old, but concurred with the director's view that fifty would be fairer, as a number of artists produce their best work in mid-career. It was agreed that the rubric of the prize, once reformulated, should resist alteration. This, it was hoped, would prevent confusion and allow the prize a period of gestation. The following terms were then quickly established. The Turner Prize would now be awarded to a British artist under fifty for an outstanding exhibition or other presentation of their work in the twelve months preceding the closing date for nominations. The prize would be highlighted by a display of shortlisted artists' work, mounted in the month preceding the televised award ceremony. The display would comprise at least six gallery spaces. Furthermore, the award itself would be increased to the sum of £20,000.

The first jury took the new age restriction seriously and, to the horror of many critics, selected a group of artists mostly in their twenties.[19] In drawing attention to the emergence of a new and vibrant generation of British artists who were already enjoying success at home and abroad, the jury had effectively dismissed the residual notion that the Turner Prize was a medal for distinguished service.

On the whole, the return of the exhibition has met with approval, particularly as in recent years the allocated space has been further increased to an optimum eight galleries, ensuring discrete displays for each artist. In addition, the Tate now provides a designated information area at the entrance or exit of the exhibition where visitors can view the artists' films (made since 1993 by Illuminations), consult publications and read notices of related educational events. Despite the unavoidable problem of securing works from the previous year at short notice the show has, nevertheless, provided a focus for critical debate, and drawn increasingly large audiences each year. In the 1992 broadsheet to accompany the show, Januszczak commented on the importance of the display:

> However cleverly or inventively you film art on television you can never capture its true presence. That can only happen in a gallery when the visitor is face to face with the art object.

Reflecting on the success of the Turner Prize, he told the present author that, in his view,

19 See, for example, *Evening Standard*, 7 Nov. 1991, p.30; Richard Cork, *The Times*, 8 Nov. 1991, p.14.
20 Fiona Darling-Glinski, 'The Turner Prize 1995: Visitor Survey', unpublished dissertation, University of Leeds 1996.

the prize had achieved the almost impossible – it had established a contemporary art event as a national event, bringing artists 'from the back streets of contemporary life to the front of the stage'.

The Tate is constitutionally required to display its collections for the edification of the public, but the present size of its holdings far outstrips its display facilities. In the past it has been difficult to justify snatching yet more space from the permanent collection for the benefit of loan exhibitions such as the Turner Prize. However, the prize has not only helped to move contemporary art closer to the centre of national cultural life, it has also succeeded in bringing new audiences to the Gallery. In 1995 Fiona Darling-Glinski, an undergraduate at Leeds University, undertook a survey within the exhibition. The results led her to conclude that the exhibition was not only increasing the profile of contemporary art but also encouraging visitors to question and interpret the works on display.[20]

There will always be those who oppose the entire concept of the prize and many who disagree with the choice of shortlisted artists. When such criticism takes the form of serious discussion of contemporary art, it fulfils an essential function of the event. The prize will always present an ambiguous experience for participating artists: most will welcome new-found fame or notoriety, but dread the barrage of tabloid mud-slinging, some will find participating in a high-profile competition challenging. But what the prize can offer artists is an opportunity to display their work at the Tate Gallery, where it might stimulate and give pleasure to increasing audiences, curious to discover something of the diverse creative activity taking place in contemporary British art.

In the modest booklet accompanying the first Turner Prize exhibition Alan Bowness, Director of the Tate Gallery, announced the terms and aims of the prize:

> The award is for the person who, in the opinion of the Jury, 'has made the greatest contribution to art in Britain in the previous twelve months'. Artists, writers on art and arts administrators alike are therefore eligible. We intend to encourage excellence in contemporary British art and its presentation and to foster a greater public interest in it.

Despite the intentions of the organisers, media 'fuss' and public interest prior to the announcement of the winner proved fairly low key. The only seriously discussed and contested issue was the naming of the upstart prize after an illustrious British artist. There seemed to be nothing controversial about the works by shortlisted artists on display at the Tate. Laurence Marks, in the *Observer Review* of 4 November 1984 even remarked on their accessibility:

> No smashed crockery. No chopped-up furniture. No shabby old suits suspended in space. It would be a dull soul who didn't warm to the exuberance of the exhibit, whatever critical judgement the cognoscenti may eventually hand down.

But two things altered this relative calm. One was coverage of the event by BBC1's *Omnibus* programme, watched by up to two million people. The other was the choice of winner. Robert Hughes, speaking on *Omnibus*, suggested that Britain was still diffident to American art, despite the fact that British artists were producing some of the strongest and best art in the world. Unfortunately, this view was compounded when the prize was given to Malcolm Morley, who had lived in the United States since 1958 and had not even been present to receive his award. A critical outburst ensued. Although Waldemar Januszczak conceded that Morley was a painter of 'uncommon force', like many other critics he could see no evidence of the artist's impact in Britain in the previous twelve months: 'Whatever Morley's historical significance – and I for one think it has been vastly overestimated – it has had absolutely nothing to do with art in Britain and merely confirms the continuing cultural dominance of the New York art world.'(*Guardian*, 10 November 1984, p.10).

For a critic such as Peter Fuller, Morley, a 'shallow' artist, was the worst possible choice. The jury's decision confirmed Fuller's repeatedly published conspiracy theories about influential collectors and the Tate Gallery's Patrons of New Art: 'Why did he get the Turner Prize? Ask any one in the art world this question and, within minutes, they will point out that Morley is one of the artists avidly collected by Charles Saatchi ... The only good thing Malcolm Morley ever did for the arts in Britain was to leave these shores more than quarter of a century ago.' (*New Society*, 15 November 1984, p.249).

Malcolm Morley

Morley's work combines a rich autobiographical, mythical and emotional content with a complex, formal approach to the practice of painting. His success lies in this fusion of explosive, unconscious expression and intellectual, almost programmatic method. In a conversation with Arnold Glimcher (*Malcolm Morley*, Pace Gallery, New York 1988, p.3) the artist commented: 'Essentially I have this tremendous belief in the relationship between what we call the unconscious and conscious life. I think we're really more like icebergs. There's this huge underbelly. The idea is to integrate the two so they become one.'

Morley's passion for painting is driven by both pleasure and anxiety. He has often talked about the 'pornography' of a painting, of the potential of paint on a surface to arouse desire. Describing his and the viewer's relationship to his pictures in the Pace Gallery catalogue (p.3) he has commented: 'I'm the first observer, the first spectator; a spectator who is impossible to please, who plays Russian roulette with pleasure. We must remember why we do a painting, which I was forced eventually to say – for the pleasure of it.'

Morley is viewed as a wilfully individualistic artist, contemptuous of stylistic fashions in art and committed to 'playing for high stakes'. Summing up

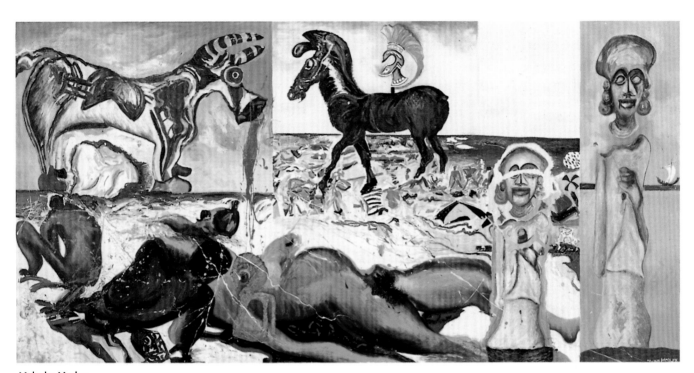

Malcolm Morley
Farewell to Crete 1984

Malcolm Morley
1931 Born in London
1952–3 Camberwell
School of Arts and
Crafts
1954–7 Royal College
of Art, London
1958 Moved to
New York, USA

Richard Deacon
1949 Born in Bangor,
Wales
1954–6 Lived in
Sri Lanka where his
father was stationed
with the RAF
1969–72 St Martin's
School of Art, London
1974–7 Environmental
Media MA at the Royal
College of Art, London
1977 History of Art,
Chelsea School of Art,
London
1989–96 Trustee of
the Tate Gallery

Gilbert
1943 Born in
Dolomites, Italy
Studied at
Wolkenstein School
of Art
Hallein School of Art
Munich School of Art
1967–8 St Martin's
School of Art, London
George
1942 Born in Devon
Studied at
Dartington Adult
Education Centre
Dartington Hall
College of Art
Oxford School of Art,
Oxford
1966–8 St Martin's
School of Art, London

Morley's aspirations in *Malcolm Morley: Watercolours* (Tate Gallery Liverpool 1991, p.11) Richard Francis wrote:

> He is ambitious to be a great painter, both in the sense of the modernist painters and a classical (a word he prefers to traditional) painter, in the sense of subject and method, making him, of course, a supremely post-modern painter. This is an ambition that he acknowledges is very difficult for him to fulfil, for it means that he must challenge, if he is to succeed, the champions, at least, of the twentieth century (Picasso, Dali, Matisse, Pollock *et al.*) and, simultaneously, provide himself with sufficient pleasure from making his work.

By the early 1980s, when 'post-modern' was first widely used to describe the condition of post-1960s art and culture, it became possible for critics to 'classify' Morley's work. Although heavily influenced by Cézanne, Morley had also absorbed a heady mixture of twentieth-century movements including Cubism, Expressionism, Dadaism, Surrealism, Abstract Expressionism, as well as Pop, Minimal and Conceptual art. The freedom with which he assimilated elements from the history of art seemed commensurate with the post-modernist disregard for modernism's slavish adherence to the 'new' in art.

Morley's unstable and lonely childhood produced experiences that later fed into his work. He has never known his father. A fascination with the sea led him to make balsa wood models of famous ships and later to serve as a galley boy in the merchant navy. As a youth, delinquent behaviour culminated in a short prison sentence. In prison he started to paint. On his release, encouraged by his teacher, he began to pursue a career in painting, first by making a painting trip to St Ives, and then securing a place at Camberwell School of Art and Crafts. Later, at the Royal College of Art, he belonged to the generation of young artists, including Peter Blake, who were to become associated with Pop art. But in 1956, Morley was dazzled by the exhibition of American abstract painting held at the Tate Gallery and determined to move to New York, where he has lived since 1958.

In 1964, after experimenting with abstraction under the influence of Barnett Newman, Morley began a series of paintings of battleships and sailors. Finding it too difficult to paint a ship from life, owing to the distortion of scale, he divided a postcard into a grid of squares so that he could faithfully transcribe the image of a ship, segment by segment, onto a larger canvas. The grid was used as a device by others at the time, notably by Richard Artswager, but Morley had also learned this traditional method of transferring a scaled image at Camberwell and the Royal College. Each section of the grid was painted independently of the whole in a 'super-realistic' style. The use of sections has subsequently been central to Morley's picture-making.

In the early 1970s he started to subvert the precision of his paintings by introducing 'accidental' marks which relate to his interest in violent images of crashes and accidents. His paintings were now made from toy models rather than postcards. Towards the end of the decade he began to paint from his own watercolours of toy models with the result that his brushstrokes became even more idiosyncratic and expressive. By the early 1980s his pictures were highly charged images, epic both in scale and content, full of obscurely personal interpretations of the world around him.

In 1980 he visited England for the first time in twenty years. In the interim he had rarely shown work in this country, and exhibitions of his work elsewhere had been so sporadic that his Whitechapel restrospective of 1983 was met with curiosity. For the first time critics had a chance to assess the development of his work over two decades. The exhibition began with early ship paintings such as *Cristoforo Columbus* (1965) and culminated with large-scale, eroticised imaginative landscapes such as *Christmas Tree – The Lonely Ranger Lost in the Jungle of Erotic Desires* (1979), and fleshy mythological paintings inspired by his recent visit to Greece. The exhibition was a revelation. Morley, whose self-styled 'super-realism' of the 1960s had marked him as a progenitor of Photorealism was now also seen as a precursor to the New Expressionism of the 1980s.

Richard Deacon
Boys and Girls 1982

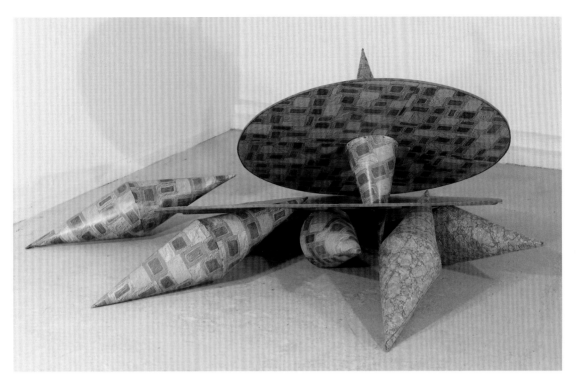

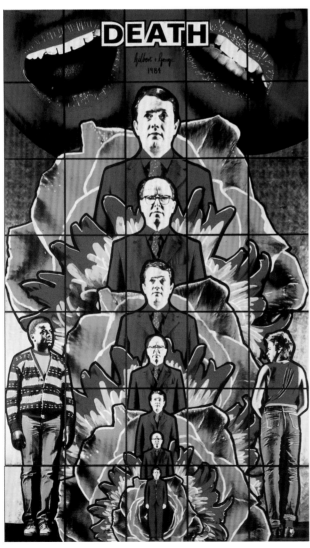

Gilbert and George
Death Hope Life Fear
1984
One of four panels

1984

The aim of the large, richly-painted works of the early 1980s was conveyed in a comment to his interviewer, Sarah MacFadden in *Art in America* in December 1982 (vol.70, no.11, p.68, New York):

> I'm after making pictures that contain a combination of images that have the power to brand, in the way that a branding iron sears. I figured that a combination of unique image arrangements could have a similar effect, the way de Chirico hits.
> The images just get lodged in your brain – there's no way of dislodging them once they're there.

Richard Deacon

Deacon was represented in the 1984 shortlist exhibition by the British Council's *Boys and Girls* (1982) and *The Heart's in the Right Place* (1983) from the Saatchi Collection. A discussion of his work can be found under 1987 when he was awarded the prize.

Gilbert and George

In 1984 Gilbert and George were represented in the shortlist exhibition by *Drunk with God* of 1983. A discussion of their work can be found under 1986 when they won the prize.

Howard Hodgkin

In the shortlist exhibition of 1984 Hodgkin was represented by *Still Life* (1982–4) and *Son et Lumière* (1983–4). A discussion of his work can be found under 1985 when he was winner of the prize.

Richard Long

In the 1984 exhibition Long was represented by two works of that year, *Chalk Line* and *River Avon Mud Circle*. He was shortlisted in 1987 and considered as a contender in 1988. A discussion of his work can be found under 1989 when he was awarded the prize.

Howard Hodgkin
1932 Born in London
1940–3 Lived in USA
1949–50 Camberwell School of Art, London
1950–4 Bath Academy of Art, Corsham
1970–6 Trustee of the Tate Gallery, London
1978–5 Trustee of the National Gallery, London

Richard Long
1945 Born in Bristol
1962–5 West of England College of Art, Bristol
1966–8 St Martin's School of Art

Howard Hodgkin
Son et Lumière 1983–4

Richard Long
Chalk Line 1984

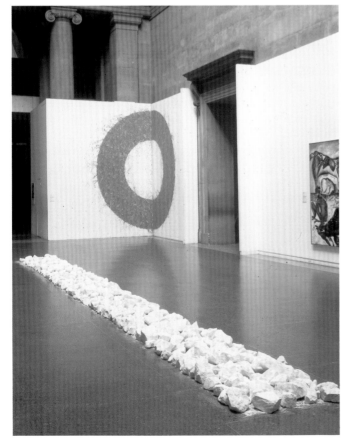

Winner
Howard Hodgkin

Shortlisted artists
Terry Atkinson for his exhibitions of work in London, Venice, and elsewhere for his activities as a teacher and writer
Tony Cragg for important exhibitions held in Europe and the USA and for a notable contribution to the Hayward Annual, London, in 1985
Ian Hamilton Finlay for a major contribution to British art, and in support of his beleaguered position at Stonypath, Dunsyre, Scotland
Howard Hodgkin for the continuing international impact of his painting, exemplified by his successful exhibition at the 1984 Venice Biennale, which was subsequently shown in the USA and Germany, and in an extended form at the Whitechapel Art Gallery, London, in 1985
Milena Kalinovska Exhibitions Director, Riverside Studios, London, shortlisted in recognition of her series of exhibitions devoted to work by younger artists
John Walker for the exhibition of his paintings at the Hayward Gallery, London, and his graphic work at the Tate Gallery; and in special recognition of the work he has recently done in Australia.

Jury
Max Gordon
Architect, representative of the the Patrons of New Art
Mark Francis
Director, the Fruitmarket Gallery, Edinburgh
Lynne Cooke
Lecturer in the History of Art, University College London
Kynaston McShine
Senior Curator of Paintings and Sculpture, Museum of Modern Art, New York
Alan Bowness
Director of the Tate Gallery and Chairman of the Jury

Exhibition
17 October–1 December 1985
Prize of £10,000 presented by Sir Richard Attenborough, 12 November 1985

In 1985 the Turner Prize was nourished by the media attention, or rather storm of controversy, it had attracted following Malcolm Morley's win the previous year. Some critics even greeted the return of the 'Great Autumn Handicap of our Visual Art World' with delight (William Packer, *Financial Times*, 22 October 1985, p.21). However, this year's winner, Howard Hodgkin, came as no surprise and met with widespread approval as he had been the favourite for two consecutive years.

For the first time a non-artist, Milena Kalinovska, Exhibitions Director at Riverside Studios, London, was shortlisted in recognition of her innovative exhibition programme. The exhibition of shortlisted artists was staged in the Octagon, the space dividing the North and South Duveen galleries, the central spine of the Tate Gallery.

Attempts were made in 1985 to introduce an educational element: lunchtime lectures on the contenders were held at the Tate, and the Institute of Contemporary Arts hosted a discussion with a panel comprising Alan Bowness, Max Gordon, Peter Fuller, Mark Francis and Kynaston McShine, with Christopher Frayling as chairman.

Howard Hodgkin

Howard Hodgkin established his reputation as a painter with a retrospective exhibition organised by the Arts Council of Great Britain in 1976. By this time he was also a well-known and respected member of the art community in Britain. But his international standing, which continues today, was not fully realised until the early 1980s. It has remained unquestioned since 1984 when his exhibition at the British Pavilion in Venice – subsequently touring in the United States, Germany and culminating at the Whitechapel Art Gallery in July 1985 – caused a sensation. At the time John McEwan assessed Hodgkin's achievement in *Howard Hodgkin: Forty Paintings* 1973–84 (Whitechapel Art Gallery, London 1984, p.10):

All Hodgkin's pictures can be thought of as the grit of some experience pearled by reflection. They begin where words fail, evocations of mood and sensation more than visual record, but descriptions indubitably of the physical as well as the emotional reality. And this perhaps explains why in an artistically conservative country like England he is thought to be an abstract painter, while in a more artistically sophisticated one like America he is admired for being representational. For Hodgkin himself the pictures could not be more intentionally specific.

Hodgkin's main preoccupation has been to convey the emotional, psychological and physical character of particular encounters. Guided by memory, he evokes the ambience of a domestic interior, the subtle meanings and effects of conversations – pauses, silences, emotional undercurrents.

Since the late 1960s he has been a frequent visitor to India and is a collector of Indian painting. He first became interested in Indian painting in his early teens, attracted by what seemed to be a completely different way of representing the world. Although Indian painting has not influenced his work in any specific way, he feels that something about the atmosphere and nature of human exchange in India has probably had an effect. He has said: 'It's the sort of nakedness of their very inhibited emotions. I mean, everything is very visible, somehow, there. Life isn't covered up with masses of objects, masses of possessions, so that the difference between being indoor and out of doors and all the sort of functions of life are much more visible' (*Howard Hodgkin*, exh. cat., Anthony d'Offay Gallery, London 1983, p.66–7).

Between the late 1950s and 1970s Hodgkin produced a series of portraits of friends, usually artists, in their own interiors, often mimicking their style. This helped him to establish his own artistic identity or 'space' in relation to the plethora of existing contemporary styles. Comparisons were drawn between his work and some British Pop artists, but Hodgkin remained relatively isolated in his art practice throughout the 1950s and 1960s. His paintings were unfashionably small and, unlike many abstract painters of the time, he worked slowly, creating the finished image through a process of layered corrections.

Howard Hodgkin
A Small Thing But
My Own 1983–5

1985

Howard Hodgkin
1932 Born in London
1940–3 Lived in USA
1949–50 Camberwell School of Art, London
1950–4 Bath Academy of Art, Corsham
1970–6 Trustee of the Tate Gallery, London
1978–85 Trustee of the National Gallery, London

Terry Atkinson
1939 Born in Thurnscoe, near Barnsley, Yorkshire
1959–60 Barnsley Art School
1960–4 Slade School of Art, London

Hodgkin's desire to produce 'physically contained' images which pull the viewer into an illusionistic space sets him within a particular tradition in Western painting, as he has pointed out (*Howard Hodgkin: Forty Paintings*, p.100):

> In the museum culture in which we now live, small contemporary paintings don't rate. And yet a Morandi, a Mondrian, a Vermeer, a Chardin, a Fragonard, a small Picasso or a small early Vuillard, to take a few random examples, can knock you out across a room ... I would like to paint a picture of sufficient emotional and physical volume that it could hang in a room alone, without seeming pretentious.

Although his painting has been influenced by numerous forbears, including Corot, Ingres, Delacroix, David, Bonnard and Degas, it was perhaps the early paintings of Edouard Vuillard that nurtured his mature style. David Sylvester noted the effect of Vuillard's intimiste paintings of late nineteenth-century interiors on Hodgkin's development, in such works of the mid-1970s as *Grantchester Road* (1975). In conversation with Hodgkin for *Howard Hodgkin: Forty Paintings* (p.105) he suggested:

> If one was doing a kind of placing of your work art-historically, I'd say that it's as if you'd taken these Vuillards and done two things to them: you've moved in, you've moved into close-up; and it's as if this flat unbroken, unbreakable surface of a Vuillard had been deflowered.

Sylvester felt that Hodgkin had, by using illusionistic painterly devices, suggested 'cavernous spaces' without 'violating the flatness of the picture-plane' (ibid. p.101). Hodgkin paints with oil on wood rather than canvas, the wood providing a solid and enduring surface for his often tentative, ephemeral subjects. Since the 1970s his most characteristic illusionistic device has been the painting of the picture frame. Rather than simply closing the picture off from the space around it, the frame acquires a more active role.

Hodgkin's subjects at this time were increasingly based on personal encounters. But his consistent aim has

been to develop a language of paint capable of producing images that are not limited by his own experience. Talking with David Sylvester he discussed the motivating force behind the development of his painterly techniques:

> I want the language to be as impersonal as possible ... It's a major concern of mine that every mark that I put down should not be a piece of personal autograph but just a mark, which then can be used with any other to contain something. I want to make marks that are anonymous as well as autonomous. They can't be one without the other it seems to me; otherwise, they would remind you of somebody's handling.

By the early 1980s Hodgkin had evolved a visual vocabulary of abstract marks – blobs, stripes, spots, swirls, feathery strokes – together with a robust and sensitive use of colour that effectively realised his ambition to create somehow, by painterly means, metaphors for lived experience. Teresa Gleadowe, writing in *Howard Hodgkin: Paintings* 1977–84 (XLI Venice Biennale 1984), the guide to the British Pavilion's exhibition, remarked:

> His current vocabulary ... asserts the abstract authority of each mark set down. And yet, in this net of voluptuous colour, the ghost of memory seems to cling more tenderly, as if he had discovered the perfect medium for its preservation.

Terry Atkinson

Terry Atkinson's practice stems from the belief that art cannot be divorced from the context in which it is made. He therefore holds the view that through art it is possible to further our understanding of the complex social and political world in which we live. Using commonplace visual forms such as snapshots, cartoons, postcards and sketches, his paintings describe people and events. Texts often accompany the pictures, giving clues as to Atkinson's intended meanings, but also serving to highlight the ways in which images are misinterpreted.

In the late 1960s Atkinson visited America and met a number of artists whose work interested him, including Sol LeWitt, Dan Graham, Carl Andre

Howard Hodgkin
Still Life 1982–4

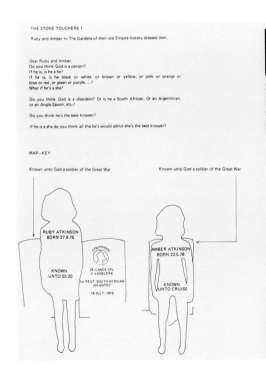

THE STONE TOUCHERS 1

Ruby and Amber In The Gardens of their old Empire history-dressed men.

Dear Ruby and Amber,
Do you think God is a person?
If he is, is he a he?
If he is, is he black or white, or brown or yellow, or pink or orange or
blue or red, or green or purple....?
What if he's a she?

Do you think God is a dissident? Or is he a South African, Or an Argentinian,
or an Anglo-Saxon, etc.?

Do you think he's the best knower?

If he is a she do you think all the he's would admit she's the best knower?

MAP—KEY

Known unto God a soldier of the Great War Known unto God a soldier of the Great War

RUBY ATKINSON
BORN 27.9.75

24. LANCE CPL
C VANBLERK
1st REGT. SOUTH AFRICAN
INFANTRY
18 JULY, 1916

KNOWN
UNTO SS 20

AMBER ATKINSON
BORN 22.5.78

KNOWN
UNTO CRUISE

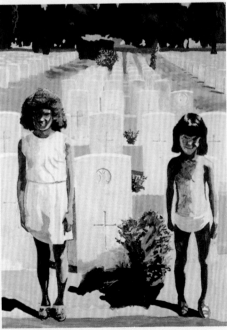

Terry Atkinson
*Art for the Bunker 4:
The Stone Touchers
Ruby and Amber in the
Gardens of their Old
Empire History Dressed
Men* 1985

Tony Cragg
1949 Born in
Liverpool
1969–72 Wimbledon
School of Art, London
1973–7 Royal College
of Art, London
1977 Moved to West
Germany

Ian Hamilton Finlay
1925 Born in Nassau,
Bahamas
1942–5 Briefly
attended Glasgow
School of Art before
serving in the army
during the Second
World War
1961 Founded The
Wild Hawthorn Press,
Edinburgh
1964–6 Lived at Easter
Ross near Inverness,
Scotland
1966 Moved to
Dunsyre, Scotland

and Robert Smithson. In 1968 he founded Art & Language with Harold Hurrell, David Bainbridge, and Mel Ramsden. Art & Language gained exposure in the early 1970s as part of the Conceptual Art movement and Atkinson remained an active member until 1974. Since 1977 he has taught in the Fine Art department at Leeds University.

During the 1980s Atkinson's work explored the relationship between politics and representation with particular emphasis on such issues as the construction of history and artistic identity. Two pictures from a new series of work called *Art for the Bunker* were included in the Turner Prize exhibition. The series consists of two contrasting narrative parts; the *Happysnap/ Historysnap* pictures, and works centring on the history of British-Irish relations. The *Happysnap/Historysnap* paintings, intimate in scale and painted on white grounds, are based on images of the artist's family. They present a notion of domestic life threatened by nuclear war and at the same time suggest the family's ability to combat this with pacifism. The second half of the series comprises larger works in coloured conte crayon, drawn on black grounds, in which the artist attempts to make visible his own unavoidable cultural position as an English artist in relation to reactions to Irish Republican violence.

Tony Cragg

In the 1985 shortlist exhibition Cragg was represented by *Still Life: Belongings* (1985). A discussion of his work can be found under 1988 when he was awarded the prize.

Ian Hamilton Finlay

Until the 1970s Finlay was better known for his poetry, plays and stories than as a maker of prints, medals and sculpture. A love of language and a deeply-felt poetic sensibility has always influenced his art, as has a belief that the aesthetic appearance should stimulate the viewer to contemplate the underlying sources and references of his work.

At his Dunsyre home, 'Stonypath', later renamed 'Little Sparta', Finlay has created a unique artwork with the collaboration of his wife Sue and a range of artists and craftsmen. It has attracted

both notoriety and international acclaim. In the midst of wild moorland he has designed and constructed a garden with a 'Temple' containing sculptural monuments which together represent meditations on philosophical and classical issues. Finlay maintains that the 'Canova-type temple' was conceived as a building in which to house works of art rather than as an 'art gallery'. But in the late 1970s he entered a dispute with his local authority, which refused to accept that the 'Temple' qualified for the rates exemption granted to religious buildings. In 1983 the authorities removed works from the temple and the garden was subsequently closed to visitors for a year. Finlay named the ongoing disagreement 'The Little Spartan Wars'. For him it represented a serious conflict concerning the 'nature of culture' and 'the relation between law and culture'. In support of his cause he looked to historical precedent, drawing particular courage from the heroes of the French Revolution: 'For some time I have felt inspired by the neo-classical triumvirate of Robespierre, Saint-Just and J.-L. David. These three created that astonishing idealist pastoral, the French Revolution (whose Virgil was Rousseau). Presumably my work will "progress" towards my being in prison, unless the necessity of revolution (a return to Western Traditions) is understood first' ('Spartan Defence: Ian Hamilton Finlay In Conversation with Peter Hill', *Studio*, 1984, vol.196, no.1004, p.61).

After 1984 he established the 'Temple' as a homage to the classical and pastoral values of the French Revolution. While its main room was conceived as an extension of the garden, an increasing number of columns and capitals were placed outside so that the 'interpenetration' of garden and 'Temple' became a key feature (see Biographical Notes in Yves Abrioux and Stephen Bann, *Ian Hamilton Finlay: A Visual Primer* 1985). The Finlays' refusal to concede over what they believe to be a matter of principle caused them considerable hardship. However, Finlay remained insistent that a bureaucracy should not be allowed to determine a cultural question which in his view it had failed properly to examine.

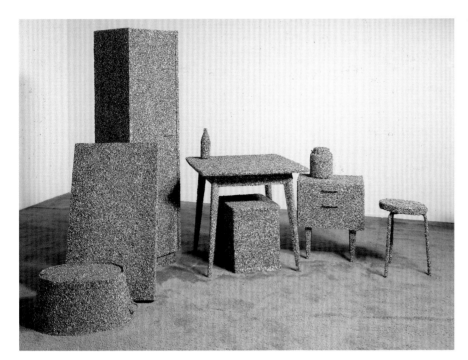

Tony Cragg
Still Life Belongings
1985

Ian Hamilton Finlay
*The Present Order is
the Disorder of the
Future* 1983

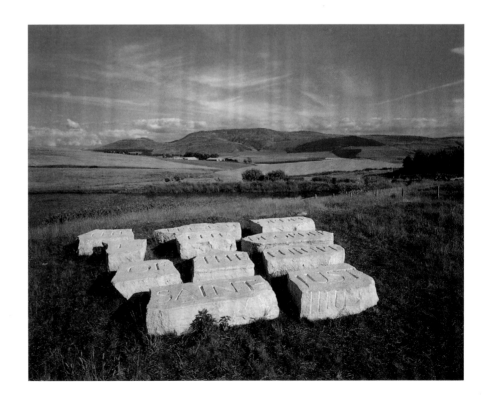

Milena Kalinovska
1948 Born in Prague, Czechoslovakia
Studied at Charles University, Prague
1970 Moved to Britain, becoming a British citizen in 1977
Studied at Essex University
1978–80 Commonwealth Scholarship to University of British Columbia

Milena Kalinovska

Milena Kalinovska was Exhibitions Director of the Gallery at Riverside Studios in Hammersmith, London from August 1982 to November 1986. Under her management the Gallery presented over twenty exhibitions each year, including the work of over two hundred artists. The gallery's policy was to exhibit work by young artists both from Britain and abroad. But the policy also promoted neglected older artists and incorporated historical exhibitions. The flexibility of the programming, together with unusual sensitivity towards the artists' intentions for the display of their work, resulted in a dynamic view of contemporary art, relatively unhindered by institutional imperatives. The gallery was run by two people, Kalinovska and her Assistant Exhibitions Organiser, Greg Hilty. They were helped by temporary gallery assistants who worked, often without pay, on specific projects and supervised the gallery. An important development in the year 1985–6 was the initiation and single-handed operation of an education programme by Kate Macfarlane.

Riverside Studios is governed by a charitable trust, and was supported until March 1985 by the Greater London Council and the Arts Council of Great Britain; at the time of Kalinovska's shortlisting it was funded solely by the GLC which was subsequently abolished. In April 1994 Riverside closed for six months owing to lack of funding. At the time of writing the gallery is still unable to sustain its own exhibition programme.

Kalinovska became Associate Director of Riverside until January 1989 when she took the post of Senior Curator at the New Museum of Contemporary Art in New York. Between 1991 and 1997 she was the James Sachs Plaut Director at the Institute of Contemporary Art in Boston.

John Walker

John Walker was shortlisted primarily for works he had made in the previous five years. During this period he significantly developed what had been his main preoccupation as a painter, namely, how to make images that are not representational, yet which somehow convey the drama of painting. This approach relates to a tradition of painting begun by Venetian painters of the Renaissance, who invented and developed a variety of pictorial means designed to celebrate the 'wonder' of painting.

Early on in his career Walker was impressed by American Abstract Expressionism: he was particularly drawn to the paintings of Jackson Pollock. However, he rejected the Americans' insistence on all-over fields of colour in favour of shapes which, since the late 1960s, he has depicted within complex illusionistic spaces. Walker's shapes are often motifs derived from or influenced by such sources as the Bible. But he resists any narrative interpretation of his work, preferring to emphasise the language of painting rather than iconography.

In the *Alba* series of the mid-1980s Walker recast meninas, infantas and the Duchess of Alba from paintings by Velasquez and Goya. Using a variety of painterly techniques, such as highlighting, glazing and contrasting brushwork he suggested a theatrical world with its roots in the Western tradition of painting. The highly coloured *Oceania* series, also of this period, represents Walker's response to Australia, where he lived and worked at the end of the 1970s and early 1980s. In 1985 Dore Ashton, in *John Walker: Paintings from the Alba and Oceania Series 1979–84* (Hayward Gallery, London 1985, p.7), observed that Walker's pictures seemed to be asking:

> By what process … can a modern painter reintegrate all the traditional ways of making a canvas into an image? In the long story that goes back to Venice, and Spain, and Holland, there has been a conversation from painter to painter that Walker enthusiastically extends. It seems to me that the overwhelming sense of inner freedom his recent works convey is a function of the perpetual animated dialogue with other painters dead and alive.

John Walker
1939 Born in Birmingham
1956–60 Birmingham College of Art

John Walker
Form and Sepik Mask
1984

Gilbert and George 1986

By its third year no one could deny that
the prize had become British art's biggest
media event. Its success ensured that at
the end of Oliver Prenn's initial three-
year sponsorship another sponsor, Drexel
Burnham Lambert, had fallen easily into
place. But despite this apparent
achievement, the Turner Prize was
experiencing serious problems. Judging
by various articles and letters it seems
that almost everyone involved was
dissatisfied.

Michael Newman, one of the 1986
jurors, wrote to Alan Bowness about the
response to the shortlist: 'Somehow we
seemed to have managed to upset
everybody, quite unintentionally' (Letter
of 10 July 1986). Worse still was that it
had been publicly reported that a trustee
of the Tate thought the shortlist 'silly,
pathetic and depressing' (Marina Vaizey,
Sunday Times, 6 July 1986, p.45).
Newman urged Bowness to change the
proposed site of the exhibition from the
Octagon. In his view the artists should be
allowed 'a spectacular presentation in
which the work will be seen in its best
possible light ... If the display falls flat,
then it really will be a disaster for the
prize, for the artists and for the public
appreciation of new art'.

A few weeks later the inadequacy of
the likely exhibition space became the
subject of an article by Andrew Graham-
Dixon in the *Sunday Times*: 'Poorly lit and
claustrophobically low-ceilinged, the
Octagon's worst feature is its shortage of
wall space ... Turner Prize exhibitors will
have to make do with an average of eleven
feet of running wall space each' (*Sunday
Times*, 3 August 1986, p.40). Graham-
Dixon canvassed some of the
participating artists, most of whom
seemed clearly disappointed by the
arrangements for the exhibition. Mel
Ramsden of Art & Language was
particularly aggrieved: 'They mount this
elaborate media operation to popularise
British art, and then fail to do anything
about showing the art properly.'

The Gallery recognised that the
Octagon was not ideal but the imminent
re-roofing of the Duveen galleries meant
that these grander spaces would not be
available for the display. However,
recognising the need to improve the
exhibition, the Director of the Tate agreed
to allocate the Turner Prize a gallery

space usually reserved for the permanent
collection. Sadly, this did little to quell
negative reviews of the both the shortlist
and the exhibition, typified by the
comments of a critic writing in the
Sunday Telegraph: 'Neither the shortlist
nor the pathetically inadequate,
unexplained, timid and esoteric
presentation currently at the Tate, are
going to "increase public interest in
contemporary art"'(Michael Shepherd,
Sunday Telegraph, 16 November 1986,
p.19).

In 1986 critics were also beginning to
question what appeared to be the
predictability of the winner. Gilbert and
George, William Hill's favourites at 6/4,
went home with the award and commen-
tators ranging from John Russell Taylor
of *The Times* to Waldemar Januszczak of
the *Guardian* questioned the validity of a
prize which appeared to be a reward for
long service, 'an occasion during which
art world inhabitants can pat each other
on the back in the vague way that
Hollywood does when it distributes its
honorary distinguished service Oscars'
(Januszczak, *Guardian*, 27 November
1986, p.14).

Gilbert and George
Gilbert and George have constantly
attempted to address themes and subjects
from human experience in such a way
that their work would be accessible to
untutored audiences. They have often
declared a belief in beauty, although as
self-styled 'campaigning artists' their
overriding aim has been to challenge or
improve society, rather than congratulate
it. In Carter Ratcliff's *Gilbert and George:
The Complete Pictures 1971–1985*, (London
1986, vii), they state:

> We want Our Art to speak across the
> barriers of knowledge directly to
> People about their life and not about
> their knowledge of art ... The content
> of mankind is our subject and our
> inspiration. We stand each day for
> good traditions and necessary
> changes. We want to find and accept
> all the good and bad in ourselves.

They met at St Martin's School of Art in
London in 1967, and have worked
together as one artist ever since. As
students they were among a generation,
including Barry Flanagan, Richard Long

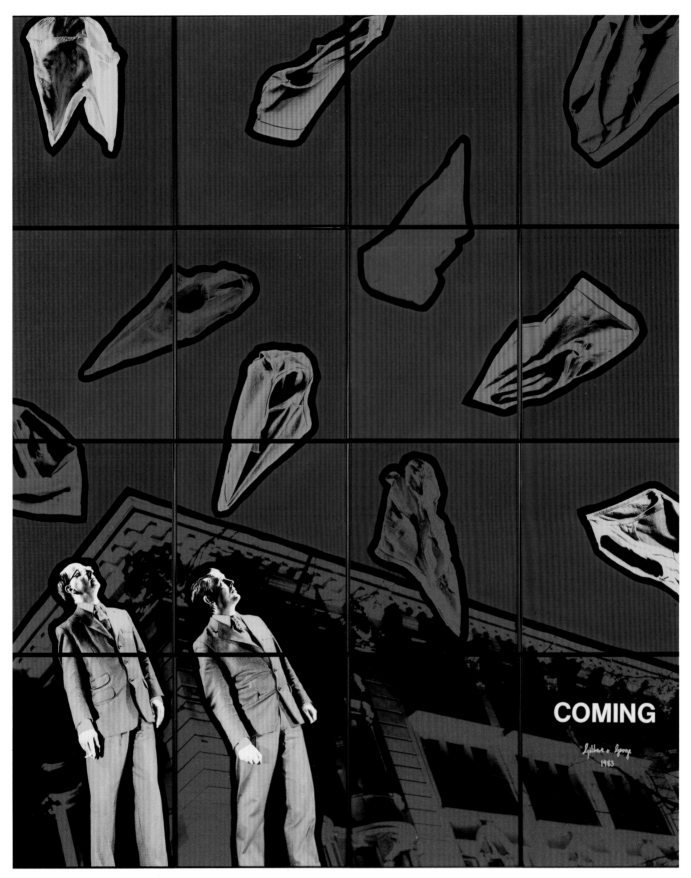

Gilbert and George
Coming 1983

Gilbert
1943 Born in
Dolomites, Italy
Studied at
Wolkenstein School
of Art
Hallein School of Art
Munich School of Art
1967–8 St Martin's
School of Art, London
George
1942 Born in Devon
Studied at
Dartington Adult
Education Centre
Dartington Hall
College of Art
Oxford School of Art,
Oxford
1966–8 St Martin's
School of Art, London

and Bruce McLean, who rebelled against the ideas of Anthony Caro and New Generation sculpture which dominated St Martin's at that time. In 1969 they began to perform 'actions', referring to themselves not as performance artists, but as 'living sculptures'. The first of these was *The Singing Sculpture*, in which they acted out the lyrics to Hardy and Hudson's version of Flanagan and Allan's music hall song *Underneath the Arches*. In 1970 a presentation of this piece lasted for eight hours each on two consecutive days.

Such has been their commitment to the transformative role of the artist that Gilbert and George have devoted their entire lives to art, adopting the persona of living sculpture in their everday lives. Both dress in white shirts, loud or emblematic ties and worsted suits – 'the responsibility-suits of our art' – which convey the seriousness of their task, and maintain a measured formality in their behaviour towards each other, and the rest of world. Assessing their achievement in 1985, Brenda Richardson wrote:

They grew up as artists in the mid-to-late 1960s under the domination of Pop Art and Minimalism, movements given to non-judgemental content and anti-expressionist form. Gilbert and George, quite contrarily, were committed to meaning and morality in art and to imaginative expression as the most honest and direct form of communication. When they decided to use their own bodies as art material and their personal convictions as content, they literally invented their own medium and carved out a unique and memorable place for themselves in the evolution of contemporary art.

In addition to the so-called 'living pieces', which they ceased to perform in 1977, Gilbert and George have worked in a variety of media, including video, drawing, painting and photography. Since 1980 their photographic pieces have become the dominant vehicle for their meditations on the human condition. Their subjects have included sex, religion, nature, urban development, authority, fear, ecstasy and death. The intellect, the soul and sex are ever-present components of their work: 'We often say

that within the person, when we are working, we have our brain, our soul, and our sex. These are the three things that we work with. Sometimes we do a picture more for sex, sometimes more for our brain, and sometimes more for our spirit. It's always with a combination of those three that we work. The whole of civilisation continues because of those driving work forces' (*Gilbert and George: The Complete Pictures*, xxxi).

Their photo-pieces comprise groups of abutted photographs, which, framed in black, form a grid. This format has several advantages. It enables them to overcome the restrictions of printing and produce mural-sized images that can convey their ideas forcefully and directly to the viewer. But the grid format also has a philosophical motive, as Gilbert and George perceives the world as having natural divisions. Again in *The Complete Pictures* (xvi) they state:

The grids are a natural part of making large photo-pieces. It is like a week had to be divided into days, for convenience. A house has to be made of Bricks. You can't make a house from one big brick ... Everything is in sections.

The grids also give the luminous photo-pieces the appearence of stained glass, which enhances the serious intention underlying their use of often shocking, and even comic, imagery. The works are laboriously hand made with exemplary precision. But their effect is that of images effortlessly magicked into existence.

Gilbert and George have used their own experience as the basis of all of their works. The photo-pieces are made from photographs of themselves, models and their immediate environment. On one level the images might be interpreted autobiographically. But they are deliberately composed as symbolic icons, rather than as narratives, devised as confrontational mediations on aspects of human activity and emotion. As Brenda Richardson explains: 'Their omnipresent self-images ... are not necessarily to suggest the literal role of Gilbert and George in the specific setting depicted. As symbolic images, they become Everyman – pilgrim, guide, and *alter ego* for their fellows' (p.15).

Gilbert and George
Death Hope Life Fear
1984
One of four panels

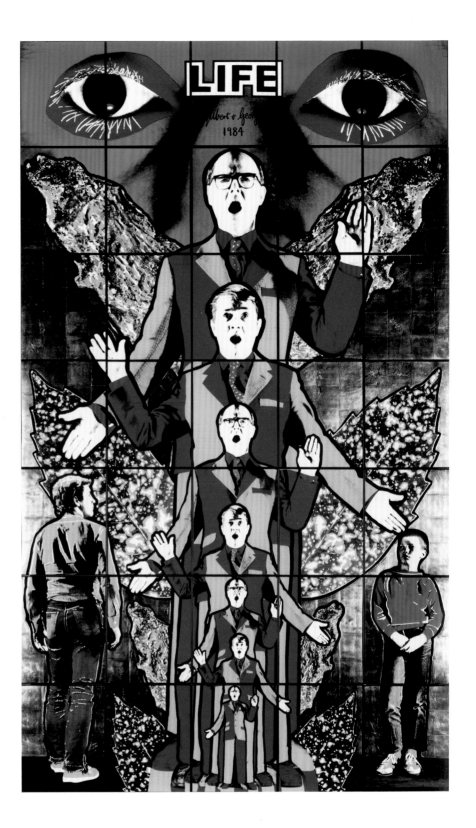

Art & Language
Michael Baldwin
1945 Born in Chipping Norton, Oxfordshire
1964–7 Coventry College of Art
Mel Ramsden
1944 Born in Ikeston, Derbyshire
1960–2 Nottingham School of Art

Victor Burgin
1941 Born in Sheffield
1962–5 Royal College of Art, London
1965–7 Yale University, Connecticut

During the 1980s Gilbert and George were prolific, both in the quantity and range of their work. During the 1970s they had combined only the powerful and emotive colour red with their black-and-white photographs. But from 1980 onwards they began to exploit the emotional, spiritual and symbolic qualities of green, blue, violet, pink, orange and yellow, favouring vivid hues. They also experimented with photographic and compositional techniques and devices such as overlapping images, superimpositions and photograms, so that the images became more complex. One such example is *Death Hope Life Fear* of 1984. In this four part polyptych (or tetraptych), the artists appear with many of their favourite motifs. These include the flower, a symbol of sex and fecundity, and youths from the East End, who frequently appear in their works as symbols of ideal manhood.

Their significance for a younger generation of British artists has been publicly acknowledged by their inclusion in such recent exhibitions as *Minky Manky*, curated by Carl Freedman at the South London Gallery in 1995 and *Some Went Mad, Some Ran Away*, curated by Damien Hirst at the Serpentine Gallery, London in 1994.

Art & Language

Art & Language has promoted theoretical debate about the social and political identity of works of art, and encouraged a thoroughgoing questioning of the cultural status of the art object and the artist. Founded in Coventry in 1968 by Terry Atkinson, David Bainbridge, Michael Baldwin and Harold Hurrell, Art & Language played an important role in the development of Conceptual Art, largely through the vehicle of its magazine *Art-Language*. Soon after its inception the magazine included contributions from Joseph Kosuth, Ian Burn and Mel Ramsden in New York. Within a few years a number of other writers were also involved, expanding the interests and alliances of the group. However, by the mid-1970s, various members and associates were pursuing individual paths, leaving Baldwin and Ramsden as the remaining protagonists of Art & Language; they now also

share their collaborative writings with Charles Harrison.

In 1986 Art & Language produced a new series of paintings called *Incidents in a Museum*, based on the spaces of the Whitney Museum of American Art in New York, an institution that had been crucial to the rise of American modernism. The paintings depict imaginary installation shots of Art & Language works as 'incidents' inside the museum. The works are shown either in the form of fragments so that details are enlarged, or as complete compositions seen scaled down. John Roberts in *Art & Language: The Paintings*, Société des Expositions du Palais des Beaux-Arts, (Brussels 1987, p.86) has commented on this strategy with particular reference to *Index: Incident in a Museum, Madison Avenue*, one of two pieces used to represent Art & Language in the Turner Prize exhibition:

> The content of the series shifts its allegorical focus from the museum as a space of provisional democracy to a space where art is made quite literally incoherent. In their work included in the Turner Prize exhibition at the Tate Gallery (November 1986) this shift of focus is given a grievously ironical emphasis. The only way we can view the museum interior is through scattered holes drilled into sheets of plywood attached an inch above the surface. These sheets are organised in the pattern of the exterior cladding of the museum.

Victor Burgin

Victor Burgin's art practice is inseparable from his theoretical writings, which are steeped in the ideas of political, psychoanalytical and linguistic theorists such as Marx, Freud, Foucault and Barthes. Influenced by a commitment to left-wing ideas, his work entails a critique of how both art and individual identity are perceived and produced in relation to specific social and historical contexts. He has said: 'What still interests me in art is its ability to criticise. Art is, in fact, the only area in which such criticism can still take place'(*Victor Burgin: Passages*, Musée d'Art Moderne de la Communaute Urbaine de Lille, Villeneuve d'Ascq, Ville de Blois, 1991, p.19). Like other conceptual artists such as Joseph Kosuth

Art & Language
Index: Incident in a Museum, Madison Avenue 1986

Victor Burgin
Office at Night 1986
From a series of seven triptychs

and Art & Language, Burgin believes that art is a system of information produced within a social context, although he has never rejected its subjective and imaginative potential.

During the 1970s Burgin developed a style of work based on the juxtaposition of texts and images. He also used familiar forms of mass communication such as photography and advertising, which he hoped would make his images more relevant to a wider audience:

> At that time, I had the feeling that the world was saturated with images, and that there was no point in manufacturing more ... I felt that an artist's job was to take already existing images and rearrange them so that new meanings appeared ... My strategy was a kind of 'guerilla semiotics': capturing images and turning them against themselves [ibid. p.24].

Since the late 1970s one of Burgin's key projects has been an exploration of the representation of women. Alluding to, parodying, or actually quoting well-known images of women from art history, he draws attention to and questions how women are repeatedly 'fetishised' through types of imagery. In *Office at Night*, for example, included in the Turner Prize exhibition (together with another image from this series, *Danaides,* both of 1986), Burgin positions a photograph of a contemporary female figure alongside the secretary from a painting by Edward Hopper.

Derek Jarman

Jarman's creativity had many outlets. As an artist, teacher, film-maker, theatre designer, poet and polemicist he engaged with important intellectual, political and moral questions. He had trained as a painter and continued to paint until his death in 1994, despite the near-blindness he suffered as a result of AIDS, producing a series of vividly coloured and expressive canvases. These late works deal uncompromisingly with mortality and with the experience of being gay.

In 1986 Jarman was shortlisted for his achievements as a film-maker, and in particular for his feature film *Caravaggio*, funded by the British Film Institute. Earlier that year at the Berlin Film Festival it had already won the prestigious

Silver Bear award for 'visual conception'. At its London opening *Caravaggio* was met with critical acclaim. Unusually for a low-budget, art-house film (made with £475,000 in a warehouse in London's then derelict Docklands) it successfully competed against Hollywood blockbusters for audiences. The creative energy and unconventional lifestyle of the seventeenth-century Italian painter Caravaggio had long been a source of inspiration for Jarman. His film drew attention to the undeniable homosexual content of Caravaggio's paintings, but what critics most admired was Jarman's imaginative exploitation of the relationship between Caravaggio's pioneering use of dramatic light and dark contrasts, known as 'tenebrism', and the medium of film itself. As Mary Davies observed in the Turner Prize 1986 exhibition catalogue (p.11):

> Caravaggio ... could be described as the inventor of cinematic lighting. The dramatic lighting effects used for the first time in his painting are now the central concern of every cameraman and film-maker. With designer Christopher Hobbs and cameraman Gabriel Beristain, Derek Jarman has created a film in which the lighting progresses from the bright luminosity of Caravaggio's early paintings to the shadowy chiaroscuro of the later works. Many of the paintings are represented as stunning *tableaux vivants* as Caravaggio's low-life models pose as saints and virgins in the silence of the artist's studio.

Stephen McKenna

Stephen McKenna exhibited regularly throughout the 1960s and 1970s, but remained an isolated figure until the 1980s. During this decade it was possible, though somewhat erroneous, to view his realistic, figurative paintings, which excavate and transform images from ancient European culture, in the context of a post-modern preoccupation with the past. Whereas post-modernism favours quotation and pastiche, McKenna's aim has been to use the imagery of classical mythology to convey what he perceives to be enduring human concerns. To achieve this goal he has adopted a subtle poetic, even surrealist

Derek Jarman
1942 Born in Northwood, Middlesex
1960–2 King's College, London
1963–7 Slade School of Art, London
Died 19 February 1994

Stephen McKenna
1939 Born in London
1959–64 Slade School of Art, London

Derek Jarman
*Michael Gough as
Saint Jerome* 1986

Stephen McKenna
*Clio Observing the
Fifth Style* 1985

approach to subject matter, as J.C. Ebbinge-Wubben observed in 1985 (*Stephen McKenna*, Institute of Contemporary Arts, London 1985, p.7):

> What at first sight looks like historicism is on the contrary a transformation, a metamorphosis of it; what seems, superficially viewed, to be imitation turns out upon closer inspection to be imagination ... He sees it as the fundamental task of painting 'to attempt to see ourselves and our surroundings ... with an eye which can discern the poetic reality rather than the deceptive ... wrapping.

McKenna paints in a manner appropriate to his classical subjects using techniques derived from 'masters' of the Western tradition such as Titian, Poussin, Courbet and Böcklin. Commenting on his relationship to art of the past, the artist has written: 'If one sees our Western culture as a body of works, rather than as a progression of ideas determined by some inscrutable historicism, it becomes unnecessary to worry about one's distance from the last temporal marker' (*Turner Prize,* exh.cat., Tate Gallery 1986, p.13).

McKenna has embraced traditional genres such as allegorical figure compositions, still-life and mythological landscape. In the 1980s he also produced a series of urban landscapes depicting the ugliness and hostility of the man-made environment. According to Ian Jeffrey, one of these pictures, *Berlin, Havel See*, exhibited in the Turner Prize exhibition, seemed to illustrate McKenna's belief that: 'Landscape painting, dedicated for centuries to the glorification of God through nature ... is in our age more a tragic celebration of a departed wholeness: a lament for dying nature' (*Stephen McKenna*, exh.cat., Museum of Modern Art, Oxford 1983, p.9).

Bill Woodrow

Until recently Bill Woodrow's sculptures have been made from discarded objects and materials, obsolete electrical appliances and domestic equipment, culled from junkyards and streets. In 1979 he began to unravel manufactured appliances by arranging their component parts in a line, or by exposing their insides. But his transformations always

retained a link between the original and finished object. With his twin-tub sculptures, for example, begun in 1981, he reassembled the dismantled or partially dismantled elements of washing machines to form sculptures, while retaining evidence of the object's original identity and function. Thus, the form of a guitar, a gun, a saw or a bicycle frame emerged, fashioned as a three-dimensional object, from the body of a 'Hotpoint'. He has recycled thrown-away objects in his work, partly because he deplores the excesses of consumer society, but also for the more practical reason that they were readily available for use.

Summing up Woodrow's inventive recasting of the familiar in *New British Art in the Saatchi Collection*, 1989, p.156, Alistair Hicks commented:

> He is a narrative sculptor and speaks directly to those of his time in a manner similar to that of the painters and sculptors of medieval cathedrals ... In looking for a different way to present information he is forced to discover an added and emphatic grace in objects that often previously possessed little ... he has given new life to appliances and machines. With a turn of his wrist he cuts out an animal or instrument, and a washing machine becomes home to a squirrel or starts playing a guitar.

Although Woodrow's sculptures often appear comic, they nonetheless relate in a complex way to contemporary social, political and cultural experience. 'His sculpture is ironic and witty and employs a wide range of rhetorical devices; for example puns, paradox and inversion. They are critical and poignant, comic and grotesque, brutal yet subtle and stress the mortality of the object and the transitoriness of life'(*Turner Prize,* exh.cat., 1986, p.15).

Self-Portrait in the Nuclear Age (1986), shown in the Turner Prize exhibition, is one of several works representing Woodrow's meditations on nuclear power and nuclear war.

Bill Woodrow
1948 Born near Henley-on-Thames, Oxfordshire
1968–71 St Martin's School of Art, London
1971–2 Chelsea School of Art, London
1996 Became a Trustee of the Tate Gallery

Bill Woodrow
Self Portrait in the
Nuclear Age 1986

Richard Deacon 1987

Winner
Richard Deacon

Shortlisted artists
Patrick Caulfield for his exhibition at the National Gallery, *The Artist's Eye*, which demonstrated the continuing pertinence of his own work
Helen Chadwick for her exhibition *Of Mutability* at the Institute of Contemporary Arts, London which showed a striking use of mixed media
Richard Deacon for his contributions to several major international exhibitions and for the touring show *For Those Who Have Eyes* that originated in Wales
Richard Long for his exhibition of new work in Geneva, and his retrospective exhibition at the Guggenheim Museum, New York
Declan McGonagle for making the Orchard Gallery in Derry, Ulster, an international centre for the artist
Thérèse Oulton for exhibitions in New York and Germany which show a fresh contribution to the tradition of oil painting

Jury
Oliver Prenn
Representative of the Patrons of New Art
Kasper Koenig
Critic and organiser of Westkunst in Cologne (1981) and the outdoor sculpture exhibition in Munster in 1987
Catherine Lampert
Senior Exhibitions Organiser, Hayward Gallery, London
Alan Bowness
Director of the Tate Gallery

Exhibition
28 October–6 December 1987
Winner's display 19 July–
29 November 1988
Prize of £10,000 presented by
George Melly, 24 November 1987

In response to some of the criticisms voiced the previous year a number of modifications were introduced in 1987. The scale of the exhibition, for example, was enlarged to fill the Octagon and the North Duveen gallery. More importantly, the rubric was changed from 'the greatest' to 'an outstanding' contribution to British art, implying that the prize was not automatically awarded to Britain's greatest living artist but to the contender who had made the most impressive impact in any one year. But despite these attempts to hone the prize, the events of 1987 did not go smoothly.

From its announcement, the shortlist in 1987 puzzled and infuriated most critics. The favourite to win was Richard Long as he was the only artist with an international reputation comparable to that of previous winners. So the jury's choice of the younger sculptor Richard Deacon caused consternation, although most agreed that he was the only other contender on the shortlist who might have had a legitimate claim to the prize that year.

The shortlist was designed to draw attention to the diversity of contemporary British art, to give as many artists as possible greater exposure and recognition. Though worthy, this aim was self-defeating as the inclusion of so many implausible contenders proved demeaning for the artists and undermined the serious intentions of the prize. A highly esteemed senior artist such as Patrick Caulfield, who was shortlisted for the *The Artist's Eye*, an exhibition he had selected from the collection of the National Gallery, was a case in point. As he had not been shortlisted for his own paintings Caulfield's chances of winning the prize appeared slim and his presence on the shortlist humiliating. Equally, the continued inclusion of non-artists, in this instance Declan McGonagle, seemed tokenistic, as William Packer pointed out in the *Financial Times* on 26 November 1987 (p.25):

> The argument may be that nomination itself is a distinction to covet, as perhaps it is, though of a perversely patronising kind. Declan McGonagle is a particular victim of this doubtful honour, for he is the

token artworld professional admitted to nominal consideration by the terms of the prize, yet tacitly understood to be in with no chance at all. How the form of critics, curators and dealers be fairly measured against that of working artists is a mystery still to be resolved.

Richard Dorment, writing in the *Daily Telegraph*, agreed that Long and Deacon aside, the contenders in 1987 seemed arbitrary, placed on the shortlist 'to lend a spurious suspense to the proceedings', or, as in the case of Helen Chadwick and Thérèse Oulton, selected in response to previous accusations of discrimination against women artists (*Daily Telegraph*, 26 November 1987, p.8). On the whole, the critics of the national newspapers agreed that the terms of the prize needed clarification. Packer expressed the consensus view when he wrote:

> It [the prize] faces a hard but simple choice: to address either recent or long-term achievement, to make that choice clear, and to confirm it by an infinitely more rigorous and consistent selection of the shortlist than has been so far. Each time, and this year is no exception, we have been presented with a choice that is no choice, a race in which any winner would be unthinkable – or at best bizarre – but for two or three, with the rest nowhere [ibid.].

Prior to the Turner Prize of 1987, Alan Bowness had been investigating the possibility of staging a winner's exhibition following the announcement, so that the public would have the opportunity of seeing an artist's work in depth. Drexel Burnham Lambert, the new sponsors of the prize, though keen to promote the event with leaflets, nomination forms and audio-visual presentations, declined to finance such an exhibition in their first year as sponsors. Nevertheless, in his foreword to the exhibition catalogue Bowness tentatively announced the Tate's intention to offer the winner a small exhibition in the summer after the award. This gesture later proved impractical as the winning artist was already committed to a conflicting exhibition at the Whitechapel Art Gallery. But in place of

Richard Deacon
Troubled Water 1987;
Fish out of Water 1987;
Feast for the Eye
1986–7

Richard Deacon
1949 Born in Bangor, Wales
1954–6 Lived in Sri Lanka where his father was stationed with the RAF
1969–72 St Martin's School of Art, London
1974–7 Environmental Media MA at the Royal College of Art, London
1977 History of Art, Chelsea School of Art, London
1989–96 Trustee of the Tate Gallery

an exhibition Deacon was happy to be represented in the front garden of the Tate between July and November 1988 by *Like a Snail (A)*, a large sculpture originally conceived in 1987 for an urban site in Münster, Germany. For critics, and more important, for visitors to the Tate, this seemed like too little too late to be of real interest.

Richard Deacon

Richard Deacon was among a generation of British sculptors who, emerging in the early 1980s, achieved national and international acclaim. These artists – most of whom have since either won, or been shortlisted for, the Turner Prize – included Tony Cragg, Antony Gormley, Shirazeh Houshiary, Anish Kapoor, Richard Wentworth, Alison Wilding and Bill Woodrow. Uneasily grouped under the label 'New British Sculpture', their work has remained diverse. Attempting to establish a feasible definition for the 'group', Lynne Cooke noted that by the late 1970s they were all shifting towards 'self-sufficient, relatively self-contained, fixed objects: objects which, moreover, were made by hand, and were fabricated rather than crafted from mundane, familiar materials' (*Starlit Waters*, Tate Gallery Liverpool 1988, pp.45–9). In different ways they sought meaning or content in their work generated by a particular approach to iconography rather than simply by the process of making.

Of this generation Richard Deacon's only significant link was with Tony Cragg, a friend and fellow sculptor at the Royal College of Art. Cragg's ambition, choice of materials, and concise presentation all had some influence on Deacon. But Deacon's main concern has been to produce striking and memorable forms that are primarily allusive. His titles play an important role in the inference of meaning and are drawn from such sources as the Bible, poetry, fairy stories and clichés. Eyes, ears, mouths and genitalia – the vessels of the senses – have often been suggested by his sculpture. These carriers of the senses have provided Deacon with metaphors for the means by which, as humans, we understand and are understood by the world.

Rather than carving or modelling, Deacon has shaped or fabricated his sculptures in a variety of materials – galvanised steel, laminated wood, corrugated iron, cloth, linoleum, leather, and more recently polycarbonate – materials unprejudiced by traditional art-historical references. The visibility of screws and rivets combined with juxtapositions of industrial, as opposed to 'fine art', materials, gives his work the look of something engineered.

In the early 1980s he began to concentrate on producing forms in which structure, shape and surface (or skin) were coterminous. This had the effect of emphasising the overall unity of the otherwise disparate parts, and of asserting the sculpture as an object. Assessing Deacon's achievement in 1988, Peter Schjeldahl wrote:

> Deacon's sculptures have a unitary, all-at-once impact that occurs at first glance ... no matter how complex they are ... The phenomenon owes to a principle of construction that Deacon associates with airplanes. A plane, he has remarked, is 'built all over' rather than, like a car 'from the ground up'. A plane's skin is no mere shell but a functional element that expresses the whole at each point. (Analogues in the natural world are seeds and fish.) The surfaces of Deacon's works have a similar air of functional integration that is proof against the craziest configurations (*Richard Deacon: Sculptures and Drawings 1985–1988*, Fundacion Caja de Pensiones, Madrid 1988, p.32).

Deacon's interest in the self-sufficient object grew out of his performance pieces at St Martin's School of Art, which produced objects at the end of the event. An important influence on his early development as a sculptor was Donald Judd, who counteracted traditional sculptural concerns with his insistence on the actuality of the object, its presence in the real world, in real space and time. Deacon has succeeded in making sculptures that have a strong physical presence, but their content is equally important.

While in America between 1978 and 1979 Deacon made a series of drawings called *It's Orpheus When There's Singing*, based on the *Sonnets to Orpheus* written by Austrian poet Rainer Maria Rilke

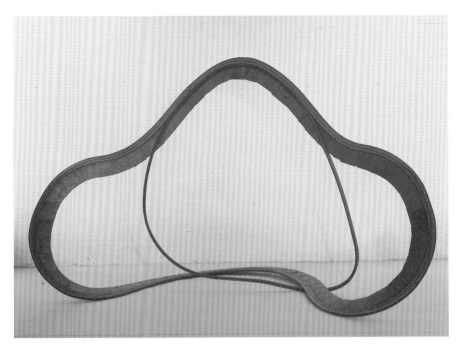

Richard Deacon
*For Those Who Have
Ears No.1* 1983

(1875–1926). The drawings reveal the important shift in his work from rectilinear, angular forms to a curvilinear, more organic visual language. Ostensibly abstract, the drawings also indicate a continuation of his interest in containers, suggesting such vessels as pots, sacks and pockets. Deacon subsequently made two versions of a large sculpture called *For Those Who Have Ears*, in 1982–3 and 1983 respectively, which share the same subject as the drawings. When questioned about the relationship between the drawings and *For Those Who Have Ears* (in the Tate's Patrons of New Art newsletter, 1985), he explained that their content had to do with a notion about song, or what Orpheus's song does to the world:

> In the story of Orpheus the trees and the rocks move and the wild animals lie down and ultimately he has the power to bring the dead back to life … What I think is that song is the power of speech. I think of speech as being in between our private selves and the world. The power of speech is a social condition of being human. Language is one of the primary means which allow us to operate on the world, both to recognise and to give it shape.

The forms of the drawings and the sculpture were reminiscent of openings or apertures, like a mouth or an ear – the head of Orpheus singing or listening – or like Orpheus's lyre.

In other works, such as *Turning a Blind Eye*, he explored the relationship between the world and the eye:

> I think that one's sexual desires are projected primarily through vision and I think fairly incessantly, there are a number of works which try and make more sense of that. Taking *Turning a Blind Eye*, the work has several different things going on for it: The shape of the work is both an eye and the shape of a vulva and also it has a plough-like shape at one end … the work itself is eye shaped, the drawing is like the exterior mount of an eye, the eyelids … Turning a blind eye is the cliché for letting things happen which you know, but decide to ignore. The work itself in its eye shape is also blind, because it's empty.

Patrick Caulfield
1936 Born in London
1956–60 Chelsea
School of Art, London
1960–3 Royal College
of Art, London

Helen Chadwick
1953 Born in Croydon,
London
1973–6 Brighton
Polytechnic
1976–7 Chelsea School
of Art, London
Died 15 March 1996

Deacon was awarded the Turner Prize for similarly 'organic' and highly allusive works like *Fish Out of Water* and *Like A Snail (B)*, both of 1987.

Patrick Caulfield

Caulfield was included in the 'Young Contemporaries' exhibition of 1961 at the RCA, alongside a number of his peers at the Royal College of Art, such as David Hockney, Derek Boshier and Allen Jones. For many, these artists came to epitomise British Pop Art. Although Caulfield's work shares some of the characteristics of Pop, his images often convey a wistful or melancholic mood quite alien to Pop Art's typically upbeat style.

Since the 1960s he has produced pictures of interiors and still lifes that suggest the banality of everyday existence. Despite his reference to real things Caulfield has stressed that the environments he depicts are entirely fictitious: 'My paintings have always been imaginary; I create a non-existent space and give it a feeling of reality.' His use of light plays an important role in this process: 'I am conscious of formalising lighting effects which of course are imagined ... the way the light plays on the object painted from life seldom bears any resemblance to the way that the light works in the rest of the composition. I believe that my use of light makes objects twist and turn' (*Turner Prize*, exh.cat., Tate Gallery 1987, p.9).

Rather than for his own work, Caulfield was shortlisted on the basis of his selection of *The Artist's Eye* exhibition at the National Gallery, London. Unlike previous selectors who had focused on 'masterpieces', he surprisingly brought together relatively unknown works from a broad range of genres such as landscapes, cityscapes, interiors, still lifes and portraits. Marco Livingstone, in 'Patrick Caulfield: A Text For Silent Pictures', *Patrick Caulfield* (1992, p.11) nevertheless perceived some underlying relationships between Caulfield's paintings and the works chosen:

> *The Interior of the Brote Kerk at Harlem* by the seventeenth-century Dutch painter Pieter Saenredam, a precisely ordered and light-filled architectural view ... provides an admirable precedent for Caulfield's equally

serene interiors ... The presentation of light as a material substance, a concern for atmosphere in creating mood and the directing of the spectator's vision by means of variable degrees of finish – a characteristic of Caulfield's art that emerged in the mid-1970s – are, in fact, to be found also in many of the other pictures selected by him.

Helen Chadwick

Helen Chadwick was appropriately one of the first women to be shortlisted for the Turner Prize. Throughout her short but productive career she was known as a maverick innovator, and her influence, particularly on a younger generation of British women artists, has been considerable.

At the centre of her practice was a desire to extend our understanding of human existence. To this end she drew on a rich variety of sources from areas of knowledge such as anatomy, science and myth. From the 1970s she began to use her own body as the cardinal means of negotiating the subject of human identity. In her *Soliloquy to Flesh* of 1989 she wrote: 'My apparatus is a body × sensory systems with which to correlate experience.' It is therefore not surprising that her work typically provokes a mixture of physical sensations, as Marina Warner has observed: 'Neither exactly pain nor exactly pleasure, not exactly terror, not exactly tranquility, but all these exquisite sensations at one and the same time ('In Extremis: Helen Chadwick and the Wound of Difference', *Stilled Lives*, Portfolio Gallery 1996).

Often exuberant and given to excess, her photographs, sculptures and installations are remarkable for their highly imaginative and perturbing use of unusual materials, including lambs' tongues, furs, flowers, meat, urine, chocolate, household cleaning fluids and hair-gel. Chadwick enjoyed combining materials that would emphasise, yet simultaneously dissolve, the contrast between given opposites – the organic and the man-made, the visceral and the cerebral, the seductive and the repulsive. One example of this approach is *Wreaths of Pleasure* (1992–4), also known as *Bad Blooms*, a series of thirteen large, circular photo-pieces which depict arrangements

Patrick Caulfield
Interior with a Picture
1985–6

Helen Chadwick
Of Mutability 1986

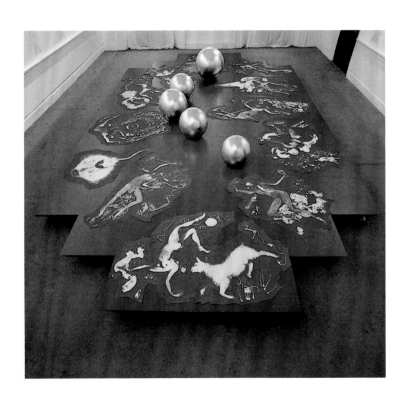

of flowers floating on the surfaces of luridly coloured domestic fluids. As Louisa Buck has observed, the effect is 'a characteristically exquisite Chadwickian celebration of unholy alliances'(*Independent*, 18 March 1996, p.16).

Chadwick was shortlisted for *Of Mutability*, an exhibition of recent work held at the Institute of Contemporary Arts in 1986. Inspired by the baroque vanitas tradition the show was noted by the jury for its 'striking use of mixed media'. *Carcass*, for example, comprised a seven-feet-high transparent pillar filled with rotting vegetables. This unequivocal and pungent image of decay or *momento mori* was for Chadwick an attempt 'to find a resolution between transience and transcendence'. The show also included images of the artist appearing to float in a pond surrounded by fish, lambs and fruit, all in a state of decomposition.

Summing up Chadwick's achievement Marina Warner concluded (ibid.): 'Her art developed from the immediacy of experience gathered through her senses, but she tested this against an inherited set of values, encoded in images and formal standards. In Helen Chadwick's art, Mannerism meets Fluxus, the Rococo merges with Situationism – who could have ever dreamed such an imaginary fusion could happen?'

Richard Long

Long was shortlisted in 1984, 1987 and considered as a contender in 1988. A discussion of his work can be found under 1989 when he was awarded the prize.

Declan McGonagle

Declan McGonagle studied painting at the College of Art in Belfast. After a postgraduate year in 1976 he lectured part-time and exhibited his work throughout Ireland. In 1978 he was appointed by Derry City Council to set up and run the Orchard Gallery. In 1984 he joined the Institute of Contemporary Arts in London as Exhibitions Director. He returned to Derry in 1986 to initiate a series of new arts projects for the City Council. He also became responsible for the development of an Outreach/ Public Art Programme and the Foyle Arts Project (centred on a nineteenth-century school building) as well as

the Orchard Gallery programme.

When the Orchard Gallery opened in 1978, funded by Derry City Council with a subsidy from the Arts Council of Northern Ireland, it was the first professionally established public arts facility in Derry. Since opening it has developed a visual arts progamme that reflects contemporary art on an international as well as regional basis. Under McGonagle's directorship, the gallery staged over twenty-five exhibitions and initiated tours and collaborations with equivalent galleries and organisations in Ireland and abroad. McGonagle helped to forge relationships with local artists and communities whose involvement with the gallery led to a variety of successful installations, performances, public art projects and related events. An important aspect of the programme included the publication of monographs, catalogues, artists' books, recordings and other printed material.

In the late 1980s the Orchard Gallery's visual arts programme expanded in the context of the City Council's developing museum and cultural service. In 1987, for example, a team of four people started working with colleges, schools and other institutions and groups in the area. McGonagle left the Gallery in 1990 to become the first director of the Irish Museum of Modern Art (IMMA) in Dublin. In 1993 he served on the Turner Prize jury.

Thérèse Oulton

Thérèse Oulton's paintings received critical attention at her Royal College of Art Diploma show in 1983. Her large canvases seemed to suggest a Romantic feeling for landscape akin to that found in pictures by Turner, Watteau and Gainsborough. The complex tracery of paint, with its allusions to rock and plant formation, and the predominance of such colours as greens, blues and browns, all pointed to the landscape tradition. The rich colours, seductive textures and often dramatic impact of her paintings of the next few years also brought to mind other 'masters' of Western art, including Titian, Rubens and Velazquez. But the paintings also seemed undeniably contemporary. Oulton's handling of paint, for example, addressed twentieth-century concerns, such as the flatness of

Richard Long
1945 Born in Bristol
1962–5 West of England College of Art, Bristol
1966–8 St Martin's School of Art, London

Thérèse Oulton
1953 Born in Shrewsbury, Shropshire
1979–83 St Martin's School of Art, London
1983–4 Royal College of Art, London

Declan McGonagle
1952 Born in Derry

Thérèse Oulton
Pearl One 1987

the picture surface and the creation of a single field of paint. Writing in 1987, she explained that her intention was to distance traditional painterly elements such as form, light and colour from their usual descriptive role: 'Kinds of brushwork or a chosen palette, etc., conjure a selected heritage but, as examples, my re-usage of chiaroscuro doesn't describe a body receding into space. The pictorial device is adrift. Light is not used as an organising principle. Each brushwork is its own generator of light or lack of it. Colour concentrates or disperses undetermined by attachments to things or spaces' (*Turner Prize*, exh.cat., Tate Gallery 1987, p.19).

In the catalogue of Oulton's first solo exhibition in 1984 (*Thérèse Oulton: Fool's Gold*) Catherine Lampert described her particular method of applying paint to canvas:

> She prepares a coloured ground and on a palette-table sets out pools of turpentine-thinned oil paint. With a sable brush, or sometimes her hands, she pushes wet paint into wet paint, perhaps working and completing the whole area in one session. When this is possible the painted surface is only skin-deep. Nevertheless the variegated forms seem to have been caressed and battered into shape. Across the surface the flux, tempo and climaxes remind us of the coded messages an orchestra conductor sends. Oulton's musical sense of continuum lends credibility and beauty to the most melodramatic eruptions.

Richard Long
Red Walk 1986

RED WALK

A JAPANESE MAPLE IN AUTUMN LEAF
BERRIES 14½ MILES
A PLASTIC SHOE 17 MILES
A MUCK-SPREADER 21 MILES
SUNSET 22½ MILES
ROSES 30½ MILES
A PLOUGH 37½ MILES
DRAINPIPES 38 MILES
COXCOMBS 39½ MILES
AN APPLE 44 MILES
FOXGLOVES 49½ MILES
A GYPSIES' FIRE 54 MILES
SUNSET 54¾ MILES
PAINT ON THE ROAD 63¼ MILES
A COAL LORRY 64 MILES
BLOOD OF A THRUSH 68 MILES
HOLLY BERRIES 71½ MILES
A JET AIRCRAFT 72¼ MILES
A ROADMAN'S HAIR 75 MILES
A LETTERBOX 80 MILES
STONES 82¼ MILES
A PLOUGHED FIELD 90½ MILES
THE FACE OF A COCK PHEASANT 91¼ MILES
A SANDSTONE CLIFF 98 MILES

BRISTOL TO DAWLISH
ENGLAND 1986

The arrival of a new Director of the Tate Gallery in 1988 provided the opportunity for a complete rethink of the terms and conditions of the prize. Nicholas Serota introduced a number of modifications: for example, from 1988 the prize would be given only to artists. But Serota's most radical change was the discontinuation of a published shortlist which in the past had caused 'anguish to artists without giving compensating edification to the public' (Letter from Nicholas Serota to Alan Bowness, 13 April 1988).

The disparity and size of the shortlist had also produced Turner Prize exhibitions that either disappointed or annoyed the art world and confused the public, who understandably believed that the quality of the work on view had some influence on the jury's final choice. As envisaged by Bowness, the shortlisted artists' display was replaced by an annual winner's exhibition staged during the summer following the presentation of the award. As things turned out, the winner of the prize in 1987, Tony Cragg, was the only artist to enjoy a one-person show of this kind.

But the abolition of the shortlist did little to encourage critical favour. For many its disappearance brought the entire *raison d'être* of the prize into question. Even a sympathetic critic such as Marina Vaizey, who lauded the winner as an 'outstanding sculptor' and an 'exciting original', bemoaned the opportunity that had been lost: 'Without the shortlist, there was no chance to survey the field, no peg for advance publicity, no public debate and hardly any gossip' (*Sunday Times*, 27 November 1988, p.8). Vaizey argued that all art prizes should be used to help art 'reach the public'. She concluded:

> There is room for more showbiz … and greater public involvement, with national exposure of the group from which the final choices are made. Contemporary art is robust enough to take such scrutiny. The goal should not be a self-enclosed world congratulating itself but making art ever more accessible [ibid.].

Unfortunately, the Gallery's attempt in 1988 to give the prize more dignity by establishing a dinner at the Tate at which an artist, politician or celebrity would deliver a keynote speech, was interpreted in the absence of a shortlist as a self-congratulatory affair. Critics claimed that audience involvement had diminished. Ironically, the nature of Tony Cragg's work attracted an unusual amount of tabloid attention and engaged the public, however crudely. Following the announcement of the winner the Press Association dubbed Cragg a 'saucy' and 'controversial' sculptor 'whose works have included … A bottle of tomato ketchup, beer, a bottle of wine, lemonade bottles, a jar of mustard, a variety of pickled vegetables and other sauce containers'. The correspondent gleefully continued: 'One exhibit on show last year, entitled *Wooden Muscle*, comprised seven lumps of rock, a tree trunk and four old scraps of wood, prompting one on-looker to comment: "I've seen a better pile in the back garden on bonfire night".'

Tony Cragg

Tony Cragg belongs to the generation of British sculptors who emerged at the beginning of the 1980s to achieve national and international acclaim during that decade. This generation, whose work was quickly though opaquely dubbed the 'New British Sculpture', includes Richard Deacon, Antony Gormley, Shirazeh Houshiary, Anish Kapoor, Richard Wentworth, Alison Wilding and Bill Woodrow. As students most of these sculptors experimented with conceptual art, installation and performance. But gradually they began to focus on making objects from mundane materials, and fabricated rather than crafted. Furthermore, their work tended to allude to meanings beyond the theories of art itself. Cragg recalled this turning point in 1987: 'For me, in the mid-seventies, the crucial question became one of finding a content, and from that came the idea that that might evolve through a more formal approach to the work' (*Tony Cragg*, exh. cat., Hayward Gallery 1987, p.24).

In 1977 Cragg moved to Wuppertal in West Germany where he has continued to live and work. His first large-scale exhibition in London was held at the Whitechapel Art Gallery in 1981. Cragg was shortlisted for the Turner Prize in 1985, but despite the rapid growth of his reputation in continental Europe and America, his work remained relatively

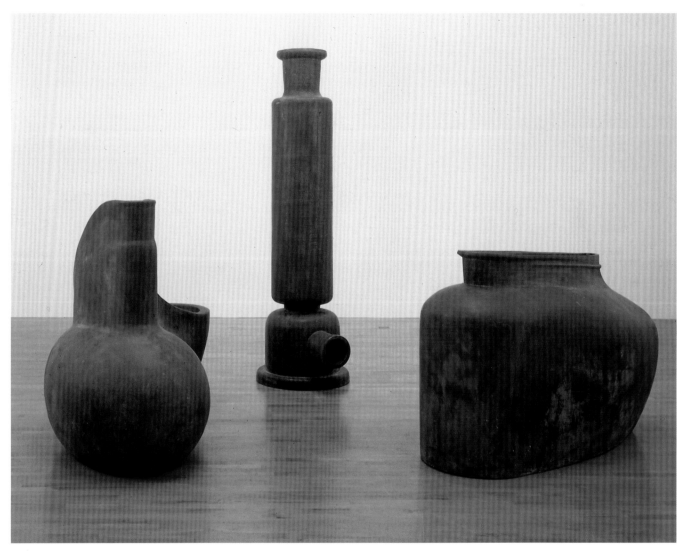

Tony Cragg
On the Savannah 1988

Tony Cragg
1949 Born in Liverpool
1969–72 Wimbledon
School of Art, London
1973–7 Royal College
of Art, London
1977 Moved to West
Germany

Lucian Freud
1922 Born in Berlin
1933 Moved to Britain
Became a British
subject in 1939.
1938–9 Central School
of Arts and Crafts,
London
1939–42 East Anglian
School of Painting and
Drawing, Dedham
1942–3 Part-time
study at Goldsmiths'
College, London
1983 Created a
Companion of
Honour

Richard Hamilton
1922 Born in London
1938–40 Royal
Academy Schools and
Central School of Arts
and Crafts, briefly
continuing his studies
at the RA in 1946.
1948–51 Slade School
of Art, London
1952 Founder member
of the Independent
Group at the
ICA, London

unfamiliar to audiences in Britain until shown at the Hayward Gallery in 1987.

Cragg's work explores his relationship to objects both natural and man-made and is motivated by a sense of ignorance of the world, of such basic processes as electricity and molecular structure. Cragg is fascinated by the physical sciences – biology, geology, physics, chemistry – and what he has described as 'first-order experiences' – seeing, touching, smelling, hearing. Through his sculptures he constantly draws attention to our responses to both organic and artificial environments, and by formal means often suggests connections between these putatively opposing worlds. A sculpture such as *Citta* of 1986, for example, a structure of repeated units, resembles the growth patterns of particular crystals, implying that man-made ordering systems often instinctively echo nature's design solutions. Typically, this work also brings into question the assumption that nature is somehow more authentic than culture. But Cragg is champion neither of nature nor culture, preferring to invest belief in the power of the object. At root his art has been a quest to understand and improve the world that we inhabit. In the Hayward Gallery catalogue (1987, p.12) he states:

I think that objects have the capability to carry valuable information for us, to be important to us, but the fact is that most objects are made in ways which are irresponsible and manipulative. Irresponsible because people – the makers of this or that – don't really consider in any metaphysical way the meanings of the objects that they're making: and manipulative because things are made for a variety of commercial and power-based reasons. My interest in the physical world, in this object world, is survivalistic at one level, but it will also lead me to dreams, to fantasy, and to speculation.

Cragg first became known for a series of sculptures made from found fragments of plastic which he began in 1978. These works gradually took the form of wall pieces, such as *Britain Seen From the North* of 1981 which is one of several works made in response to inner-city unrest that he witnessed on a visit to Britain at that time. Although Cragg uses

discarded material his main concern is to treat it as new, raw material rather than to appropriate or recycle. Lynne Cooke has observed: 'objects are not simply recuperated or reclaimed for the realm of art but instead are used in ways which he deems more consequential, to make propositions and statements' (Hayward Gallery catalogue, p.45). He has used an eclectic range of materials, including stone, wood, concrete, metals, rubber, plastic, glass, and he often incorporates existing objects into his sculptures. During the mid-1980s Cragg produced bodies of work dealing with the broadly interpreted themes of landscape and the city. Many of these works were shown at the Hayward Gallery in 1988. *Minster* of 1987, for example, comprises towers built from circular objects which recall chimneys, church spires, capacitors in early radios and the cell receptors of the eye. Similarly, *Capillular Landscape* of the same year draws comparisons between geological layers and cross-sections of human nerve tissue. Cragg commented in the Hayward Gallery catalogue (pp.34–6): 'In a sense it's obvious that in terms of the physical world scientists make more fundamental statements but artists and philosophers don't have a less important job. They humanise, they find out what the significance of science is for human beings ... I think you have to make images of objects which are like thinking models to help you get through the world.'

His interest has always been in the meaning of objects, whether they are organic or man-made. In 1984 he explained the underlying aim of his work, which was to explore connections between the laws governing nature and those invented by man in order to foster a more appreciative relationship between human beings and their increasingly alienating world (*Tony Cragg's Axehead*, Tate Gallery 1984, p.12):

At one time the number of objects produced was quite limited. They were functional and there was a very deep relationship with these things. Because of industrial manufacturing techniques and commercial producing systems we are just making more and more objects and we don't gain. We don't have any deep-founded

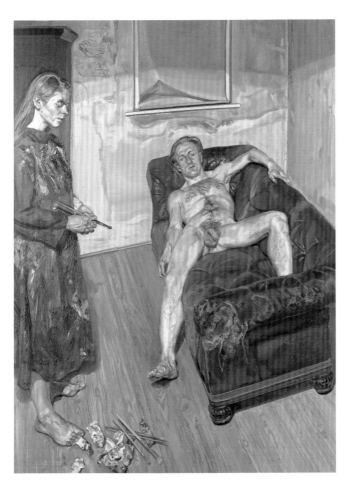

Lucian Freud
Painter and Model
1986–7

relationship with these objects, even those made of traditional materials like wood, as in the the case of *Axehead*. There are lots of familiar materials which are now produced in new ways through industrial techniques and we don't even have time to really reflect on these changes. If we work on the premise that the quality and nature of our environment and what we are surrounded with is actually having a very direct effect on us, on our sensibilities, perhaps even our emotions and intellects, then we have to be more careful with these objects and spend more time learning something about them.

In 1987 Cragg confessed that the motivation behind his work was to find a way of surviving in a visually hostile environment (Hayward Gallery, p.20):

> Perhaps I should be frank and … say that I'm trying to improve the quality of my life. To find for myself a way of dealing with it.

Lucian Freud
For information on his work see 1989.

Richard Hamilton
Through his activities with the Independent Group, Richard Hamilton was a key instigator of a Pop Art sensibility in Britain, producing a now famous definition of Pop's basic principles. Hamilton's work is perhaps best understood as an attempt to transform the tradition of Western art in the light of these principles, making him a contemporary history painter. His main subject, our complex relationship to the modern world, has led him to deal with a range of important social and political issues. In the early 1980s, for example, his memorable painting *The Citizen* (1982–3) initiated a series of paintings on the theme of the 'Troubles' in Northern Ireland.

Hamilton has been preoccupied with how the display of art contributes to its possible meanings since the 1950s, when he curated the exhibition *Growth and Form* at the Institute of Contemporary Arts in 1951. As much of his new work concentrated on the subject of 'interior' spaces, the

Richard Hamilton
Lobby 1985–7

Richard Long
1945 Born in Bristol
1962–5 West of
England College
of Art, Bristol
1966–8 St Martin's
School of Art, London

David Mach
1956 Born at Methil,
Fife, Scotland
1974–9 Duncan of
Jordanstone College of
Art, Dundee
1979–82 Royal College
of Art, London

Fruitmarket Gallery exhibition was designed as a series of rooms each functioning as discrete installations in themselves. Bringing together his work of the 1980s for the first time, this exhibition confirmed for many that Hamilton was at the height of his powers, continuing to develop his ideas using a variety of media and technologies.

Richard Long

For a discussion of Long's work, see 1989, when he was awarded the prize.

David Mach

Through his sculptural installations David Mach has aimed to demythologise contemporary art for an unitiated public. To achieve this goal he has adopted a number of strategies: making temporary work in public spaces in order to undermine the commercial basis of the art world, using familiar consumer products such as bottles, books and tyres as his basic material, and collaborating with others so as to dispel the image of the artist as an alienated creative genius. His use of discarded manufactured objects and materials has aligned him with peers such as Tony Cragg and Bill Woodrow. However, his work is distinctive in that he transforms his materials visually and conceptually without changing their original physical or associative character. Through his sculpture he has attempted to extend rigid definitions of the theme of landscape in art.

In 1986 Mach installed *Fuel for the Fire* at Riverside Studios in Hammersmith. A curvilinear tidal wave created from old magazines surged from a fireplace, swallowing domestic objects lying in its path, threatening, like mass consumer culture, to engulf everything before it. Later in the decade he increasingly used objects for their potential meanings rather than primarily as raw material. In *101 Dalmatians*, for example, Mach addressed the theme of consumer desire by installing a 'chaotic nightmare of household furniture ... orchestrated by a pack of ornamental dogs, themselves the very objects of desire, works of art and commodities' (Frances Morris, *David Mach: 101 Dalmatians*, Tate Gallery 1988, p.11).

Richard Long
Untitled 1988

David Mach
101 *Dalmatians* 1988

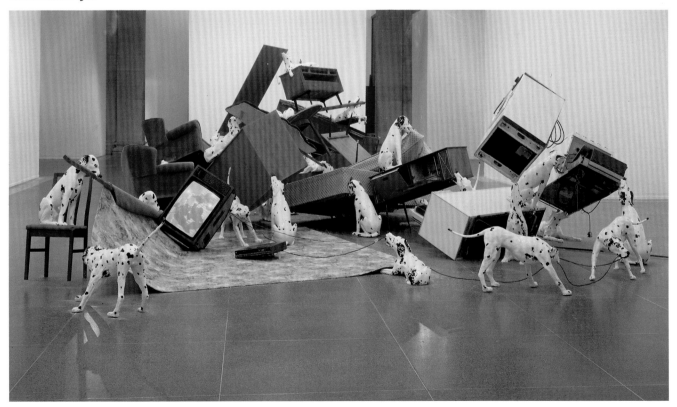

Boyd Webb
1974 Born in
Christchurch,
New Zealand
1968–71 Ilam School
of Art
1972–5 Royal College
of Art, London

Richard Wilson
1953 Born in London
1971–4 Hornsey
College of Art, London
1974–6 Reading
University

Alison Wilding
1948 Born in
Blackburn,
Lancashire.
Grew up in St Ives,
Huntingdonshire
1967–70
Ravensbourne College
of Art and Design,
Bromley, Kent
1970–3 Royal College
of Art, London

Boyd Webb

At the Royal College of Art Boyd Webb experimented with casting the human body in fibreglass. When documenting his work he discovered that taking photographs gave him a greater imaginative freedom and he began to take pictures of carefully staged tableaux comprising actors and props within dramatic settings. Drawing on Victorian genre painting and the sensibility of Surrealism, his works suggest elusive narratives that transform the everyday into a magical and marvellous place. In the words of Greg Hilty he has created 'a poetic experimental universe ... governed like our own world, by conditions which are at once self-perpetuating; stasis and migration, growth and decay, life and death' (quoted in *Spellbound*, Hayward Gallery, London 1996, p.125). An enduring feature of his work has been a concern with ecological issues such as pollution, nuclear war and the effects of technology, although his approach to these subjects has been discreetly subversive rather than overtly political.

In 1981 Webb began to make Cibachromes, high-quality photographs with excellent colour resolution, which enabled him to work on a larger scale with a new vibrancy. His fabricated environments became more fantastic, hinting at parallel universes where familiar objects are denied their logical properties or functions. Michael O'Pray has recently commented: 'Webb's work projects a sense of the "impossible", presented as solace for the disappointment of the world as it is' (*Spellbound*, Hayward Gallery, p.128).

Alison Wilding

See 1991 when Wilding was shortlisted for the prize.

Richard Wilson

See 1989 when Wilson was shortlisted for the prize.

Boyd Webb
Pupa Rumba Samba
1986

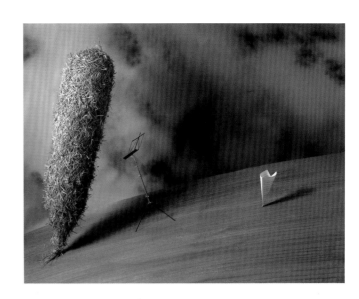

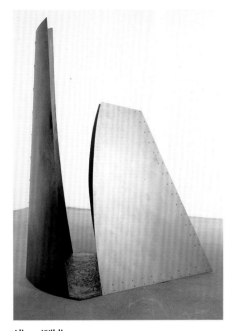

Alison Wilding
Stormy Weather
1987

Richard Wilson
20:50 1987

1989 will be remembered as the year in which Richard Long finally secured the prize. All five artists who had appeared on the first shortlist had now won the award, and agitation for further changes to the terms of the prize reached fever-pitch. The absence of a shortlist in 1988 had proved as contentious as any published list in previous years. So by way of concession, in 1989 the jury announced a review or 'highlights' from the preceding twelve months, commending seven artists from whom a winner would be chosen. The rubric of the prize now declared that the award would go to an artist 'for an outstanding achievement and contribution to art in Britain in the preceding twelve months' in deference to the increasing number of important and influential exhibitions by foreign artists taking place in Britain. This explains why for the first time a foreign artist, Giuseppe Penone, was considered for the Turner Prize. But these amendments pleased almost no one and critical reaction to the prize in 1989 was fiercer than ever. Geordie Greig in the *Sunday Times* (19 November 1989, p.C5) reported that discontent among artists and dealers had 'reached unprecedented levels' largely because: 'The competition is trapped fatally between those who believe art is not a competitive business and such prizes demean it, and those who support the idea of a Booker-like media extravaganza but accuse the organisers of half-heartedness in attracting coverage ... Whoever wins, it seems unlikely that the Turner Prize will emerge unscathed. The furore over Andre's bricks may seem minor in comparison with what happens this year.'

Most critics were still unclear about what the prize was actually for, as John Russell Taylor pointed out in *The Times* of 20 November (p.20):

> If the award is an accolade received on entry to the inner circle of the art establishment, then the choices are fair enough. But that is hardly going to generate the sort of excitement that the Booker Prize regularly achieves, because there is no chance of the prize being snatched by an untried youngster or a rank outsider.

After the announcement of the prize, several works by Richard Long in the Tate's collection were placed on display (*A Line in Bolivia – Kicked Stones* of 1981 and *Ten Days Walking and Sleeping on Natural Ground* of 1986) and a small winner's exhibition was planned for the following year. But Long's exhibition never took place (instead he became the first artist to participate in the Tate's series of annual exhibitions by contemporary sculptors in the newly renovated Duveen sculpture galleries, inaugurated in 1990). Drexel Burham Lambert had pledged to extend their sponsorship of the prize for a further three years at the enhanced level of £20,000. But in February 1990 DBL wrote to Serota reneging on their sponsorship. Furthermore, they were forced to withdraw expenses for the winner's exhibition. Drexel had gone bankrupt leaving the prize high and dry and non-existent during 1990.

Richard Long

Richard Long's work is about his relationship to the landscape. Since 1967 he has based his work on making walks in a variety of locations. He has undertaken solitary walks all over the world, often in remote areas, ranging from the Highlands of Scotland to the Alps, the Andes, the Sahara and Lapland. Using maps, words, and photographs he records things he has seen and evokes experiences he may have had on the walk, including those of time, space, movement, sight, sound, touch and taste. As part of his walk Long often creates a sculpture in the landscape, using elements readily to hand such as twigs, driftwood and stones. In remote areas these sculptures have remained anonymous, gradually returning to the natural environment. The impermanence of his sculptures is crucial, whether produced in the open air or installed in a gallery space: for Long their ephemeral quality suggests the reality of the human condition. Although he is often affected by the beauty of the landscape Long does not set out to depict this, or any other aspect of the natural scene. Instead, he aims to give the idea of the walk, recording facts such as the distance covered and weather conditions. Often physically demanding, the walks nevertheless give the artist great pleasure. In Rudi Fuchs's *Richard Long* (1986, p.74), he comments:

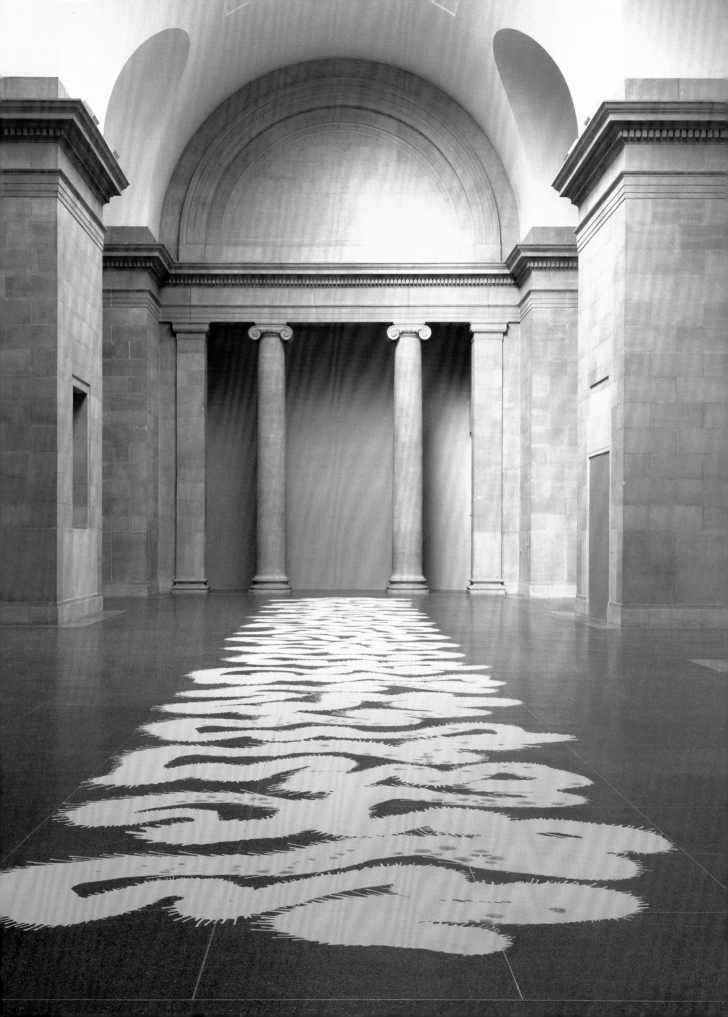

Richard Long
1945 Born in Bristol
1962–5 West of
England College
of Art, Bristol
1966–8 St Martin's
School of Art, London

Gillian Ayres
1930 Born in Barnes,
London
1946–50 Camberwell
School of Art, London
1981 Moved to North
Wales
1987 Moved to
Cornwall

Behind my work ... is the idea that I have seized an opportunity, won a fantastic freedom, to make art, lay down abstract ideas, in some of the great places of the world. So even with storms or bogs or blisters or tiredness, the way I can make my work is intensely pleasurable and satisfying. Even in the more modest ambience of a road walk, the labyrinth of country roads, the inns, the bed and breakfasts, the fabric of country life is still an enjoyable part of making the work and, although not specifically the subject of it, it is implicit in the idea of the work and the place of it.

Although Long has played down the romantic aspect of his art practice, his total involvement with the landscape and his often poetic responses to it place him in a particularly English romantic tradition that can be traced to Constable and Wordsworth. His relationship to the land is always based on personal experience, not just of the present but also of the past. He has talked, for example, of his art as carrying the pleasures of childhood – damming streams, throwing stones and building sand-castles – into adult life.

Often referred to as a 'land artist', Long has identified his work more closely with Italian Arte Povera and Conceptual Art. Although he works in and with the land, his method of working distinguishes him from North American land artists such as James Turrell and Robert Smithson who employ technological means to realise their work. In contrast, Long explores the relationship between man and nature on a human scale, indeed, he sees his work as a 'self-portrait, in all ways'. In an interview with Georgia Lobacheff, he commented: 'To walk across a country is both a measure of the country itself (its size, shape and terrain) and also of myself (how long it takes me and not somebody else). In other works, like my hand circles in mud, or waterlines, my work is more obviously an image of my gestures' (*Richard Long,* São Paulo Bienal 1994, British Council 1994, p.6).

Long has emphasised the primacy of his own experience as the source for his works and enjoys discovering new and original paths. In Fuchs' *Richard Long* (pp.72–3) he says:

I am interested in walking on original routes: riverbeds, circles cut by lakes, a hundred miles in a straight line, my own superimposed pattern on an existing network of roads – all these are original walks ... The surface of the earth, and all the roads, are the site of millions of journeys; I like the idea that it is always possible to walk in new ways for new reasons.

But alongside his insistence on the personal is a deliberate use of abstract, universal shapes and forms. In the interview with Georgia Lobacheff (p.5) he comments:

All my work is about my choices, my preferences. I like stones, so I use them, in the same way I make art by walking because I like walking. Stones are practical, they are common, they exist almost all over the world, they are easy to pick up and carry, they are all unique, universal and natural. But I also use other materials, like mud and water. My preference is always for simple, elemental and natural materials.

Long's sculptures always comprise universally recognisable geometric shapes shared by cultures all over the world. His sculptures might take the form of a straight line, a spiral, a cross, or more typically a circle. Geometric shapes provide the visual language of Minimal art, but in their natural setting his abstract sculptures suggest a more mystical interpretation. Writing about Long's work in his Palazzo delle Esposizioni catalogue (Rome 1994, p.17), Mario Codognato commented on the undeniable symbolism of the circle:

Ever since the dawn of civilisation human beings have produced abstract and schematic representations of the red disc of the sun and the image of the full moon and used them to express the notion of homogeneity, of absence of division. The circle has always been viewed as an indivisible totality. Circular movement is perfect in itself, unchangeable, it has no beginning or end. Hence its use as a symbol for time can be found in all

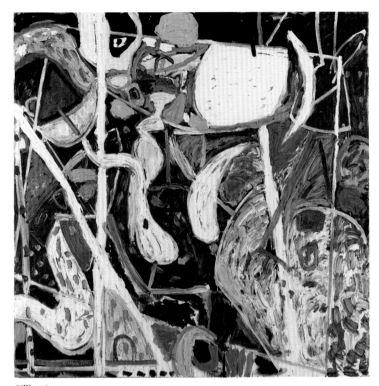

Gillian Ayres
Dido and Aeneas 1988

cultures, from the Babylonians to the Greeks ... and from the native peoples of North America to the modern wristwatch.

The universal language of Long's sculptures and mud paintings was particularly noted in 1989 when his work was seen alongside artists from around the world in the controversial exhibition *Magiciens de la Terre*, held at the the Centre Georges Pompidou, Paris.

Gillian Ayres

Since the late 1970s Gillian Ayres has enjoyed the kind of critical reputation that few British women artists of her generation have achieved. Her large, abstract paintings have a distinctive exuberance created by a joyful celebration of colour and opulent forms. Although titles help to suggest a particular mood, her subjects remain elusive, deriving as they do from personal rather than theoretical imperatives, as Alistair Hicks has observed in his *Gillian Ayres* (exh. cat., Arnolfini Gallery, Bristol 1989, p.8):

> In many ways she is the existential heroine; she lives for the present. There is no sign of a theme, the paintings vary dramatically from one to the the next. She is honest enough to systematically report her feelings. One factor only unites her work, her deep commitment to painting, the momentum of her life.

In the 1950s, Ayres, like many of her peers, was affected by American Abstract Expressionism. In 1957 she was struck by a photograph depicting Jackson Pollock painting his canvas on the floor and for some years she also adopted this practice. Yet despite her admiration for Pollock, Ayres has, nevertheless, continued to place her own work firmly within a European tradition. She has said, for example: 'Titian, Rubens and Matisse are the greatest painters, unashamedly, of sheer beauty but they also used the medium to the fullest in every sense before or since'; and, 'I would like my paintings to have the same affect as Chartres or late Titian'. Monet's late paintings, such as his images of Rouen Cathedral dissolving in colour and light, have also inspired her search for the sublime.

Lucian Freud
1922 Born in Berlin
1933 Moved to Britain
Became a British
subject in 1939
1938–9 Central School
of Arts and Crafts,
London
1939–42 East Anglian
School of Painting and
Drawing, Dedham
1942–3 Part-time
study at Goldsmiths'
College, London
1983 Created a
Companion of
Honour

Giuseppe Penone
1947 Born in Garessio
Ponte, Piedmont, Italy
1966–8 Academia di
Belle Arti, Turin

Paula Rego
1935 Born in Lisbon
1952–6 Slade School
of Art, London
1956 Returned to
Portugal
1962 Began to divide
her time between
London and Portugal
until settling in
London in 1976

During the 1980s Ayres intensified both the substance of her paint and its colour. She exchanged her acrylic-based paints, plastics and resins, for oil and introduced sumptuous colours such as gold. Assessing the significance of her 1989 exhibition at the Arnolfini Gallery, Hicks concluded: 'The present exhibition reveals her desperately fighting to contain some of the force that she had previously allowed to disappear into thin air, to find new relationships between areas of paint. It has created an extra tension. She has become a painter for all seasons' (ibid. p.10).

Lucian Freud

In 1987 Lucian Freud's major retrospective exhibition opened in Washington, touring to Paris and finally London in February 1988. Writing in the exhibition catalogue, Robert Hughes declared Freud as 'the greatest living realist painter'. The show provided an occasion for the assessment of Freud's career and at the same time stimulated a wider critical debate about the role of figurative painting at the end of the twentieth century.

In the 1940s Freud painted with such stark clarity of line that Herbert Read was moved to call him 'the Ingres of Existentialism'. In the late 1950s, possibly influenced by the works of his close friend Francis Bacon, he began to use a hog-hair brush enabling him to force the paint into raw equivalents for hair and flesh. For the depiction of flesh he began to use Cremnitz white, a heavy, grainy pigment with more lead oxide and less oil medium that other whites, which allowed him to convey the physical properties of skin, fat and muscle. Although his means of handling paint have changed, the intensity with which Freud scrutinises his subjects has remained a constant feature of his work.

Freud's sitters, usually relations or friends, are observed over a period of months or even years. Through this obsessive, interrogative looking he has striven to collaborate with them, to give his paintings a sense of his sitter's presence rather than mere likeness. He has said: 'In a culture of photography we have lost the tension that the sitter's power of censorship sets up in the painted portrait'; 'The painting is always done very much with their co-operation' and 'I am only interested in painting the actual person; in doing a painting *of* them, not in *using* them to some ulterior end of art' (Robert Hughes, *Lucian Freud: Paintings*, exh.cat., British Council, South Bank Centre, London 1987, pp.18 and 20).

Freud's paintings, nevertheless, have a characteristic edginess. The lives that he depicts are shown against the familiar backdrop of his studio, a bare, shabby environment devoid of ornate props. Although seemingly brutal in their rendering of the human form, his paintings retain a sympathy with their subjects. As Robert Hughes observed: 'they bypass decorum while fiercely preserving respect' (ibid., p.21). For Hughes, Freud has addressed the crisis in the European tradition of the Ideal Nude which began in the late nineteenth century with the works of Degas and Rodin. Like these artists Freud has found a pictorial truth that has the power to disturb the audience of his own time.

Giuseppe Penone

Penone is the only non-British artist to have been a contender for the Turner Prize. This unique interpretation of the Turner Prize rubric in 1989 was intended to draw attention to the significant increase in exhibitions in Britain of work by foreign artists. Penone, who showed work at the Arnolfini Gallery, Bristol and at the Dean Clough Arts Foundation in Halifax, is an artist of international repute, having been associated with the Arte Povera movement in Italy since 1969. His work also relates to Land and Process art.

Paula Rego

Paula Rego is primarily a story-teller. Using collage in the 1960s and 1970s and since 1981 by painting directly, she weaves stories that deal with the darker side of human nature, with revenge, betrayal and desire. But her stories have no clear narrative: having no past or future they force the viewer to reach his or her own conclusions. Adrian Searle has commented that when confronting her pictures: 'We step into ... an enigmatic moment in which we have lost our bearings, and the only way to negotiate it is through a process of

Lucian Freud
Standing by the Rags
1988–9

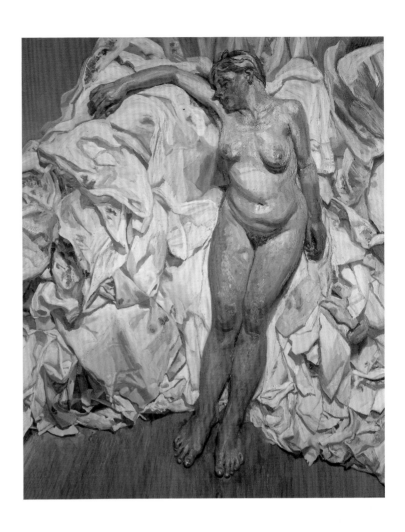

Paula Rego
The Maids 1987

Sean Scully
1945 Born in Dublin; family moves to London shortly after
1965–8 Croydon College of Art
1968–72 University of Newcastle-upon-Tyne
1972–3 Harvard University, Cambridge, Massachusetts
1975 Moves to USA

Richard Wilson
1953 Born in London
1971–4 Hornsey College of Art, London
1974–6 Reading University

deduction, supposition, and an attendance to the hierarchical, psychological disposition of the composition. And, of course, through our own imaginations, our own private histories' (*Unbound: Possibilities in Painting*, Hayward Gallery, London 1994, p.84).

Rego's visual imagination and pictorial language have been nourished by a variety of sources, ranging from *Alice in Wonderland* and Disney films to Portuguese folk tales and the caricatures of Pluma y Lapis. But most important has been childhood experience, which she treats as an ever-present reality affecting adult life. The recurring themes of her work – nurturing and punishment, freedom and repression, power and impotence – are those which dominate childhood. Rego has likened her studio to the playroom where she spent hours in imaginative reverie. She even begins her paintings crouching on the floor as she did when drawing in her playroom.

Until the 1980s her stories were told primarily through pictures of animals, a conceit common to folk tales, fables, nursery rhymes and cartoons. Then humans, particularly pubescent girls, began to take centre stage. In her series *Girl with Dog* of 1986, Rego depicts themes such as punishment and domination with a new-found ambiguity. The dogs, like children, are shown subjected to the omnipotent care of their mistresses. Ruth Rosengarten has observed that for Rego: 'The dividing line between nurturing and harming – between love and murder – is always hair-thin, for the artist's concern is not with good and evil at their extremes, but with the area between, the acts of cruelty with which love is shot' (*Paula Rego*, exh.cat., Serpentine Gallery, London 1988, p.19).

Rego's retrospective exhibition of 1988 included a number of recent works depicting monumental, strong-faced girls. Although graced with such charming attributes of girlhood as decorative clothes and hair, Rego reveals them to be intelligent, calculating and dangerous. In her appraisal of Rego's paintings of this period in *Modern Painters* (vol.1, no.3, Autumn 1988, p.34) Germaine Greer was unequivocal about their achievement: 'After the violation of Balthus's keyhole

vision, feminists hardly dared to hope that a woman painter could reassert woman's mystery and restore her intactness. Rego's paintings are full of shuttered windows, closed doors and vessels of ambiguous content. Her female types smile mirthlessly in a new version of the grin of the Maenads. Her paintings quiver with an anger and compassion of which we have sore need.'

Sean Scully

For a discussion of Sean Scully's work see 1993.

Richard Wilson

Richard Wilson's transformations of architectural spaces using industrial materials such as oil and metal, together with natural phenomena such as water and light, have often produced aesthetic effects that verge on the sublime. Elegant and deceptively minimal, his works destabilise established perceptions of architectural space and structure, heightening our awareness of mundane surroundings.

Perhaps his best-known work is *20:50*, first exhibited in 1987 at Matt's Gallery, London. Although site specific, this extraordinary installation can be adapted to almost any space: it is now permanently on display at the Saatchi Collection in London. On entering a room by means of a small corridor the viewer is momentarily unaware that the space has been partially filled with sump oil. The experience is physically disorientating and visually breathtaking: 'The rising and rapidly narrowing walkway that must be negotiated creates an unnerving sense of vertigo as the viewer is thrust out into space amongst an expanse of oil that reflects the surrounding architecture perfectly on its dark, faultless surface ... unlike water or mirrors, the reflection is contained entirely on the surface. It is impossible to see through even the first millimetre of the oil' (James Roberts, *Richard Wilson*, DAADgalerie, Berlin 1993).

In 1989 the Turner Prize jury was impressed by Wilson's four new installations which also dealt with architectural intervention: *Leading Lights* at Brandts Klaedefabrik, Odense, Denmark; *Sea Level* at the Arnolfini Gallery, Bristol; *High-Tec* at the Museum

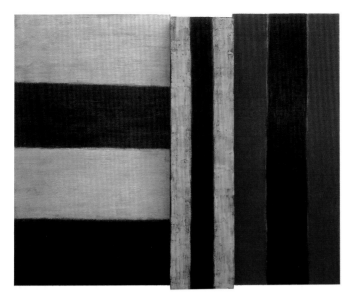

Sean Scully
Paul 1984

of Modern Art, Oxford and *She Came in Through the Bathroom Window* at Matt's Gallery, London. The last-named work involved suspending a window frame into the gallery space so that instead of being looked through it became an object to be looked at. The frame was still connected to its original position in the wall by panelling, so that part of the outside world appeared to have moved with the window into the gallery. James Roberts has eloquently described the effect:

> You become very aware of the air that has been displaced and is now a boxed and quantifiable volume with a very real presence. The view through the window somehow becomes pictorialised, as if it had become a schematic representation of the effects of perspective ... the physical projection into the space reminds you that viewing can be a two-way process and that, equally, windows allow the viewer inside to be viewed from outside [ibid.].

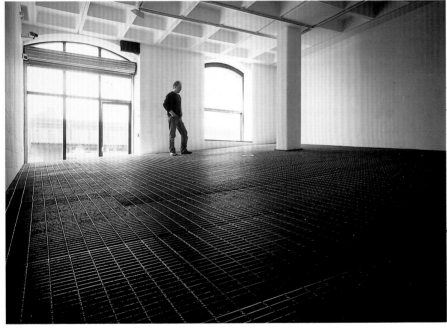

Richard Wilson
Sea Level 1989

Anish Kapoor 1991

Winner
Anish Kapoor

Shortlisted artists
Ian Davenport for his powerful demonstration of the expressive possibilities of abstract painting, as seen in *The British Art Show*, in his debut exhibition at Waddington Galleries, and in exhibitions overseas
Anish Kapoor for the development of his sculpture as seen in his exhibitions in Grenoble, Madrid, Hanover and the XLIV Venice Biennale,
Fiona Rae for the impressive way in which she has extended the range of subject matter embraced by abstract painting, as seen in Aperto at the XLIV Venice Biennale, and in her recent London exhibition at the Waddington Galleries
Rachel Whiteread for her resonant sculptures of the spaces surrounding domestic objects and rooms, seen in the installation *Ghost* at the Chisenhale Gallery, East London, in exhibitions at the Arnolfini Gallery, Bristol, Karsten Schubert, London, and in various exhibitions abroad

Jury
Maria Corral
Director, Reina Sofia Centre, Madrid
Andrew Graham-Dixon
Art critic of the *Independent*
Norman Rosenthal
Exhibitions Secretary, Royal Academy of Arts, London
Adrian Ward-Jackson CBE
Chairman, Contemporary Art Society
Penny Govett
Representative of the Patrons of New Art
Nicholas Serota
Director of the Tate Gallery and Chairman of the Jury

Exhibition
6 November–8 December 1991
Prize of £20,000 presented by Robert Hughes, 26 November 1991

Anish Kapoor
Void Field (detail) 1989

From March 1990 the Tate Gallery worked towards reshaping the Turner Prize with its new sponsor Channel 4. Thanks to the enthusiasm of Channel 4's Commissioning Editor for Arts, Waldemar Januszczak, and an enhanced level of sponsorship, Nicholas Serota was able to effect significant improvements in the presentation and promotion of the prize, including the re-introduction of a shortlist exhibition. In the newly established broadsheet catalogue accompanying the Turner Prize exhibition of 1991 Serota took stock of previous failings and gave some explanation of the new-look prize, which now imposed an age limit of fifty years, and was to be awarded for 'an outstanding exhibition or presentation' during the preceding year:

The early history of the Turner Prize, established in 1984, has been in part a search for a format which is appropriate to the visual arts ... This year, after a lapse of one year, the Turner Prize is reinstated with terms which aim to give even greater focus. The decision to exclude artists aged over fifty is a recognition merely of the fact that comparisons are invidious between the achievements of artists of such differing ages as thirty and seventy. More significant, perhaps, is the decision to award the prize for 'an outstanding exhibition or other presentation' which has taken place during the year. This gives the prize a much clearer relationship to specific events, rather than being for an 'outstanding contribution', which carries with it the suggestion of an acknowledgement of a lifetime achievement.

The jury, in considering the exhibitions of the last twelve months, could not fail to note the impact of a younger generation of British artists both at home and abroad. Serota defended the jury's unprecedented inclusion of so many young artists on the shortlist:

Of course, there were doubts about the wisdom of singling out two or three artists from a generation that has not yet fully defined its position. However, the jury eventually decided that the shortlist, and therefore the exhibition and Channel 4 film, ought to reflect passion rather than caution; better a shortlist which reflects conviction than a balanced end-of-term report.

But no such reasoning could placate the critics, many of whom were outraged by the youth of the contenders, and empathised with Kapoor's position as the only contender over thirty years old. Even more scandalous were rumours that the jury itself was at odds over the shortlist. On 26 November 1991, the eve of the award, Andrew Graham-Dixon replied to such accusations in the *Independent* (p.16):

I remember the first jury meeting in July as an amicable event which bore little resemblance to the descriptions of it that have subsequently appeared in the press. I do not recall the moment when, according to Roger Bevan, the 'other jury members, including the late Adrian Ward-Jackson and Maria Corral, protested this contentious shortlist' but were overcome by 'tactics of insistence'.

The shortlist was widely interpreted as an indulgent concession to fashion, a view summed up by Richard Cork: 'The short-list's trendiness amounts to a massive snub for the whole notion of working steadily towards well-earned maturity in middle age ('Young, Gifted and Rising too fast?', *The Times*, 8 November 1991, p.14). But like other critics, Cork was forced to acknowledge that considerable effort had gone into improving the presentation of the artists' work in the Gallery. The exhibition, traditionally held in the Octagon or North Duveens, now occupied six galleries in the 1979 extension. Furthermore, a video and information panels now helped to introduce visitors to the work on display. Richard Dorment was even moved to write: 'Despite everything you may have read, this is a calm, unassuming and really rather beautiful little exhibition of four thoughtful young artists'('Winner in a Class of His Own', *Daily Telegraph*, 27 November 1991, p.18).
Attempting to analyse why the prize continued to provoke controversy Marina Vaizey noted that in previous years sniping had been led 'by those critics and dealers who believe a

romantic British realism is the only genuine British art, and who confuse aesthetic evaluations with Colonel Blimp flag-waving'. But in 1991 the confused focus of the prize had been inadvertantly perpetuated by the disparity in age and achievement of the contenders. Neverthess, Vaizey was encouraging and endorsed the higher profile of the exhibition: 'The Turner Prize needs fundamental popularising ... It seems like a religion in which the public is barred not only from the priesthood but even from the congregation ... We need clearer explanation and demonstration of the marvels of contemporary art, of the way it makes us see and feel; we need more exhibitons of these artists, more television and radio coverage, and a piece of art any of us can potentially own for the price of a hardback book' ('No Wiser After the Event', *Sunday Times,* 1 December 1991, p.5).

The exhibition was clearly attracting new audiences and their apparent incomprehension of the work on display called for greater elucidation and serious critical discussion. Andrew Graham-Dixon, in summing up his experience as a juror in 1991, came to a conclusion that perhaps still holds true: 'The greatest problem facing the prize, now, may not lie within it but without. Its effectiveness depends on the willingness of others to address the contemporary art to which it seeks to call attention, and to do so with at least some of the seriousness with which that art was itself made' (ibid.).

Anish Kapoor

Anish Kapoor gained recognition as a sculptor in the early 1980s. Although appropriated under the term 'New Sculpture', he stands apart from the artists grouped under this label, with the exception of Shirazeh Houshiary and possibly Alison Wilding. His work is driven by a desire for self-knowledge, and to represent this quest he has developed a visual language dominated by archetypal images, including void, mountain, vessel, tree, fire and water. Powerfully evocative, beautiful and sublime, his art has been recognised as having universal spiritual resonance.

The son of an Indian father and an Iraqi Jewish mother, Kapoor's rich cultural heritage has had a formative influence on his work. In 1979 a visit to India, together with his growing interest in Jungian psychoanalysis, contributed to Kapoor's development of distinctive forms and images. Curvaceous and sexual, these forms appear to symbolise different aspects of the feminine principle. Jeremy Lewison has argued that Kapoor's preoccupation with imagery suggestive of the female body can be understood as the artist's search for the Jungian 'anima', the unconscious female characteristics within man. One of Jung's followers, Eric Neumann, has examined female archetypes as represented in art and equates 'anima' or the 'transformative character' with creativity. Lewison has written in *Anish Kapoor: Drawings*, exh.cat., Tate Gallery, 1990, p.11):

> For Kapoor the interior of the body is an unknown area, a chasm or void which is both comforting and fearful, protective and restrictive, creative and destructive ... These binary oppositions ... are also key elements of Kapoor's images and, furthermore, of Indian, specifically Hindu, culture where the feminine deity (*shakti*) is perceived as the energising female counterpoint or consort of the male god. In cults which elevate the female principle above the male, the female is seen as the energising force which stimulates the masculine potential which is seen as dormant – even dead – without her.

The union of binary opposites – male and female, body and spirit, darkness and light – creates the sense of 'wholeness' that Kapoor seeks to invoke throughout his work.

Colour has played a key role in his art. Like many modern artists, including Yves Klein and Barnett Newman, he believes in its spiritual, symbolic value and transformative power: 'Colour has an almost direct link with the symbol-forming part of ourselves. That is something we have without formal education. It is just there' (ibid., p.21). Kapoor's early sculptures comprised groupings of enigmatic forms covered in pure pigments of red, yellow and blue.

Anish Kapoor
1954 Born in Bombay, India
1973–7 Hornsey College of Art, London
1977–8 Chelsea School of Art, London

Ian Davenport
Untitled 1989

Ian Davenport
Untitled (Drab) 1990

1991

Ian Davenport
1966 Born in Sidcup, Kent
1984–5 Norwich College of Art and Design
1985–8 Goldsmiths' College, London

These pigments, inspired by the powders used in Hindu worship, leave no trace of the artist's hand so that the sculpture appears, in the artist's words, 'unmade, as if self-manifest, as if there by its own volition' (Germano Celant, *Anish Kapoor*, 1996, unpag.).

In the late 1980s and early 1990s Kapoor began to make works on a larger scale, many of which explore the theme of the void. Placing pigment, most often blue, inside the cavities of roughly hewn stone vessels he drew attention to the polarity between outside and inside, light and darkness. Kapoor has explained the sense of interior and exterior in terms of the human body:

> An essential issue in my work is that the scale always relates to the body. In the pigment works from 1979 to 1983, a sense of place was generated between the objects. This place has now moved inside the object so it has been necessary to change the scale. The place within is a mind/body space. A shrine for one person! [ibid.].

His aim with these new works was to create an object that did not really exist, a 'non-space', represented as a cavernous, ethereal space in the centre of the stone, as dark as the body's interior. Archetypally, this inner space is identified with the unconscious. The artist has said: 'Void is really a state within. It has a lot to do with fear, in Oedipal terms, but more so with darkness. There is nothing so black as the black within. No blackness is as black as that.' Kapoor's 'void' pieces attempt to produce a sensation of the sublime, a sensation that leads towards communion with God, or in Kapoor's terms, towards self-knowledge or 'wholeness' (ibid.).

Although a number of his works continued to comprise several pieces, notably *Void Field* shown at the Venice Biennale in 1990, in the Turner Prize exhibition Kapoor was represented by a single stone object. Writing in the accompanying broadsheet Sean Rainbird commented:

> In the urn form of the object displayed in this exhibition, there are echoes of an object made for everyday use: a receptacle for the storage of precious liquids. Its substantial height and girth ... hinder visual exploration of its less accessible, incorporeal inner recesses. However, the coexistence of two such contrasting states of being within one sculpture intimates the potential in human experience for the spirit to unite with the body, part of a transformative process that lies at the heart of Kapoor's work.

Ian Davenport

During the late 1980s and early 1990s Ian Davenport was recognised as one of a number of younger artists who were confidently addressing and contributing to the post-war tradition of abstract painting. The sheer physicality of Davenport's paintings always suggests the importance of the process by which they were made. However, his paintings are not 'action paintings' in the manner of Jackson Pollock. As he points out in his 'Notes on Painting' (published in the catalogue for *The British Art Show* in 1990), Davenport clearly aims to exert an element of control over the medium: 'The structure of the painting is formed by the paint running into itself. Each of my paintings has evolved from a very deliberate process, not from intuitive marking.'

Davenport's paintings of the early 1990s were restricted to one colour. By dripping or manipulating different types of paint and varnish layers over an evenly painted matt ground he achieved contrasts, layers and a certain sense of depth. The apparently random flow of paint in rivulets down the surface of the canvas is in fact achieved by a number of precise techniques – tilting the canvas through one of four planes, adjusting the slant to influence the duration and flow of the paint, sometimes upending his canvases at the end of painting so the drips extend from the bottom to the top. At the same time, Davenport works with the innate properties of his materials allowing gravity and the viscosity of his paints and varnishes to determine the form of each trail of paint.

Although every channel or drip is potentially unique, Davenport subjects each painted trace to an overall structure, containing these individual elements within an organised whole. In the same way, he resists any kind of spiritual or

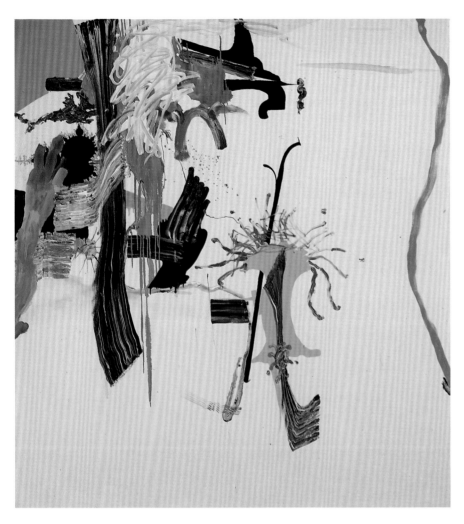

Fiona Rae
Untitled (yellow and black) 1991

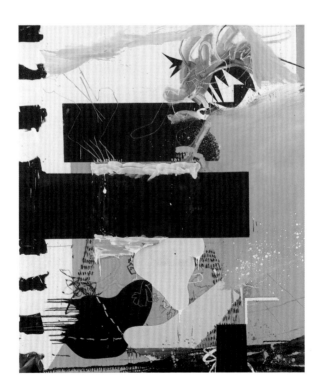

Fiona Rae
Untitled (yellow) 1990

Fiona Rae
1963 Born in Hong
Kong (1970 moved to
England)
1983–4 Croydon
College of Art
1984–7 Goldsmiths'
College, London

Rachel Whiteread
1963 Born in London
1982–5 Brighton
Polytechnic
1985–7 Slade School of
Art, London

transcendent reading of his paintings: his grounds and overlays do not stain the canvas in the manner of Mark Rothko. The lines of paint are methodically released from the top of the canvas. Davenport deliberately attempts to control the paint, but his generous use of the material often produces sensuous, elegant and arresting surfaces.

Fiona Rae

When Rae emerged as a painter in the late 1980s her apparent virtuosity with the medium – her ability to move effortlessly from one type of brush mark to another – quickly won critical admiration. Since the late 1980s her work has explored the language of visual signs, challenging our expectations of paintings, of what they might be about or what they might contain. Rae appears to question why we probe a picture in search of a motif, almost as a visual reflex, like finding images in cloud formations. Her paintings ask why we suspend our critical awareness of the mechanics of painting and submit so eagerly to the illusion that something is actually depicted.

Her early paintings took the form of ordered rows of signs, each painted in isolation, suggesting the pictograms of hieroglyphic languages. But these signs did not correspond to any code or language. Rae's paintings of the early 1990s are more chaotic, containing disparate gestures or motifs that look out of place and disruptive. Characteristically, the paintings contrast vaguely recognisable motifs with grounds that are neutral or divided into fields of abutting or interpenetrating colours. Scrutinising the variety of painted marks on the surface of the canvas – drips, flourishes, lines, fields of colour – the viewer is uncertain which are deliberate, which accidental. In this way Rae invites a reconsideration of the relative importance of the different components within each work and the role they might play in relation to the composition as a whole.

In some canvases, certain lines and shapes resemble the visual language of cartoons and calligraphic line drawings, or of particular artists, for example, Brice Marden, Phillip Guston, Hans Hofmann and Picasso. In the context of Rae's

paintings, how far do these recognisable marks retain their status? Most importantly, Rae's ambiguous marks encourage and yet frustrate any attempt to construct narratives for the painting. Since every viewer will identify the imagery differently, a universally agreed meaning seems impossible.

Rachel Whiteread

In 1991 Rachel Whiteread was represented in the shortlist exhibition by *Ether, Untitled (Amber Bed)* and *Untitled (White Sloping Bed)*. A discussion of her work can be found under 1993 when she was winner of the prize.

Rachel Whiteread
Untitled (Amber Bed)
1991

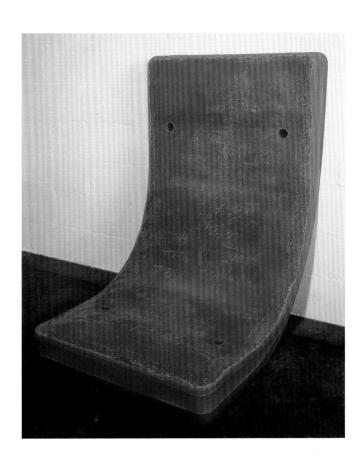

Rachel Whiteread
Untitled (Sink) 1990

Winner
Grenville Davey

Shortlisted artists
Grenville Davey for the continuing development of his sculpture as seen in his exhibitions at the Kunsthalle, Bern and Kunstverein, Dusseldorf and also for his strong presence in *Confrontations* in Madrid
Damien Hirst for his exhibitions at the Institute of Contemporary Arts, London, his display at the Saatchi Collection, London and the work shown in *Made for Arolsen* at Schlosshof, Arolsen, alongside Documenta
David Tremlett for the many recent exhibitions of his work on the Continent, notably *A Quiet Madness* at the Kestner-Gesellschaft, Hanover
Alison Wilding for the subtle strength of her sculpture, seen in her exhibitions *Immersion* at the Tate Gallery Liverpool and *Exposure* at the Henry Moore Sculpture Trust Studio at Dean Clough, Halifax

Jury
Marie-Claude Beaud
Director of the Foundation Cartier pour l'art contemporain
Robert Hopper
Director of the Henry Moore Sculpture Trust
Sarah Kent
Art critic of *Time Out*
Howard Karshan
Representative of the Patrons of New Art
Nicholas Serota
Director of the Tate Gallery and Chairman of the Jury

Exhibition
4–29 November 1992
Prize of £20,000 presented by Rt Hon. Peter Brooke, Minister for the Arts, 24 November 1992

Grenville Davey
HAL 1992

Compared with the shortlist of 1991 this year's list was relatively evenly balanced, including two mature and two younger artists. But ferocious criticism continued unabated. Commenting on the jury's selection, the Director explained that there had been fewer exhibitions of younger British artists in Britain than in previous years but British art had 'continued to grow in reputation abroad through significant group and solo exhibitions'. This led critics to accuse the jury of not having seen all the exhibitions for which the contenders had been nominated. As in 1991, a number of critics argued that the selection was guided by fashionable international taste, only this year they drew attention to the overbearing influence of Goldsmiths' College and two of London's leading commercial galleries, the Lisson and Anthony d'Offay. This was a strange point to make, as 1992 marked the arrival of two young and distinctly radical dealers who represented artists on the shortlist, Karsten Schubert and Jay Jopling, both of whom challenged the dominance of the heavyweight galleries.

Frank Whitford's article in the *Sunday Times* (29 November 1992, pp.8, 13) typified local resistance to the rise of a new kind of conceptual art in the early 1990s. Lamenting the choice of artists, he concluded:

> The 1992 prize and its seven predecessors have been awarded by juries who manifestly take a narrow and blinkered view of the current state of art in this country, and their decisions have done less to initiate intelligent discussion than to confirm the ill-founded but widespread suspicion that most commercially and critically successful art is the product of self-delusion or a conspiracy cooked up by a coterie of self-appointed experts.

The dismissal by many senior critics of a new generation of artists whose thinking about art and art practice seemed to differ radically from their immediate predecessors proved too much for Waldemar Januszczak, who attacked his former colleagues (*Guardian*, 21 July 1992, p.34):

> As art critic of the Guardian for ten years I watched a lot of things come

and go – fashions, art movements, artistic reputations, aesthetic priorities – everything except art critics ... They just stayed where they were, writing the same copy for the same magazine or newspaper, show after show, week after week, piece after piece, journalism's dullest baseliners ... Since when has being a good artist involved being an old artist? Since, I suppose, the moment that being an old critic first became confused with being a good critic.

Few of the more established critics were prepared, for example, to discuss such an artist as Damien Hirst with any seriousness. Richard Dorment was one of the exceptions: 'A 29-year-old avant-garde artist has created a work which in the popular consciousness has the instant recognisability of Whistler's Mother ... I've learnt not to dismiss Hirst. The creator of the shark possesses some kind of genius, whether for finding unforgettable visual images or for manipulating the press I'm not entirely sure' (*Daily Telegraph*, 26 November 1992, p.19).

The favourite in 1992 had been Alison Wilding, with Hirst as the wild card 'wunderkind', so Grenville Davey's win was utterly unpredictable, least of all for the artist himself. Davey later advised the artists shortlisted for the 1993 prize that 'Protective headgear, thick gloves, barrier cream, a length of rubber hose and definitely a sense of humour are objects an artist might need in order to survive the next few months leading up to the announcement of the the winner'. Davey's work was widely dismissed as 'boring', but his conversations with visitors to the exhibition proved more rewarding than reading reviews: 'Their attitude to the prize isn't a romantic view, it's very real; they come to the Tate's Turner show and get to grips with the work in a concrete way' (*Sunday Times*, 1 August 1993, p.9).

If winning brought mixed blessings, 'losing' was even harder. Sarah Kent, art critic of *Time Out* and one of the jurors in 1992, published candid accounts of her involvement in the Turner Prize following the announcement of the winner. In the Patrons of New Art Newsletter (Spring 1993, p.5) she commented on the pressures which the event placed on the shortlisted artists, but defended the principle of the prize:

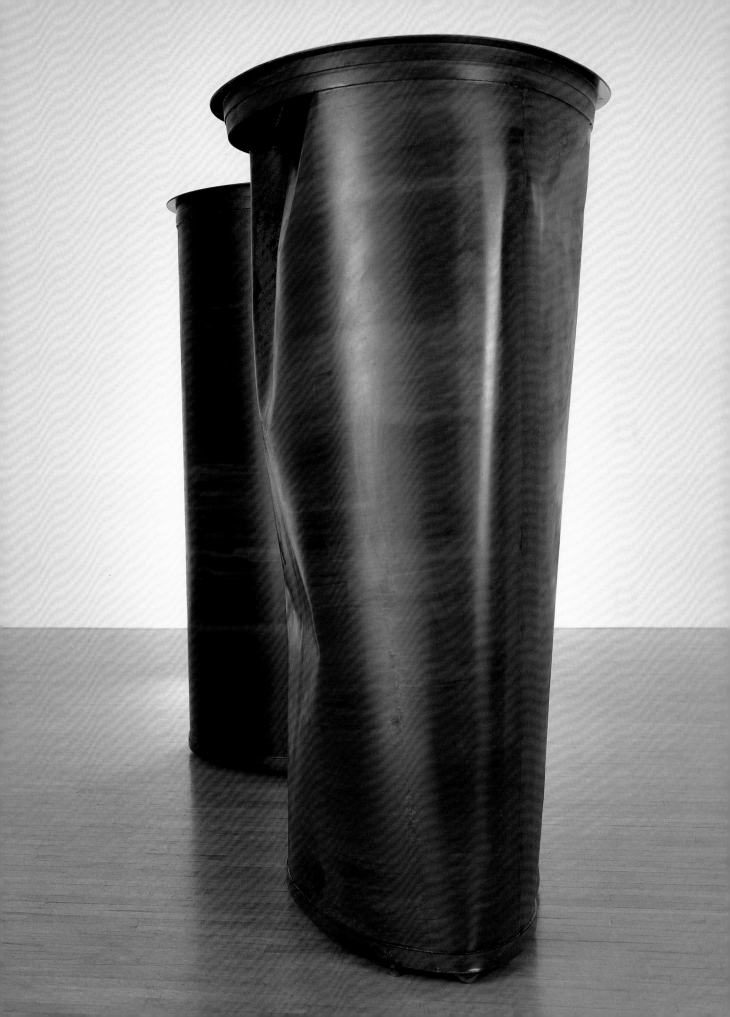

Of course, I expected the runner-up to be disappointed, but nothing had prepared me for the misery felt by the losers, nor for the sense of outrage amongst some of their supporters. Because the prize-giving is broadcast nationwide, their defeat was experienced as a public humiliation ... But in the long term I am convinced that the benefits of taking part far outweigh the pain. Several critics have called for the abolition of the prize, dismissing it as a media circus because of its high profile. This seems ludicrously misguided. The Turner Prize makes an important commitment to art as a living process, recognising that it is not enough for the Tate Gallery to venerate the dead ... The controversy generated by the event is not something to be feared; it is a healthy sign of interest. Fierce argument indicates intense feeling. Better to live in the spotlight, than to moulder in the gloom.

Had she won the prize Wilding would have been the first woman to do so. In 1992, a number of articles on the Turner Prize discussed the continued absence of a woman from the roll of honour, despite the increasing visibility of female artists in public and commercial galleries.

Grenville Davey

In the 1992 Turner Prize line-up Greville Davey was considered by many to be the outsider. But although relatively unknown to a wider public he had been successfully exhibiting work since 1987, when the Lisson Gallery gave him his first show, and had enjoyed subsequent solo exhibitions in Rome, Amsterdam, Paris, Bern and Düsseldorf.

At the centre of Davey's sculpture is an interest in the relationship between the art object and perceived reality. In the twentieth century the idea of the autonomy of the art object – its own reality as a structure of colour, texture, form and materials – has been fundamental to modernism, and led to the making of abstract art. At the same time, many artists, including Davey, have continued to explore reality and our

relationship to it. During the late 1980s he was preoccupied with the form of the circle. At first glance his sculptures seem aligned to the tradition of abstract art that upholds Platonic ideas about the absolute beauty of pure forms. However, Davey quietly challenges these notions by subtly modifying geometric purity. On closer inspection, his cool abstract forms are reminiscent of domestic or industrial objects, oddly enlarged and out of context. His sculptures are invested with other contradictions: they appear to be manufactured but are mostly made by hand. They also imply an action which further enhances a narrative meaning such as screwing down, lifting off, welding or fitting. In an exhibition catalogue of 1989 Marjorie Allthorpe-Guyton commented:

> Davey's achievement is that his work is aligned to Minimalism in its refusal of the illusion of representation and yet he reveals simultaneously how and why representation works. He manages this by exploiting the simplest of sculptural language and makes us sharply in touch with our emotional and physical experience of the world.

Davey's reference to everyday objects is characteristically elusive. But though associations with the world of real objects and things are understated, it is possible to view the works, as Davey puts it, as 'objects with purpose', that is, they are not the outcome of exclusively aesthetic decisions. In *Ce & Ce* of 1989, for example, Davey casually places two large rusted steel circles overlapping one another against a wall. The informal positioning and steel lips of the circles suggest the lids of vats or giant paint pots, momentarily set aside. But the diameter groove also gives the circles the appearance of enormous nail or screw heads.

Davey seems to experience the world in terms of parallels or analogies: the noise of rainwater running in the drain in his studio is equivalent to the noise of electric cable shorting; amid the chaotic rattle of dropped metal he hears the sound of a telephone ringing. It seems that his sculptures begin life with a similar parallel or analogy with some object.

Grenville Davey
1961 Born in Launceston, Cornwall
1981–2 Exeter College of Art and Design
1982–5 Goldsmiths' College, London

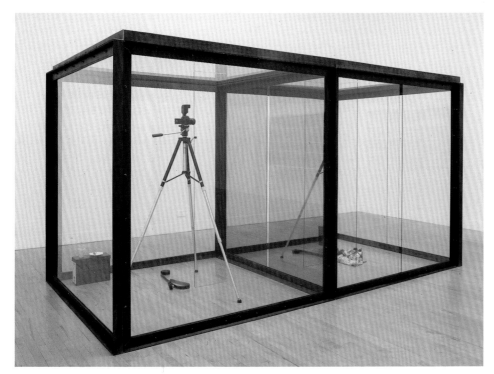

Damien Hirst
The Asthmatic Escaped
1992

Damien Hirst
*I Want You Because
I Can't Have You* 1992

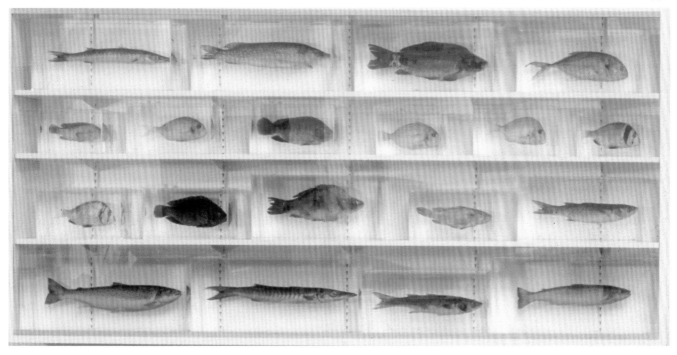

Titles play an important role in suggesting possible insights to the viewer. In *Right 3rd and 6th* of 1989, undulating curves break the geometry of the basic cylindrical forms of the piece. The title gives the clue – dentists' notation for teeth. The curves were made by Davey bending sheets of hardboard between his knees and then fixing them in position while under tension. He found the title by phoning the first dentist he came across in the Yellow Pages and asking for the names of teeth. The circular forms of *Right 3rd and 6th* have smoothly finished painted surfaces. At this time Davey often painted industrial-sized objects in such domestic pastel colours, the colours of kitchens, bathrooms and bedrooms. *Drum* (1989–90), for example, comprises a pair of steel drums painted milky-white and cream, reminiscent of objects as banal as yoghurt pots.

Davey showed two works in the Turner Prize exhibition. *Common Ground* (1992) was the latest in a series of sculptures playing on the identity and functionality of industrial furniture. Like a number of Davey's sculptures, such as *Dry Table*, its form suggests a freestanding counter. But all of these sculptures are denuded in some way of their basic functionality. *Common Ground*, for example, is given an asphalt surface and its interior comprises a cage of steel mesh whose formal beauty coexists with its industrial references. The other piece included in the exhibition, *HAL*, also of 1992, suggests the generic cylindrical container found in a variety of contexts in the industrial environment.

Damien Hirst

In 1992 Damien Hirst was represented in the shortlist exhibition by two works of 1992, *I Want You Because I Can't Have You* and *The Asthmatic Escaped*. A discussion of his work can be found under 1995 when he was the winner of the prize.

David Tremlett

During the early 1970s David Tremlett was acknowledged as making a particular contribution to Conceptual Art. He was one of a number of British artists, such as Gilbert and George and Richard Long, whose work was recognised internationally and who were collectively seen as a distinctively British presence in avant-garde art.

A common thread in Conceptual Art was anti-materialism, favouring art that was unconventional, fragile or ephemeral in its physical forms. Tremlett shares this view, believing that 'the permanence of the work is in the idea'. A large part of his activity as an artist has been in the making of wall drawings which have a finite existence. Some of his wall drawings are never even seen in public, being made and left on site in the places where he has been moved to make work. More permanent are the large drawings on paper which, like the wall drawings express Tremlett's response to a particular place or thing seen. However, he emphasises that 'The drawing on paper has always had one purpose which is the dream to create a larger version on some interior/exterior surface'.

The tension between Tremlett's need to give monumental physical expression to his art and his feeling for the transience of existence extends to his medium – pastel. This he describes as 'a pigment dust both permanent and fragile'. He delights in the idea of 'the fragility of pastel used to create large structures'.

In 1970 Tremlett began to travel widely in pursuit of his art and has continued to do so: 'Much of my time as an artist has been spent working and travelling cheaply, in the Middle East, Asia, East Africa and the Southern States of the USA ... and naturally Europe ... Writing and drawing out of cheap hotels in towns and villages.' His subjects are 'bits and pieces you bump into, the unsavoury side of street life – dog shit, broken glass, tin cans'. Tremlett's work also deals with his vision of space, volume, time and distance. His sense of volume, space and proportion manifests itself most purely in the wall drawings, whose shapes refer sometimes to the floor plans, sometimes to other architectural details that appeal to him, of the buildings that have captured his imagination. He is particularly attuned to humble and everyday spaces – ordinary dwellings, bars and hotel rooms. In May 1990, for example, on the coast of Tanzania, Tremlett discovered Mjimwema, a group of ruined seaside villas built by sisal traders in the early 1950s. He speaks of their character as

Damien Hirst
1965 Born in Bristol
1986–9 Goldsmiths' College, University of London
1992 Shortlisted for Turner Prize

David Tremlett
1945 Born in St Austell, Cornwall
1963–6 Birmingham College of Art
1966–9 Royal College of Art, London

David Tremlett
*Wall Drawings at
Abbaye de St Savin,
France* 1991

David Tremlett
Walls and Floors 91
1992

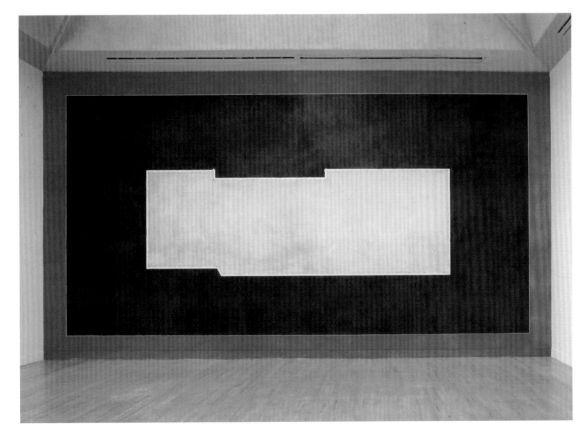

Alison Wilding
1948 Born in
Blackburn, Lancashire
Grew up in St Ives,
Huntingdonshire
1967–70
Ravensbourne College
of Art and Design,
Bromley, Kent
1970–3 Royal College
of Art, London

'unpretentious domestic dwellings, not ruins of architectural value', of their 'feeling of a skeleton', and of poetry arising from their decay. The wall drawing included in the Turner Prize exhibition was based on his experience of this place.

Alison Wilding

Alison Wilding belongs to a generation of sculptors who were identified in the early 1980s as the instigators of a recognisable, if somewhat difficult to define, 'New British Sculpture'. After leaving the Royal College in 1973 she made installations incorporating everyday objects, but within a few years these ceased to be of interest to her and she gave up making work. However, by 1981 Wilding had established the basis of a vocabulary of sculptural forms which she continues to develop. She is also remarkable for a distinctly original and robust approach to materials.

One of Wilding's enduring sculptural preoccupations has been to explore the phenomenon of duality. Her sculptures often comprise two separate elements which interpret such elemental opposites as positive-negative, male-female, light-dark. Her use and understanding of numerous materials, including copper, brass, wood, beeswax, lead, galvanised steel, transparent plastics, silk, cotton, linen cloth, fossils, rubber and a variety of paints, pigments and chemical agents for patinating surfaces, has enabled her to set up unusual contrasts of form, colour and surface in ways that are often poetic.

In the summer of 1991 she exhibited ten years' work at the Tate Gallery Liverpool and five new works at the Henry Moore Sculpture Trust Studio at Dean Clough in Halifax. She chose to show one of the works from Dean Clough in the Turner Prize exhibition, *Assembly* (1991), made of two diverse and contrasting parts successfully brought together as a sculptural whole. According to Wilding one part is 'a steel tunnel with no light at the end' and the other is 'light, liquid and life'. The latter part is made of strips of PVC whose structure was carefully worked out in theory, although she had no idea what the final effect would be. It is typical of Wilding's working method to discover the finished sculptural form through the often slow and painful process of making the object.

Wilding also exhibited *Red Skies* of 1992 which belongs to a group of hollow upright forms whose veiled interiors are glimpsed through narrow slits or peephole-like apertures in their sides. The placing of one or more objects inside another was a recent development in her work. In *Red Skies* two sections, one inverted, of a darkly patinated steel cone, are placed to contain yet reveal a hollow column of transparent red acrylic. This is topped with a spun brass sphere, drilled with holes into which are inserted three different wires, two brass and one bronze, tightly coiled down on the surface, creating an effect, says Wilding, like 'worms cast on a beach'. She wanted the title to 'encompass an area of unease'. This work exemplifies key aspects of Wilding's achievement, namely her ability to produce formally resolved sculpture which alludes to some of the most basic elements of our psychology.

Alison Wilding
Assembly 1991

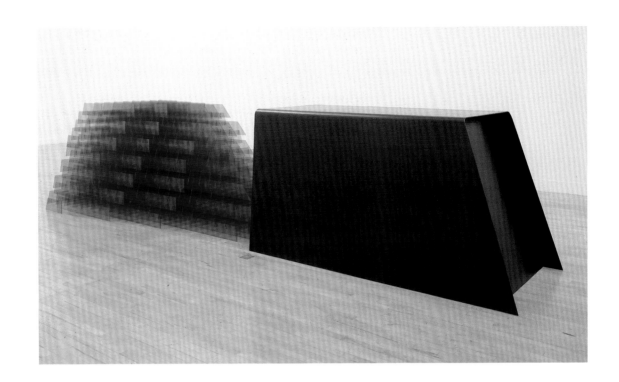

Alison Wilding
Red Skies 1992

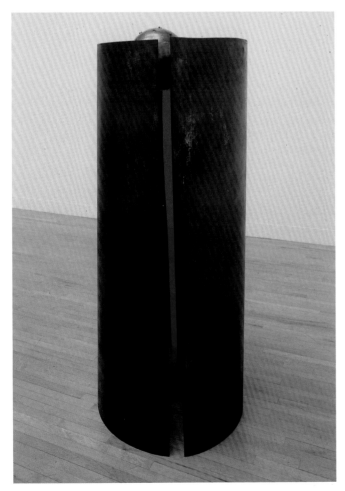

Rachel Whiteread 1993

Winner
Rachel Whiteread

Shortlisted artists
Hannah Collins for her strong representation at the Third International Istanbul Biennial, where she exhibited her series *Signs of Life*, and also for her retrospective exhibition at the Centre d'Art Santa Monica, Barcelona
Vong Phaophanit for his installation of *Neon Rice Field* at the Serpentine Gallery, London and at the Venice Biennale Aperto, and also for *Litterae Lucentes (Words of Light)*, an installation in the grounds of Killerton Park in Devon
Sean Scully for exhibitions of his work at Waddington Galleries, London, Mary Boone Gallery, New York, and for his major retrospective at the Modern Art Museum, Fort Worth
Rachel Whiteread for the continuing development of her work as shown at her retrospective exhibition at the Stedelijk Van Abbemuseum, Eindhoven, the Sydney Biennale, and Galerie Claire Burrus, Paris

Jury
Iwona Blazwick
Curator of exhibitions in Britain and abroad
Declan McGonagle
Director of the Irish Museum of Modern Art, Dublin
David Sylvester
Art historian
Carole Conrad
Representative of the Patrons of New Art
Nicholas Serota
Director of the Tate Gallery and Chairman of the Jury

Exhibition
3–28 November 1993
Prize of £20,000 presented by Lord Palumbo, 23 November 1993

In retrospect, 1993 can be viewed as a watershed for the Turner Prize, a year that saw a significant increase both in visitors to the exhibition and audience appreciation of the works on display. The prize became firmly established as a newsworthy event of national and international interest, despite the persistence of negative critical coverage. A number of critics were completely wrong-footed by the public's response to the shortlisted artists. Giles Auty, for example, erroneously claimed in the *Spectator* (20 November 1993, p.56) that:

> As an exercise in poor public relations both by the Tate Gallery and Channel 4, the Turner Prize as handled at present would be hard to improve upon. By now probably the only people who care which of this year's shortlisted artists will carry off the cash are the contestants themselves. In spite of the enormous efforts made each year to drum up public support for the prize, scepticism has become deep-rooted even among those who can be bothered to take an interest.

Some critics continued to attack the terms of the prize and complained about the prevalence of conceptual and installation art. Ironically, it was *Neon Rice Field*, the installation piece by Vong Phaophanit that, despite critical jeering, most impressed the public with its serene sensuality. Writing in the *Daily Telegraph* (10 November 1993, p.21) Stephen Pile argued that contemporary art, as seen in the Turner Prize, was nowhere near as weird and incomprehensible as traditional art in the National Gallery. He conducted a vox-pop in the exhibition and discovered that nobody found the works difficult at all:

> In fact, my vox-pop showed that visitors universally liked all four shortlisted artists. A helpful video at the door shows them discussing their work in a clear, unpretentious way and who are we to disagree with them? ... The uniformed attendants felt that the warm, red glow gave a strong sense of the lifeforce in this simple white foodstuff which sustains half the planet. That was absolutely my own feeling. Everyone enjoyed the uncomplicated beauty of this piece,

which combines a very simple, Zen elegance with the rather Western energy of strident red neon.

Other critics concurred that the work on display was more appealing than in recent years. Sue Hubbard concluded: 'This year I detect a sea-change. There is a new cohesion. The show is balanced, thoughtful, organic. Painting, photography, sculpture and installation are all represented, and each artist speaks with eloquence in his or her chosen medium' (*New Statesman and Society*, 12 November 1993, p.33). David Lillington admired the exhibition but recognised that it made the jury's task even more difficult: 'This year the absurdity of the choice has been given a kind of formal structure which drives it home with extra force. The judges have to compare a painter, an installation artist, a photographer and a sculptor. It's crazy. Still, it gives us something to talk about' (*Time Out*, 10–17 November 1993).

Significantly, a number of writers attempted to explain why there seemed to be such an increasing disparity between critical condemnation of Turner Prize artists and public appreciation. Richard Cork in *The Times* (23 November 1993, p.31) observed that:

> Knocking modern art, as hard and frequently as possible, is fast becoming a national media pastime ... Focusing on what artists do, they never bother to ask themselves why ... This month, the rice in Vong Phaophanit's installation at the Turner Prize exhibition is the latest focus for those bent on proving that contemporary art suffers from terminal cynicism or idiocy. Many of those who delight in reviling him probably have not seen the work, let alone pondered the mulitple meaning it conveys.

Cork blamed this attitude on Britain's unhealthy adherence to 'heritage culture':

> While our appetite for the hallowed past swells to addictive proportions, our response to the new is invariably begrudging. We mistrust the unfamiliar, preferring instead to reserve our enthusiasm for art already sanctified by time. It is as if the crisis

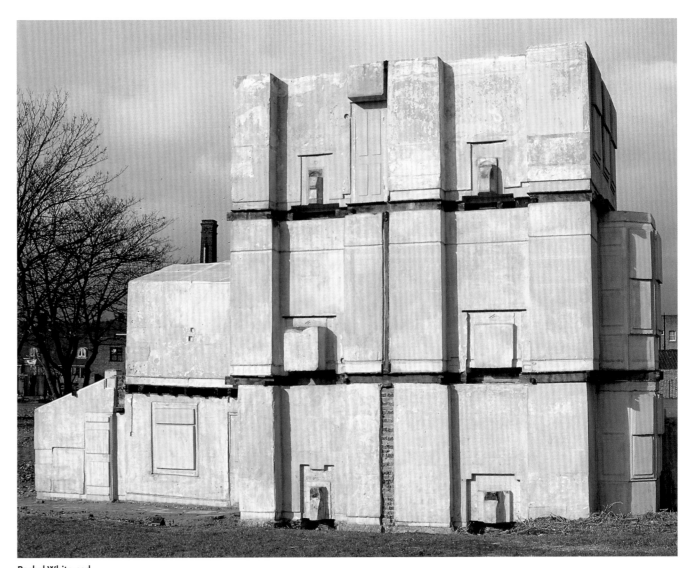

Rachel Whiteread
House 1993

1993

Rachel Whiteread
1963 Born in London
1982–5 Brighton Polytechnic
1985–7 Slade School of Art, London
1992–3 DAAD Scholarship in Berlin

afflicting Britain's post-imperial identity had made us seek reassurance in history, and shun contact with the disconcerting products of our own age.

For Andrew Graham-Dixon the problem was caused by the level of debate amongst critics writing on contemporary art:

If I had a pound for every time the question 'But is it art?' had been voiced in newsprint and on the air since the 1993 Turner Prize shortlist was announced, I might have made more money than Rachel Whiteread did last night when she won it. Public discussion of art, it may be said, is the last thing that the prize has promoted. Vituperation, spleen, the widening of rifts between the various bitter factions that make up the British art world and the endless asking of that same old question, 'But is it art?': these are what it promotes. But is that a reason to get rid of it? Perhaps not. The Turner Prize does serve an extremely useful function even if it was not the one it was originally intended to serve. It focuses attention on how almost primevally backward, how dull, how embarrassingly narrow-minded and ill-informed most discussion of contemporary art in this country remains.

He puzzled over why, unlike people in the rest of Europe, Britains continued to doubt whether art was art, or not, and concluded: 'Perhaps because it enables them to conceal a very British fear; the fear of responding to art, the fear of feelings (yuk) and a corresponding reluctance to articulate them. If you decide that something is not art at all then (phew) you are safe from all that.'

Rachel Whiteread won the prize in 1993. Public response to her enormously successful public sculpture *House* proved impossible for the jury to ignore, although technically the piece fell outside the previous twelve months. Its profundity and ability to speak to a wide audience confirmed her stature as an artist. Ironically, Whiteread was also awarded a prize of £40,000 for being the 'worst' artist in Britain by erstwhile pop band the KLF, now the K Foundation, who spent £200,000 publicising their

alternative Turner Prize which supposedly comprised a public ballot. David Lillington pointed out the flaws in the K Foundation's efforts as self-styled art terrorists: 'They give all the evidence of believing in prizes, in artists, in comparisons of quality, in grading it and rewarding it – they use the same grammar as the thing they attack. The Turner Prize will survive because groups like the K Foundation will keep it there. Besides, what they do won't stop these four artists being excellent at what they do' (*Time Out*, 10–17 November 1993).

Rachel Whiteread

Rachel Whiteread's work is based on taking casts from the most commonplace objects, but the results are very far from literal representations. Her sculptures are vaguely familiar, yet they are puzzling, almost surreal. That her sculptures are not casts of the objects themselves but of the space above, below, adjacent or inside, creates this sense of mystery. The artist has commented: 'I wanted to use things that already existed. I wanted to get inside them or beneath them and try to reveal something previously unknown ... One of the first pieces I made in rubber was *Untitled (Amber Bed)* [1991]. The piece spent some time slumped up against the wall in my studio. It had a very strange, almost human presence.'

By casting the areas around objects Whiteread gives form to the spaces we have inhabited, the spaces that have contained our existence. The casts are often redolent of childhood memories: 'There are always scary places, like the space under the bed or inside the wardrobe or the space in the angle between an open door and the wall. These places are scary but also slightly erotic – secret, hidden. The stuff you don't really know about at that age.'

Materials such as plaster and rubber play a crucial role in the transformations and metamorphoses that take place in Whiteread's work: a bath cast in plaster becomes a sarcophagus; a kitchen sink a baptismal font; the inside of a hot-water bottle a torso that somehow echoes the Cycladic figures which stand at the very beginnings of sculpture. Beds and mattresses take on a life of their own. The plaster works, with their characteristically

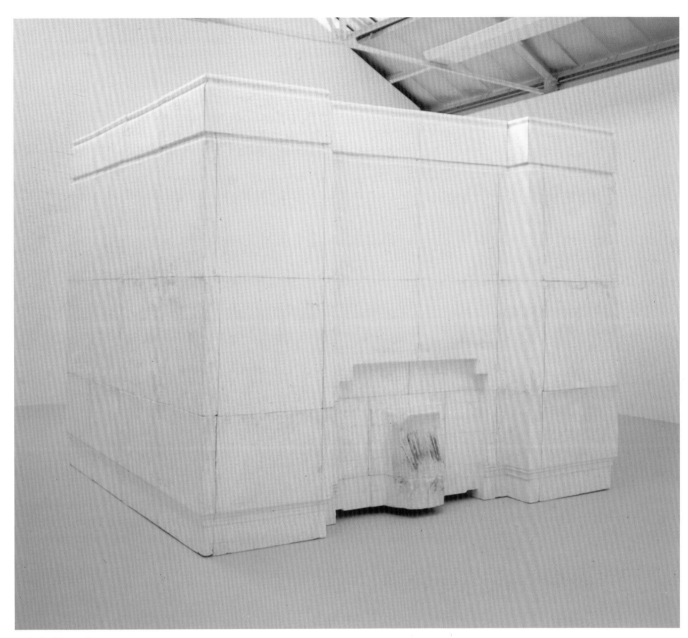

Rachel Whiteread
Ghost 1990

white, geometric block-like forms, have a visual severity that suggests the restrained aesthetic of Minimalism. Her work in rubber is more organic and sensual. In both media the response of the material to light is also important. Rubber in particular offers the artist a range of colours and degrees of translucency.

In the Turner Prize exhibition Whiteread was represented by *Untitled (Room)*, a new work shown for the first time. It was made in Berlin where she had been living and working on a DAAD (German academic exchange service) Scholarship. This sculpture was related to *Ghost* (1990), which first brought her to wide attention, but it also marked an important point of departure. *Ghost* was made from plaster casts of the four walls of the living room of a deserted 1930s terraced house in North London. Assembled with the positive side facing outwards they formed a room you could not enter, a room turned inside out. The new piece was also the cast of a room. However, it was not a found space but invented, constructed for the purpose in Whiteread's studio. Her aim was to create a room that was 'utterly standard ... just like a unit devised for people to survive in ... I wanted to make something fundamentally dull and basic'. *Ghost* was acclaimed for its monumentalisation of the mundane. Whiteread hoped that the effect of *Room* would be 'more monumental than *Ghost* – like a burial chamber or something you might find in an archaeological museum'.

Soon after she had been shortlisted for the Turner Prize in the summer of 1993 Whiteread commenced work on a project commissioned by Artangel in collaboration with Beck's beer. Preparations for the project, a public sculpture, had been in progress since 1991, although Whiteread had first conceived the idea when at art school. *House*, a cast of the interior of the last remaining house of a late nineteenth-century terrace in Grove Road, in London's East End, was completed on 25 October 1993. Although, strictly speaking, the work fell outside the year in question, the Turner Prize jury were unable to ignore the extraordinary impact of the piece, both nationally and internationally. From its completion to

its demolition, and well beyond, *House* became a focus for public debate about the role of contemporary art. Artangel summed up the artist's intentions: 'Like many public sculptures and memorials, *House* is a cast. But unlike the bronzes which commemorate triumphs and tragedies, great men and heroic deeds, this new work commemorates memory itself through the commonplace of home. Whiteread's *in situ* work transforms the space of the private and domestic into the public – a mute memorial to the spaces we have lived in, to everyday existence and the importance of home.'

Such was the level of public and media interest in *House*, particularly after the Turner Prize award, that Bow councillors revoked their decision not to extend the lease beyond November. The work was allowed to remain standing until the 12 January 1994, so that between five and eight hundred visitors per day could continue to experience the sculpture themselves. For many, *House* was a profoundly moving *momento mori* to individual lives and lost communities. It was praised by some critics as the most extraordinary and imaginative public sculpture made by an English artist this century. For others, it was a folly, another hoax in the style of Carl Andre's 'Bricks'.

Although she had fought to extend the life of *House*, at no point did Whiteread conceive of the project as an enduring monument: '*House* is to do with memory and ultimately it will become just that ... *House* makes a point about the smallness and fragility of the spaces we actually live in, worry about, decorate ... all those things that are a part of life.'

Hannah Collins

Hannah Collins is one of a significant number of artists who, since the 1960s, have adopted photography as their medium. She was represented in the Turner Prize exhibition by a group of works including several elements from a large installation made for the Third International Istanbul Biennial in 1992. Titled *Signs of Life* it continued her long-standing interest in the places occupied by those who exist on the margins or borders of society. In and around Istanbul she created a series of images focusing particularly on the city's role as a crossroads for refugees and economic

Hannah Collins
1956 Born in London
1974–8 Slade School of Fine Art, London
1978–9 Fulbright Scholarship in USA

Hannah Collins
Signs of Life (section)
1992

Hannah Collins
The Truth 1993

migrants moving from East to West. The artist was moved, for example, by the sight of an ex-Russian Army rubber boat being sold by Russian migrants in a street, 'an empty boat filled with air stranded on a dry city street' that evoked 'the edge of life and death'.

Collins has remarked that her work is 'both sculptural and pictorial'. It is often scaled to suit the environment, varying in size from one to thirty metres. The photographic images are mounted onto a variety of supports, including linen or cotton draped or hung like banners, and constructed metal panels are arranged as free-standing installations. The sculptural aspect of her work thus lies in its use of available space: 'I take into account space and there are different kinds of space at work: the space created by the piece, the space it occupies physically; how it relates to the public or private space in which it hangs.' This approach tends to produce a dramatic enhancement of the viewer's experience of the work, a dramatically enhanced realism.

Pictorially, Collins's work embraces the categories of traditional art: landscape and cityscape, interiors, still life, the figure. She frequently refers to the themes and imagery of the great art of the past. *The Truth*, for example, has connections with images of Mary Magdalen or Lady Godiva. But references of this kind are always secondary to the visual power and immediacy of her photographs, and to the meanings that they might suggest. Collins touches on many fundamental human issues: 'I am aware that social and political truths are embedded in my life and that these are reflected in the content of my work.' The artist has said that her art explores the interface between personal history and the specifics of the culture in which she finds herself, and she stresses that 'the work is dependent upon the cultural milieu from which it emerges ... the most important thing for me is that my work develops deep links with the environment in which it is made'.

Vong Phaophanit

Vong Phaophanit has said of his installation pieces: 'The work is based on ... no rules, except perhaps a new subjectivity ... if there is an object, an aim, it is to start from a point and lead

outwards from there.'

The meanings of Phaophanit's art are inevitably related to his particular origins and background, but they are equally related to the traditions of art in his adopted culture and to his life as an artist living in Britain. He was born in 1961 in Laos, a former French colony. At the age of eleven he left to be educated in France and remained there after Laos ceased to be a constitutional monarchy and became the People's Democratic Republic of Laos in 1975. From 1980 to 1985 he attended the art school at Aix-en-Provence.

Phaophanit's art is immediately striking for its choice and use of such materials as rice, rubber and bamboo, and for the role played in it by light. All the elements of his works are bound together into a whole whose effect is purely aesthetic. But, produced on a large scale in South-East Asia, his materials are loaded with cultural, historical and economic significance. The artist neither denies nor asserts these meanings, using his materials, as modern sculptors have done from Brancusi onwards, to explore both their aesthetic possibilities and to create a potentially symbolic or metaphoric statement.

In the summer of 1993 he made a work outdoors at the National Trust property, Killerton Park, an eighteenth-century landscaped estate. On a long, red-brick wall of the kitchen garden, in front of which had been planted a grove of bamboo and palm trees, he placed nine Laotian words fashioned in red neon. He titled the work in Latin, *Litterae Lucentes (Words of Light)*, but deliberately withheld the meaning of the Laotian words. As well as emphasising the visual qualities of the piece this also drew attention to the politics of language. Phaophanit points to the annexation of the exotic plants, their importation into England where they are named in Latin. 'To name', he says, 'is to possess, to own, to control.' By denying us access to the meaning of his words he presents them deprived of that inimical power to name.

For the Turner Prize exhibition Phaophanit made a new variant of *Neon Rice Field*, one of a series of such fields that had impressed the jury during the previous year. Neon light placed just beneath the surface of translucent rice grains, arranged in furrows, produced

Vong Phaophanit
1961 Born in Laos (since 1975 People's Democratic Republic of Laos)
1972 Educated in France (until 1985)
1980–5 Ecole des Beaux-arts, Aix-en-Provence
1985 Moves to Britain

Vong Phaophanit
Neon Rice Field 1993

Vong Phaophanit
Litterae Lucentes 1993

1993

Sean Scully
1945 Born in Dublin;
family moved to
London shortly after
1965–8 Croydon
College of Art
1968–72 University of
Newcastle upon Tyne
1972–3 Harvard
University,
Cambridge,
Massachusetts
1975 Moved to USA

a beautiful, seductive glow. Much of Phaophanit's work depends on on the 'interactions of materials'. *Neon Rice Field* brings together two disparate things, one natural and organic, the other manufactured. The result is rich in both its physical presence and 'possibilities of meanings'.

Sean Scully

Since about 1980 Sean Scully has set out to make his own contribution to the tradition of abstract painting which aims to represent the spiritual. He has said: 'I am interested in art that addresses itself to our highest aspirations. That's why I can't do figurative paintings – I think figurative painting is ultimately trivial now.' He also believes strongly that abstract art can be more, not less, accessible than representational art: 'Abstraction's the art of our age … it allows you to think without making oppressively specific references, so that the viewer is free to identify with the work. Abstract art has the possibility of being incredibly generous, really out there for everybody. It's a non-denominational religious art. I think it's the spiritual art of our time.'

Scully's spirituality is of the muscular variety. His earliest mature work featured grids of narrow stripes of brilliant colours. By the early 1980s the stripes had broadened out in the manner which he continues to use, and the paintings had become often very large constructions of separate panels, each in fact an individual canvas on a massively constructed stretcher. In some cases panels of different depths were brought together, creating effects of relief. With their combinations of vertical and horizontal striped elements these works have a powerful, almost architectural or sculptural presence, for some commentators even evoking ancient sacred monuments such as Stonehenge. The stripe is Scully's image; he sees it as a neutral form which can be made to carry various meanings. He uses stripes as the building blocks with which he can continue to explore the types of structure underlying some of the greatest art of the past, 'the large structures that represent us and our culture for all time'.

The origins of his paintings are deeply personal but, Scully emphasises, they 'are not just about me. I want them to address something larger. So I don't feel a painting is finished until it has a strong identity of its own, apart from mine. I'm not interested in self-expression'.

Around 1980 he began to change his application of paint, abandoning acrylic paint for traditional oil, mixing pure colours with old-fashioned earth hues – umbers, ochres and siennas. In this way he developed a distinctive palette of rich, brooding colour. Brushing his colours on in layers, using large Italian house-painters' brushes, he creates strongly textured surfaces. He usually uses a number of brushes on the same painting 'so the work is about different surfaces at different times'. Colours glow through from one layer to another, increasing the richness and complexity of the painting. For the lower layers the paint is mixed with a resin medium which speeds drying. But for the surface layers he uses the sumptuous medium of stand-oil – viscous heat-treated linseed oil. This, he says, 'makes the paint sexy', giving it a lot of body but also 'a slight translucency'.

Winner
Antony Gormley

Shortlisted artists
Willie Doherty for his video and photographic installations including work shown at Matt's Gallery, London, the Arnolfini Gallery, Bristol, the Douglas Hyde Gallery, Dublin and the Centre for Contemporary Art, Warsaw
Peter Doig for his exhibition of painting at the Victoria Miro Gallery, London, and for his strong contribution to a number of group exhibitions including *Unbound* at the Hayward Gallery, London, and John Moores Liverpool Exhibition 18 at the Walker Art Gallery
Antony Gormley for exhibitions of his sculpture including *Field* seen at the Malmo Konsthall, Tate Gallery Liverpool and the Irish Museum of Modern Art, Dublin, and for his contribution to several group exhibitions including *Ha-Ha* at Killerton Park, Devon
Shirazeh Houshiary for exhibitions of her sculpture and drawings, notably at the Second Tyne International, Newcastle upon Tyne, Camden Arts Centre, London, the Art Gallery of York University, Ontario and the University Gallery, University of Massachusetts, Amherst

Jury
Marjorie Allthorpe-Guyton
Director of Visual Arts, Arts Council of England
Roger Bevan
Representative of the Patrons of New Art
Jenni Lomax
Director, Camden Arts Centre, London
Milada Slizinska
Curator and art historian, Centre for Contemporary Art, Warsaw, Poland
Nicholas Serota
Director of the Tate Gallery and Chairman of the Jury

Exhibition
2 November–4 December 1994
Prize of £20,000 presented by Charles Saatchi, 22 November 1994

Antony Gormley
Testing a World View
(detail) 1993

It was widely reported that the shortlist for 1994 was relatively 'safe'. Antony Gormley won the award for his installations of *Field*, which had captivated the British public throughout the year. Sadly, the scale of *Field* prohibited its display in the Turner Prize exhibition. None of the artists was scandalously under the age of thirty, and none of them worked with tabloid-tempting materials such as rice or animal carcasses. But the public continued to visit the Turner Prize exhibition in their thousands, and although the press faithfully resorted to generating controversy about contemporary art, there was a notable trend towards more serious discussion of the artists' work. One critic even welcomed what he thought might be the end of controversy for its own sake: 'The adversaries supply the contempt and the copy that creates the 'controversy' which keeps the Turner Prize a hot topic ... But after years of watching the same clique slug it out, battle fatigue has set in. Sorry, boys, but we've been there and debated that one time too many. It's time to call a truce and cut out all the clapped-out talk about controversy. For once, let's see what's on show' (Cosmo Landesman, *Sunday Times/Culture*, 27 November 1994). Some critics found the inclusion of a painter, Peter Doig, the most 'deviant choice' on the shortlist because the last painter to win the award had been Howard Hodgkin in 1985. Painters had in fact been shortlisted almost every year since the inception of the prize.

A few critics noted that the exhibition had expanded by one room with an additional area given over to information including the profile films made by Illuminations for Channel 4, a reading desk and explanatory wall texts. Richard Cork in particular commented on the improved presentation (*The Times*, 8 November 1994, p.33):

The 1994 exhibition deserves a welcome. As if to celebrate the coming-of-age of a prize now a decade old, this year's survey is given more space than before. The first room is devoted entirely to information about the artists, with the help of television monitors, relevant publications and seating for anyone who wants to linger and study. It establishes the right

mood for the show, where every exhibitor enjoys a handsome arena clearly separated from the other artists.

As well as providing more information for visitors to the exhibition in London, in a new initiative to engage audiences around the country, the artists' films were shown in seven regional galleries in conjunction with related public events.

On the night of the award ceremony a group of artists, designers and architects gathered at the gates of the Tate Gallery with placards bearing their own works. Taking advantage of media coverage of the event, this protest organised by FAT (Fashion, Architecture and Taste) aimed to display what was excluded from the Turner Prize and to convey frustration with the ways in which art is administered and promoted.

Antony Gormley

Anthony Gormley has been widely credited with making a substantial new contribution to the western tradition of sculpture of the human body. Since the early 1980s he has used his own body to make sculptures that explore the human experience of being in the world. His work meditates on the relationship between our physical and spiritual selves, a duality that has preoccupied philosophers and artists since the beginning of civilisation.

In 1981, assisted by his wife, the painter Vicken Parsons, Gormley began to make moulds from his body which he used as the basis for lead body cases. The process is demanding as Gormley has to maintain a pose whilst he is first cast in plaster: 'I am trying to make sculpture from the inside, by using my body as the instrument and the material. I concentrate very hard on maintaining my position and the form comes from this concentration' (*Antony Gormley*, exh. cat., Tate Gallery Liverpool 1993, p.20). Although he continues to work with cases Gormley has since gone on to make solid forms, which aim to make physical the experience of the space within the body.

Between 1993 and 1994 Gormley's more recent work was shown in a touring exhibition involving Malmo Konsthall, Tate Gallery Liverpool and the Irish Museum of Modern Art, Dublin. Two works from this show, *Testing a World*

Antony Gormley
1950 Born in London
1968–70 Read
archaeology,
anthropology and art
History at Trinity
College, Cambridge
1973–4 Central School
of Art and Design,
London
1974–7 Goldsmith's
College, London
1977–9 Slade School
of Art, London

Willie Doherty
1959 Born in Derry,
Northern Ireland
1977–81 Degree in
Fine Art,
Ulster Polytechnic

View and *Sense*, were displayed in adjacent rooms at the Tate Gallery for the Turner Prize exhibition. Gormley has described *Testing a World View* as a sort of 'psychological Cubism'. It comprises five identical, solid iron figures awkwardly bent at the waist to form right angles. Gormley arranges the sculptures in different configurations each time the work is installed, so that they seem to 'test' themselves against the architecture. In this way, 'the piece expresses the polymorphousness of the self; that in different places we become different. If Cubism is about taking one object and making multiple views of it in one place, this is a dispersion of one object into several cases for itself' (ibid, p.48). For the artist the right-angled pose of the body introduces a psychological dimension, suggesting the 'body in crisis'. 'Flung around the room' they demonstrate the current crisis of confidence in the Western world view (*Antony Gormley*, exh. cat., Museum of Modern Art, Ljubljana 1994, p.6).

The iron figures that make up *Testing a World View* are generalised representations of the human body, occupying an architectural space. *Sense* belongs to a series of concrete sculptures in which Gormley seems to have inverted this condition. Inside a concrete block he leaves the precise impression of his body, so that the block describes the space between the body and a compressed notion of architecture. The imprint of his body, seemingly once trapped or encased within the concrete, reminds the viewer of the vulnerability of flesh. On confronting these works several critics have called to mind the shadow traces of human bodies on the walls left standing at Hiroshima. But, for Gormley, they have more positive implications. *Sense*, for example, explores the experience of sensation which the artist defines as, 'an awareness of being and an awareness of being in space' (ibid., p.5). In this work the western concept of space, as something contained and quantified by geometry or measurement, is turned on its head: 'What *Sense* expresses is the way in which the imaginative space inside the body, the darkness of the body, connects with outer space – deep space' (ibid., pp.5–6). Gormley has expressed a concern for the fragility of the earth,

particularly its 'living edge' or 'skin', the biosphere. In different ways both *Testing a World View* and the concrete blocks suggest the fundamental nature of our engagement with the earth and challenge our complacency towards it.

Perhaps the most notable of Gormley's works of this period was *Field*, an extraordinary installation first made in 1989. A recent version, *Field for the British Isles*, was made in collaboration with families and artists from the local community in St Helen's, and Ibstock, a local brickmaking company. Collectively they produced approximately 40,000 hand-sized clay figurines. The exact shape and scale of each figure were determined by the person making it. The artist has stressed the importance of the communal experience of producing the work: 'The makers are also the work's first audience and it is not like the audience of a spectacle. It's more like a collective experience of active imaginative involvement' (*Antony Gormley*, exh. cat., Tate Gallery Liverpool 1993, p.52). *Field* is viewed from the threshold of a room that cannot be entered. When we confront the work it returns our gaze. This has the uncomfortable effect of making us, and not the figures, the subject of the work.

There are many ways in which *Field* can be understood. Perhaps the most poignant interpretation is that this 'ocean of humanity' demonstrates our existence in the world both as individuals and collectively as the human race.

Willie Doherty

Willie Doherty is one of an increasing number of artists who work with the camera. From the late 1980s his main subjects have been Derry and its surrounding countryside. Derry, also still known by its 'colonial' name of Londonderry, was the site of some of the key events in the present phase of the Irish 'Troubles' – the 1968–9 protests by Catholics demanding civil rights, and the 1972 'Bloody Sunday' when thirteen civilians were killed by British troops at the end of an anti-internment rally. In 1991 Doherty commented: 'I am writing from a place with two names, Derry and Londonderry. The same place. Here things are never what they seem and always have more than one name. To understand this duality is to begin to

Willie Doherty
*The Only Good One is
a Dead One* (detail)
1993

Willie Doherty
Border Incident 1993

1994

Peter Doig
1959 Born in Edinburgh
1966–79 Lived in Canada (moved to London in 1979)
1979–80 Wimbledon School of Art, London
1980–3 St Martin's School of Art, London
1989–90 Chelsea School of Art, London
1994– Trustee of the Tate Gallery

understand how this place functions and how lives are lived here. Failure to recognise this duality is to miss the essential dynamic of what has been called a microcosm of the Northern Irish problem' (Willie Doherty, *Camera Austria*, 1991, no.37, p.11).

As a result of the 'Troubles' Derry has become one of the most photographed cities in Europe. But photographic documentation of the war in Northern Ireland has consisted largely of clichéd images. Picturesque photographs of victims and bomb-damaged buildings have only served to simplify events. In the late 1980s the introduction of media censorship made Doherty acutely aware of how opinions and events are influenced by media coverage. 'In this place with two names the paradox of difference easily collapses into misrecognition and is most easily described by the overdetermined language of "mindless violence" and "terrorism", which have become the only words available to the Press, in the absence of real political dialogue' (ibid). Doherty's work offers a critical response to such distorted documentation.

Doherty was represented in the Turner Prize exhibition by a double screen video installation *The Only Good One is a Dead One*, which toured several venues between 1993 and 1994. The phrase 'innocent victim' is much used in media reports of sectarian violence. In *The Only Good One* … Doherty questions the meaning of this phrase within the particular context of Northern Ireland. In Derry, Catholics and Protestants have grown up in an atmosphere of mutual suspicion. Simply being a member of the opposite community somehow imputes guilt. Doherty comments on this 'war of the mind', but he does so without taking sides. Both videos were shot at night. One shows the view from a car parked in an urban street, the other the view from the windscreen of a car driving down an isolated country road. The videos were filmed in actual time using a hand-held recorder suggesting that the narratives at play are 'real'. A soundtrack comprising a monologue accompanies the work. In it a man imagines being both the victim and perpetrater of a terrorist act of violence. Thus Doherty illuminates the shared human experience of living in a state of

war. He also invites investigation of how this psychological condition is constructed. His work comments, for example, on the constant presence of surveillance, which increasingly affects all levels of social exchange.

Peter Doig

Peter Doig's paintings first attracted attention in 1991 when he won the Whitechapel Art Gallery's Artist Award.

The tension between the narrative or representational content of painting and its purely visual, decorative and abstract qualities has remained a central issue for modern art. Part of the significance of Doig's work is that he has found a distinctive way of balancing these two elements. .

The dominant subject of Doig's paintings has been the traditional theme of man in nature. But his works draw on diverse references ranging from paintings by landscapists in the western tradition, such as Edward Hopper and Claude Monet, to newspaper photographs, stills from films such as *Friday the Thirteenth*, banal postcards and travel brochures. Such sources act as 'triggers' for his memory and imagination. The surfaces of his paintings often comprise a fusion of intricate layers, skeins, and blobs of paint. The sheer visibility of the stuff of paint, which rarely translates in reproduction, serves to interrupt the narrative themes suggested by the image. This interplay of form and content produces a type of imagery that can evoke a strong response, bordering between attraction and repulsion.

In the Turner Prize exhibition Doig was represented by two snow scenes, *Pond Life* (1993) and *Ski Jacket* (1994), and three paintings from a series based on Le Corbusier's *Unité d'Habitation* at Briey-en-Forêt in France. The first *Unité d'Habitation* was completed in 1952 in Marseilles, an eighteen-storey block of flats which Le Corbusier hoped would become a standard type for postwar low-cost housing. The *Unité* in Briey, built in 1957, was vacated in the 1970s and narrowly escaped demolition. Doig was drawn to the building by its peculiar setting. Located in a wood, this monument to modernist aspiration is almost engulfed by the natural environment. The menacing power of

Peter Doig
Cabin Essence 1993–4

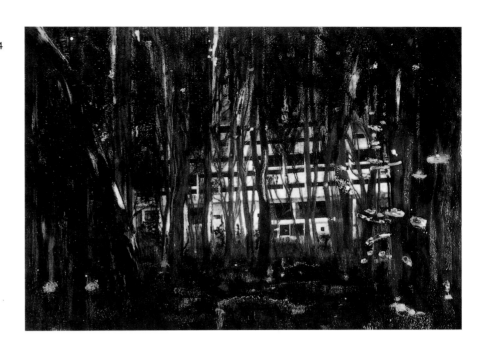

Peter Doig
Ski Jacket 1994

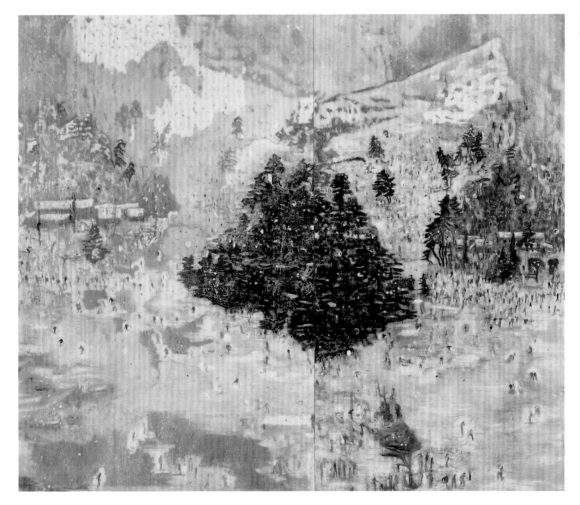

nature is strongly conveyed in Doig's paintings of this motif: for example, *Cabin Essence* of 1993–4 shows the building screened by a wall of impenetrable trees which recall the claustrophobic, prison bar trees depicted by the forerunners of the *fin de siècle* Symbolist movement, Edvard Munch and Vincent van Gogh.

Seemingly random splatterings of white paint are visible on the surfaces of these pictures. According to Doig these marks refer us back to the picture's beginnings, 'to the nothingness of painting – in just the same way as the whiteness of Corbusier's *Unité* represents negative space' (Paul Bonaventura, *Artefactum*, vol.11, no.53, Sept. 1994, p.15). The white paint could represent light reflected off the building, but it also visually disrupts the surface, preventing the depicted image from slipping into naturalism.

Doig constantly strives towards rendering the tension between the extremes of fact and fantasy. But, at root, his works emanate from an excitement with the substance of paint as a medium of visual expression.

Shirazeh Houshiary

For Shirazeh Houshiary imagination is the 'creative force of the universe'. Without it there is no existence. Art is an activity located in the realm of the imagination, and through art the artist documents his or her own path towards self-knowledge: 'An artist is someone who is capable of unveiling the invisible, not a producer of art objects' (Stella Santacatterina, Conversation with Shirazeh Houshiary, *Third Text*, no.27, Summer 1994, p.78). Her sculptures, paintings and drawings develop over a long period, informed by Sufi poetry and ancient writings from East and West on subjects including mathematics, philosophy, religion, art and astronomy.

Houshiary's world view is largely inspired by the poetry of Jalalu'ddin Rumi, the thirteenth-century Sufi mystic. 'Sufism' means 'the way' or 'the path', a way of being in the world and having contact with the centre of one's being. This quest for self-knowledge is common to most world religions. Houshiary believes that shared truths have been gradually clothed in a variety of external forms, which obscure the underlying unity of human experience. From the late 1980s onwards her work has gradually focused on geometric shapes, notably the square, circle, triangle and cross.

A five-part sculpture, *The Enclosure of Sanctity* (1992–3), and five recent paintings were Houshiary's contribution to the Turner Prize exhibition. The paintings were selected from a group of works depicting a square orbiting inside a circle. The delicate images were made by repeatedly drawing a Sufi chant in Arabic using pencil on matt black or white grounds. The squares are divided into patterns of light and dark. In many cultures the square symbolises the Earth and its four elements of earth, water, wind and fire, while the circle denotes Heaven. The union of the square and the circle therefore suggests the union of Heaven and Earth.

A belief in the interconnectedness of all life underpins *The Enclosure of Sanctity*, which hinges on the interplay between light and dark, the forms for the expression of the divine in Sufi writing. *The Enclosure of Sanctity* comprises five lead cubes installed according to precise measurements. The cubes evoke a planetary system, the central cube representing the sun, around which orbit Mercury, Venus, the moon and Mars. Planets, which we think of a spheres, are visualised as cubes. But the square, as Houshiary has demonstrated in her paintings, is fundamentally related to the circle: when it spins it creates a sphere in space. In this way the circle and the square demonstrate both the distinctiveness and the sameness of all life.

Inverse pyramids have been removed from each cube, and the remaining internal spaces divided by grids corresponding to numbers with which each planet is identified. Copper, gold and silver leaf, applied to certain segments of the grids, further enhance the uniqueness of each cube. Houshiary has written: 'Through studying these cubes, we can realise the multiplicity of the state of existence. We will understand that at every moment, our human individuality is only one of these states of existence, and to unveil these is to know the real centre' (statement accompanying Houshiary's exhibition at Camden Arts Centre, London, 1993).

Shirazeh Houshiary
1955 Born in Shiraz, Persia (Iran)
1976–9 Chelsea School of Art, London
1979–80 Junior Fellow, Cardiff College of Art

Shirazeh Houshiary
*The Enclosure of
Sanctity* 1992–3

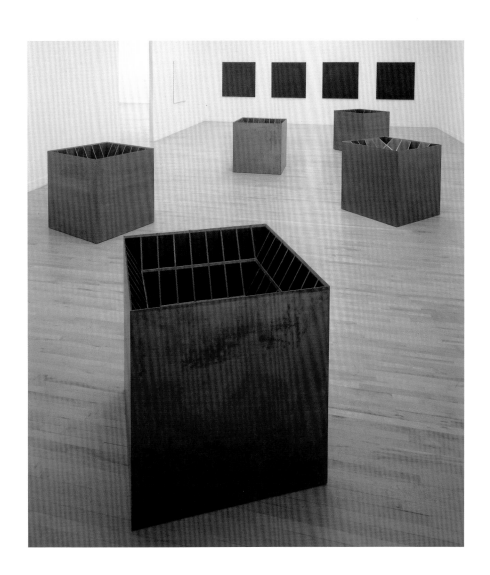

Shirazeh Houshiary
*The Enclosure of
Sanctity* (detail)
1992–3

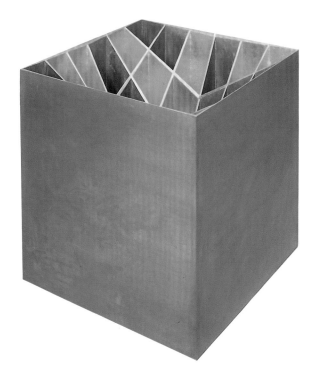

Damien Hirst 1995

Winner
Damien Hirst

Shortlisted artists
Mona Hatoum for her exhibitions at the Centre Georges Pompidou, Paris, and at White Cube, London, and her contribution to a number of group shows in Britain and abroad
Damien Hirst for his curatorship of and his own contribution to *Some Went Mad, Some Ran Away*, a touring exhibition which opened at the Serpentine Gallery, London, and for other presentations of his work in Britain and abroad
Callum Innes for exhibitions of new paintings at the Frith Street Gallery, London, the Angel Row Gallery, Nottingham, and most recently at the Galerie Bob van Orsouw, Zurich
Mark Wallinger for the exhibitions of his work at the Ikon Gallery, Birmingham, and the Serpentine Gallery, London

Jury
William Feaver
Art critic, *Observer*
George Loudon
Representative of the Patrons of New Art
Elizabeth Macgregor
Director of the Ikon Gallery, Birmingham
Nicholas Serota
Director of the Tate Gallery and Chairman of the Jury

Exhibition
1 November–3 December 1995
Prize of £20,000 presented by Brian Eno, 28 November 1995

Damien Hirst
Mother and Child,
Divided 1993

The 1995 Turner Prize exhibition attracted unprecedented numbers of visitors who queued daily to see the work of the shortlisted artists. Many were curious to see Damien Hirst's *Mother and Child, Divided* which created a tidal wave of tabloid excitement: 'Have they gone stark-raving mad? The Turner Prize for Modern Art (worth £20,000) has gone to Damien Hirst, the 'artist' whose works are lumps of dead animals ... Modern art experts never learn. But, perhaps they are smart, since they make huge profits out of garbage – and now dead animals' (*Sun*, 30 November 1995). The notoriety of the piece was unwittingly increased when the exhibition opened temporarily without it.

There seemed to be no middle ground as far as critical response to Hirst's work was concerned: was he a contemporary genius or arch hoaxer intent on conning the public? John McEwan summed up the opposition in the *Sunday Telegraph* (3 December 1995):

If Damien Hirst is anything, he is the ring-master of of his own career – on to his next trick, his next sensation, before the audience starts to think. There are the freak shows of the animals, the jolly paintings, his beaming self.

Whereas Richard Dorment in the *Daily Telegraph* (6 January 1996) articulated the relevance of Hirst's work for the present:

Hirst's work acknowledges a buried sense of loss and longing for completeness that some psychoanalysts believe is universal. That this was the artist's intention seems to me clear from the title, which refers not to a cow and newborn calf, but to a mother and a child. Instead of sweeping aside our twin fears of being alone and of dying, Hirst makes it impossible to turn away from either.

Some acknowledged Hirst's claim to the prize, despite the calibre of the other contenders: 'Damien Hirst should have won the Turner Prize when he was nominated for it three years ago and I'm glad he's won it now. No one has done more to raise the profile of contemporary British art at home and abroad – and by his outrageously ambitious art works and energetic ease at dipping and dodging

between the role of artist, curator, film director and media maverick, he's fired an entire generation with the belief that even in the frosty climate of the British art world, anything's possible' (Louisa Buck, *Independent*, 29 November 1995, p.3).

Members of the public were either moved or disgusted by *Mother and Child, Divided*: few remained indifferent and many voiced their opinions to the Tate Gallery and newspaper editors. One punter, for example, wrote passionately in Hirst's defence to the *Daily Telegraph* (Mark Sutton, letter to the editor, 2 December 1995):

I was disappointed by your editorial on the award of the Turner Prize to Damien Hirst ('A Turner for the Worst', November 29). One of the briefs of the Turner Prize is to draw attention to artists who have best raised the profile of British art, whether at home or abroad. Hirst has clearly done that. His work is shown, respected and bought by art-lovers and collectors all over the world, and is one of the reasons why contemporary art is enjoying more attention now than it has in three decades. For that alone he deserves recognition.

Art, like beauty, is in the eye of the beholder. Whatever my own opinion of Hirst's work, to say that it 'has the artistic merit of a bucketful of spittle' is to abrogate critical responsibility. I recently saw some of his work at an exhibition in the Serpentine Gallery, where it resulted in a great deal of interest, enjoyment, amazement, revulsion and argument from my fellow viewers. To fire up such a range of emotions – whether we like the work or not – is one of the primary functions of art; and the level of heated interest aroused by Hirst's work is a measure of his success at doing that. The point of the Turner is not to satisfy all tastes, which it could never hope to do. Its value is to stimulate debate and to encourage the public in this country to treat art as a serious issue about which we can hold serious opinions. As your Leader shows, this year it has at least done that. I suggest that your readers do not listen to the opinions of your paper, the art critics

112

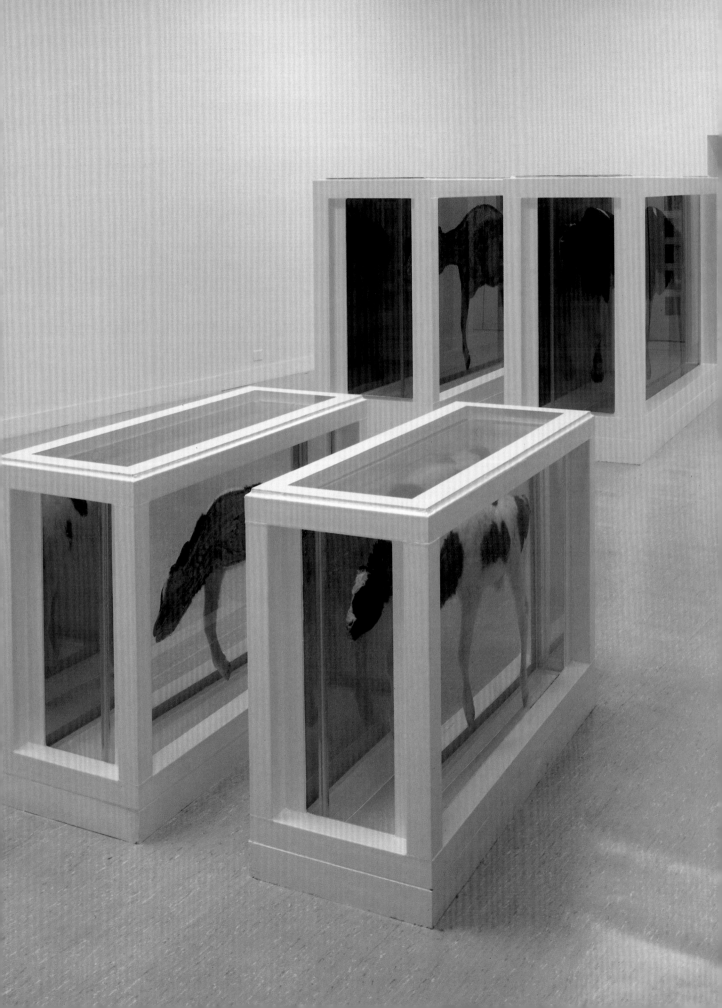

or myself, but go out and visit galleries and decide what type of art they like for themselves – since that ultimately is what art is about.

As one of Hirst's natural history pieces which make use of dead animals, *Mother and Child, Divided* enraged and upset animal rights protestors. When Hirst won the prize one protestor wrote in complaint to the *Evening Standard*: 'I must express my disappointment at the moral bankrupcty of the judges of the Turner Prize. However you view the exhibit, it increased the demand for dead animals by two, created unnecessary death and cheapened the life of a mother and child. Justice may yet be done should the artist be reincarnated as a dairy cow' (Paul Gaynor, *Evening Standard*, 1 December 1995, p.45). Hirst was himself in sympathy with the protestors as one of the aims of the piece was to provoke people into thinking about the way animals are treated. He had not slaughtered the animals in the name of art, but had acquired them from a knacker's yard where they had died of natural causes.

Hirst was not the only artist to excite the tabloid press. Mona Hatoum's video installation *Corps étranger* gained particular notoriety as it comprised an endoscopic and coloscopic film inside the artist's own body.

Damien Hirst

Since the late 1980s Damien Hirst has produced a body of highly memorable works which have intensified critical debate about the nature of contemporary art. The impulses driving his work derive from the dilemmas inherent in human existence: 'I am aware of mental contradictions in everything, like: I am going to die and I want to live for ever. I can't escape the fact and I can't let go of the desire.' One of his aims has been to 'make art that everybody could believe in' (Damien Hirst quoted in *Damien Hirst*, exh. cat., ICA 1991, p.7). This has sometimes involved using provocative materials – blood, flies, maggots, dying butterflies and dead animals. But he 'uses shock almost as formal element ... not so much to thrust his work in the public eye ... but rather to make aspects of life and death visible' (quoted in Jerry Saltz, *Art in America*, June 1995, p.83).

Hirst's most successful works have an immediate impact, physically communicating a thought or feeling. Brutally honest and confrontational, he draws attention to the paranoic denial of death that permeates our culture. His investigation into the traditional theme of mortality is not, however, intentionally nihilistic. On the contrary, recognition of the human condition allows life without fear: 'The horrible things in life make the beautiful things possible and more beautiful' (*Damien Hirst*, exh. cat., ICA 1991). Hirst is fascinated by systems: his own *oeuvre* is in fact organised into groups of work that address basic anxieties and desires. Most notable is a series of sculptures known collectively as *Internal Affairs*, which seem to consider the dichotomy between mind and body and the coexistence of life and death. Staging objects within steel and glass chambers or vitrines, the artist conveys a sense of human presence or narrative. One such work, *The Acquired Inability to Escape* of 1991 comprises two sections, the largest containing a table, chair, cigarettes, lighter, ashtray and stubs, the smaller remaining numbingly empty. For Hirst, the cigarette is a multi-layered symbol suggesting beauty, luxury, danger and death. Here, his addiction to smoking can be interpreted as a metaphor for decadence, a kind of bittersweet pleasure in hastening death.

The Acquired Inability to Escape marked the beginning of Hirst's interest in the division of space as a means of intensifying the emotional impact of his work. His steel and glass chambers refer to the aesthetic of Minimalism, established in the 1960s and reworked in the 1980s by artists such as Jeff Koons. At the same time they echo the claustrophobic, cubical frames depicted in the paintings of Francis Bacon, encasing nightmarish, fleshy images of man and beast. Hirst's chambers arose 'from a fear of everything in life being so fragile ... I wanted to make a sculpture where the fragility was enclosed. Where it exists in its own space. The sculpture is spatially contained' (*Minky Manky*, exh. cat., South London Gallery 1995). In more recent years he has divided and sometimes inverted these works, slicing the chambers in half, infiltrating the airtight vitrine with a band or gap of gallery space,

Damien Hirst
1965 Born in Bristol
1986–9 Goldsmiths' College, London
1992 Shortlisted for Turner Prize

Damien Hirst
Amodiaquin 1993

and turning the objects upside down.

Rigorously minimal structures and attention to spatial relationships are used effectively in Hirst's controversial *Natural History* series. *Mother and Child, Divided*, shown in the Turner Prize exhibition, unites the compelling power of the extraordinarily visceral *Natural History* sculptures with the formal concerns developed in other works. This piece comprises a cow and calf, each bisected, the four halves displayed in separate tanks of formaldehyde solution. The tanks are placed so that the viewer can pass between the divided animals, closely examining the exposed entrails and flesh pressing against the glass. For some, this is disturbing, even repulsive. For others it generates a melancholic empathy.

Mother and Child, Divided was first exhibited in 1993 at the Venice Biennale, where its subject was peculiarly poignant and provocative. Venice, in particular, is a treasure trove of High Renaissance images of the gloriously fecund Madonna nursing the holy infant. The relationship between mother and child remains sacred in Catholic culture and in Italy agitation surrounding the issue of birth control and abortion is highly charged. Characteristically devoid of sentiment, Hirst strips the closest of bonds between living creatures to its starkest reality. The title denotes the slicing of the animals, but also points to the the separation of mother and offspring. Isolation has been one of Hirst's abiding themes.

Hirst also exhibited two recent paintings from his series of 'spot paintings' – white canvases in a variety of shapes and sizes, covered with a slightly de-registered pattern or grid of coloured circles. Within each painting the spots are the same size, their colour arbitrary: 'The grid structure allows no emotion. I want them to look like they've been made by a person trying to paint like a machine ... I liked the way you could create this formal way of making a painting, and that I could do it for the rest of my life. I like this idea of a created painter, the perfect artist' (*Damien Hirst*, exh. cat., ICA 1991, p.9 and *Minky Manky*, exh. cat., South London Gallery 1995).

The coloured circles are reminiscent of sweets or pills, a likeness endorsed by the pharmaceutical stimulants or narcotics which give their name to each painting.

Hirst perceives medicine as a belief system: 'I can't understand why some people believe completely in medicine and not in art, without questioning either' (ICA, p.1).

Through his activities as artist and curator Hirst is one of the most influential artists of his generation. Gordon Burn has attempted to sum up his contribution: 'The fact that generosity of intention and dark energies can coexist in the same nature; the fact that individuals can – are fated to – live lonely, even desperate lives, within otherwise mutually sustaining partnerships. These are the great imponderables – the fundamental splits, dualities and twinnings – that ... it has come Damien's turn to investigate. That he brings to his inquiry such a brilliant, sordid, uncompromising and twisted imagination, is our good fortune' (Gordon Burn, *Damien Hirst*, exh. cat., Jablonka Galerie, Cologne 1994).

Mona Hatoum

Mona Hatoum first became known in the early 1980s for a series of remarkable performance pieces. Towards the end of that decade her practice had shifted from 'live' works to video, installation and sculpture, although these apparently disparate areas of her work continue to feed into one another. She has commented that 'in the process of developing a piece of work, I go through a rigorous paring down of all that is superfluous to arrive at a precise and contained form. Always in my work in all its manifestations ... formal considerations are of primary importance' (*British Art Show* 1990, exh. cat., South Bank Centre, London 1990, p.62).

Hatoum has focused on confrontational themes such as violence, oppression and voyeurism, often making powerful reference to the human body, its vulnerability and resilience. Paradox, or a sense of conflict, seems to pervade her work, arising from the juxtaposition of opposites such as beauty and horror, desire and revulsion. She has persistently aimed to engage the viewer, soliciting interpretation and eliciting emotional, psychological and physical responses.

In 1975 she settled in London after civil war broke out in Lebanon while she was on a visit to Britain. In the context of this war her early work was readily interpreted

Mona Hatoum
1952 British, born Beirut, Lebanon, of Palestinian origin
1975 Settled in London
1975–9 Byam Shaw School of Art, London
1979–81 Slade School of Art, London

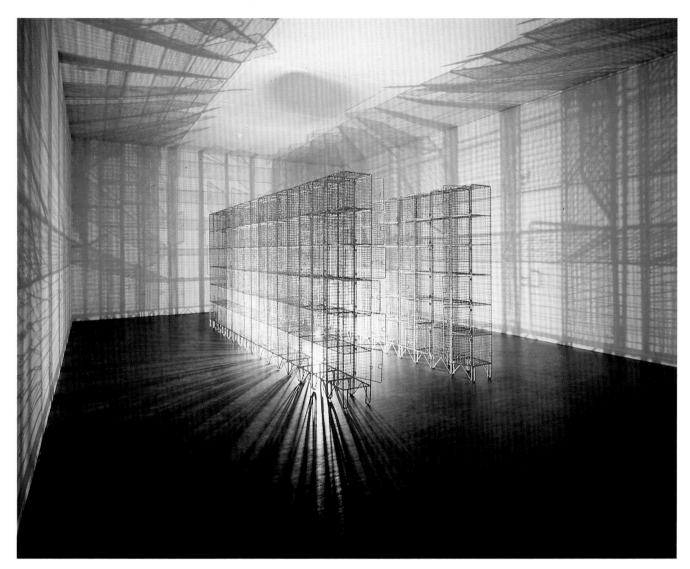

Mona Hatoum
Light Sentence 1992

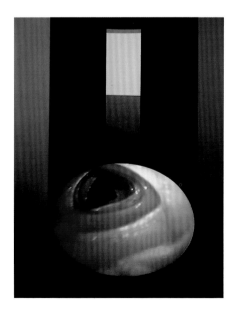

Mona Hatoum
Corps étranger 1994

Callum Innes
1962 Born in
Edinburgh, Scotland
1980–4 Grays School
of Art, Aberdeen
1984–5 Edinburgh
College of Art
Lives and works in
Edinburgh, also works
in Glasgow

as a metaphor for universal conflict and resistance to oppression, although her achievement has been subtly to interlink aesthetic and political issues.

In the Turner Prize exhibition Hatoum was represented by two pieces, the earliest being *Light Sentence* of 1992, a U-shaped cage of wire-mesh lockers, stacked six-and-a-half feet high in a darkened room. In the centre, a naked lightbulb slowly moves up and down casting a web of shadows, which fully extend when the bulb touches the ground. The gentle swaying of the light sets the shadows in motion. The simplicity of the structure and the complexity of the linear forms are both beautiful and sinister. *Light Sentence* refers to imprisonment (confusingly suggesting both 'getting off lightly' and 'life sentence'). But the abstract nature of the installation suggests, as in other works by Hatoum, a generic type of institutional building associated with physical confinement.

The other installation on display was *Corps étranger (Foreign Body)*, a specially constructed tubular room containing a video projected onto a circular screen on the floor. With the help of medical technology (endoscopic and coloscopic examination of the full tract of the digestive system) the video charts the journey of the eye of a camera penetrating the artist's body. Travelling across the surface of Hatoum's body the camera then explores each orifice by turn. This 'fantastic voyage' is accompanied by a sound track made from an echocardiographic recording of the heartbeat as heard from different areas of the body.

Repelled and attracted, perhaps excited or intrigued by the sights and sounds of the inner chambers of the body, we imagine falling into these pulsating tunnels, propelled by peristalsis through our unfamiliar selves. As well as discovering the body as something alien, the viewer is at the same time invited to become the voyeuristic 'foreign body' inside the artist. On another level, the artist herself, as both woman and exile, could be regarded as 'foreign' by a patriarchal European culture.

Callum Innes

Following a stay in Amsterdam in 1988, Callum Innes abandoned his figurative

approach to painting in favour of abstraction which seemed to offer a degree of detachment, allowing him to produce paintings that could exist beyond the limitations of his own experience or personality: 'My starting point is a desire to create an image that is somehow natural, that exists in its own right, holds a place for itself' (*Callum Innes,* exh. cat., Institute of Contemporary Arts, London 1992, p.18).

Innes's paintings are often admired for their enigmatic, meditative or even spiritual quality. Their quiet beauty is won from a tension existing between various elements. Starting with the monochrome, an established format of abstract painting favoured by minimalist painters since the 1960s, Innes etches away at the surface of the paint with a turpentine-laden brush.

His working method has been described as 'deliberately accidental' because he controls the amount and flow of turpentine, setting up a dynamic relationship between intention and intuition. Using this method he has established his own vocabulary in the form of distinctive groups of paintings, some of which were shown in the Turner Prize exhibition.

Prior to his nomination Innes began replacing his characteristic earthy palette with vibrant, dazzling pigments such as zinc yellow, cadmium red and cobalt violet. This departure was primarily stimulated by his *Resonance* or white paintings: 'Working with white is working with colour because of the fields of colour that open up when light hits the surface'.

Innes's monochrome grounds are painted from left to right with sweeping brushstrokes, the hog hairs creating a wall of horizontal lines. The impression of horizontality offers some resistance to the vertical lines of turpentine which transform the canvas. The vertical line or band became a highly significant pictorial element for American Abstract Expressionists working in the 1940s and 1950s. Barnett Newman, for example, used this line or 'zip' as a means of expressing the infinite: the vertical symbolically connects heaven and earth, unites spirit and matter, by splitting the canvas, imaginatively extending beyond its edges.

Callum Innes
Monologue 1994

Callum Innes
Exposed Painting,
Cadmium Orange
1995

1995

The vertical line is the starting point for each of Innes's *Exposed* paintings. Incising the monochrome ground with a line of turpentine the artist gently washes paint away from one side, gradually exposing an entire section of the canvas. The *Exposed* paintings seem rigidly geometric, but the line dividing solid colour from the cleansed area of the canvas betrays signs of human frailty – untrue, faintly wavering, sometimes slanting. Innes has commented: 'My approach is quite minimalist, but I'm not really interested in clean, clear-cut abstract paintings, pure formal exercises, I want emotion but also ambiguity' (ICA 1992, p.18). At its fringes the 'exposed' canvas retains traces of the paint previously covering the surface. For the artist, 'The most interesting part of the painting is the exposed part. That's the active part, where the painting actually exists' (quoted in Gill Roth, *List*, 27 Jan.–9 Feb. 1995, p.61).

Mark Wallinger

Since the mid-1980s Mark Wallinger has explored the complex theme of identity with imagination and irony. His primary concern has been to establish a valid critical approach towards the 'politics of representation and the representation of politics'.

Wallinger acknowledges that the pursuit of truth is subject to the anomalies and blind-spots of an artist's particular context and time. He adopts the strategy of parabasis which, as described by Jon Thompson, 'allows the author or artist to be both inside and outside of the action; to make comment before, during and after the depicted events. Like the Shakespearean chorus which is situated in an eternal present and yet is ... 'presumed' to know the pattern of events in advance, parabasis allows the writer or artist to expose him or herself as deeply implicated in the course of events, but to do so in the distanced voice of objective, critical commentary' (Jon Thompson, *Mark Wallinger*, exh. cat., Ikon Gallery, Birmingham and Serpentine Gallery, London 1995, p.12).

Wallinger's subjects stem from passionate interest or involvement, so that the critical edge of his work is twinned with the sensibility of an enthusiast or 'fan'. Horse-racing, for example, 'has an extraordinary aesthetic frisson for me which covers everything from the gambling to the magical identification with the animal on which your money rides to the sheer beauty of the thoroughbred' (quoted in Paul Bonaventura, *Art Monthly*, no.175, April 1994, p.7).

In a series of paintings called *Half-Brother*, two of which were included in the Turner Prize exhibition, Wallinger portrayed four hybrid racehorses derived from the Jockey Club's official record of thoroughbred stallions. Each work comprises two panels, the left depicting the head and forelegs of one particular animal, the right depicting the tail and hindlegs of his half-brother (in racing terminology this term applies only to progeny sharing the same mother). A racehorse's pedigree multiples two-by-two-by-two in a kind of biblical symmetry. By the disruptive ruse of the child's game of consequences, Wallinger draws attention to both the cold financial calculations which prefigure equine unions, and the more sinister aspects of playing God in the perfection of a race. Wallinger's investigation of horse-racing culminated in 1994 when, with the support of a syndicate, he purchased a two-year-old filly which he named *A Real Work of Art*: 'In choosing a race-horse as the subject of the piece I am signalling the fact that the thoroughbred is already an aestheticised thing, its whole purpose being to give pleasure to its owners and followers' (ibid.). As the owner of a racehorse Wallinger was required to register his 'colours', (the distinctive livery worn by jockeys racing for a particular owner, with the Jockey Club. Wallinger felt that the very term 'colours' provided a 'poetic tie-in with the act of painting. If you mix up all of the colours on a palette you end up with brown' (ibid.). Wallinger made a series of forty-two paintings, each representing the registered 'colours' of owners with the surname Brown and titled simply *Brown's*.

Mark Wallinger
1959 Born in Chigwell, Essex
1977–8 Loughton College
1978–1 Chelsea School of Art, London
1983–5 Goldsmiths' College, London

Mark Wallinger
Half-Brother (Exit to Nowhere/Machiavellian)
1994–5

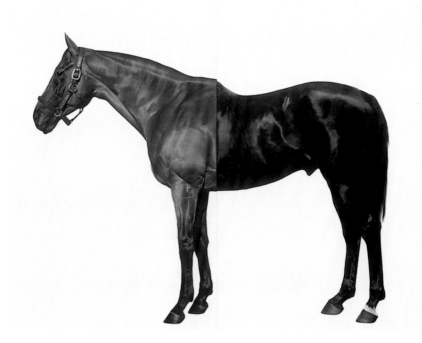

Mark Wallinger
Brown's 1993

Winner
Douglas Gordon

Shortlisted artists
Douglas Gordon for the presentation of his work at the Van Abbemuseum, Eindhoven; and for his contribution to a number of group shows, particularly *The British Art Show*, beginning in Manchester and touring to Edinburgh and Cardiff, and *Spellbound* at the Hayward Gallery, London
Craigie Horsfield for the continuing development of his work as shown in solo shows at the Antoni Tapies Fundacio, Barcelona, and at the Barbara Gladstone Gallery, New York, and for his contribution to the Carnegie International, Pittsburgh
Gary Hume for his solo exhibition seen at the Kunsthalle, Bern, and the Institute of Contemporary Arts, London, and for his contribution to several group shows, including *Wild Walls* at the Stedelijk Museum, Amsterdam, and *Brilliant!* at the Walker Art Center, Minneapolis
Simon Patterson for his solo exhibitions at the Lisson Gallery, London, and at the Gandy Gallery, Prague; and for his three separate solo exhibitions in Japan at Artium, Fukuoka, the Röntgen Kunstinstitut, Tokyo, and the Kohji Ogura Gallery, Nagoya

Jury
Bice Curiger
Editor-in-Chief, *Parkett* magazine, Zurich
Mel Gooding
Writer and critic
Edward Lee
Representative of the Patrons of New Art
James Lingwood
Curator and co-director of the Artangel Trust
Nicholas Serota
Director of the Tate Gallery and Chairman of the Jury

Exhibition
29 October 1996 – 12 January 1997
Prize of £20,000 presented by Joan Bakewell, 28 November 1996

Douglas Gordon
Something Between My Mouth and Your Ear 1994

The 1996 prize continued to draw visitors to the Tate Gallery despite the absence of an artist using 'shocking' materials and of tabloid hysteria. When the shortlist was announced, the most art correspondents could find to say about it was that it was 'boring' or 'sensible'. Brian Sewell's much quoted view was that: 'If the Turner Prize is trying to commit suicide by boring the pants off us, it is going the right way about it. These four are nobodies. They are not outrageous or a slap-in-the-face or whatever else Tate director Nicholas Serota wants to tell us, they are plain damned dull and boring' (*Independent*, 20 June 1996, p.9). Another critic suggested: 'You might just as well award the prize to the contestant with the nicest legs. With this tedious lot one is tempted to shout "Come back Damien all is forgiven"' (*Art Review*, September 1996). But this was not by any means the only response to the prize. Richard Dorment, for example, was both impressed by the artists selected for the shortlist – 'This is the strongest list in years, and what's more it has variety and feels fair, making it difficult to predict an obvious winner' (*Daily Telegraph*, 19 June 1996) – and by the exhibition: 'The exhibition of the shortlisted candidates for this year's Turner Prize opened last week at the Tate Gallery in London, and already the art press has dubbed it boring. I couldn't disagree more. For me the absence of artists such as Damien Hirst and the Chapman brothers from the list gives us a chance to ask a question that doesn't usually get asked in the brouhaha surrounding the Turner. If almost anything can be called art – and one of these artists works with video, another paint, a third with photography, a fourth with language – how do you determine quality? ... Whoever wins, this is a first class show and had become so popular that this year it has been extended until January 12' (*Daily Telegraph*, 6 November 1996, p.21).

Adrian Searle also commented on the public's commitment to the prize regardless of critical apathy: 'Public interest in the Turner extends beyond the handing out of big cheques, and despite the drearily predictable gor-blimey-they-must-be-bonkers tabloid knee-jerk, it is clear that many people in Britain actually like contemporary art. The enthusiasm for younger British art has gone beyond a fad' (*Guardian*, 29 October 1996, p.6).

But Searle also expressed his view on the only controversial aspect of the shortlist. Women had been excluded in a year when young British women artists had been particularly visible: 'It is an all-male contest this year which doesn't say much for parity, let alone the perceived achievements of women artists these past twelve months.' William Feaver also criticised this aspect of the shortlist: 'There could well have been an all-bad-girl shortlist. Tracey Emin, Sarah Lucas, Georgina Starr, Gillian Wearing ... At the very least, Cornelia Parker should have been there at the Tate' (*Observer Review*, 1 December 1996, p.9). Many others shared this view, although some conceded that the omission of women had not been deliberate. Gallerist Laure Genillard, for example, concluded that: 'The strength of women's art in the last ten years has been overwhelming to the point of taking the art world by surprise. Therefore I don't think it is possible today to deliberately boycott women artists from the Turner Prize shortlist. If there are no women selected this year, I think this happened coincidentally in the shortlisting process' (*Make 72*, Oct.–Nov. 1996). Speaking about the issue of the all-male shortlist on behalf of the jury Nicholas Serota revealed that: 'At least one woman artist featured in the final discussion this year, but in the end, the collective decision of the jury was that those shortlisted had, this year, greater claims. Perhaps I should add that the jury rejected the idea of putting a woman artist on the shortlist simply because she was a woman.'

There was no clear favourite to win in 1996. When the prize went to Douglas Gordon a number of critics noted that this was the first time a video artist had received the award. Others also commented on the fact that it was extremely rare for an artist based outside London to achieve such an accolade.

Douglas Gordon

Douglas Gordon has worked in various media, mostly painting, installation and more recently film. In the broadest terms, his project has been to investigate how and why we establish meanings for our experiences, given that we live in an

Douglas Gordon
1966 Born in Glasgow
1984–8 Glasgow
School of Art
1988–90 Slade School
of Art, London

environment saturated by new information which constantly erodes any coherent sense of self. Gordon aims to tempt the viewer into becoming more aware of the shifting subjectivity of his or her perception of the world. But certain recent works also indicate disquieting discoveries about his own responses to certain pathological mechanisms underpinning mass culture; particularly the areas of voyeurism, sadism and eroticism.

Since the early 1990s he has been fascinated by such phenomena as perception, memory and amnesia. In 1990 he first produced *List of Names*, a wall text compiling 1,440 names of people he had met, but only those he could remember in the process of making the piece. A later work, *Something Between My Mouth and Your Ear*, explores the power of music as an identifying mechanism for various stages in life, evoking the past and marking the present. In an entirely blue room, the audience listens to thirty songs that were 'in the air' between January and September 1966, the months prior to Gordon's birth. The songs may have formed his earliest conscious or unconscious memories.

His preoccupation with memory, combined with a passion for cinema, led Gordon to work with films. His primary concern is with the viewer's psychological relationship with the moving image: 'We can be attracted to the spectacle of cinema while watching something completely repulsive' (Blocnotes interview with Stephanie Moisden, unpublished, 29 Dec. 1995, p.2). In 1993 he first exhibited the critically acclaimed *24-Hour Psycho*, now recognised as a pivotal work in his *oeuvre*. Using slow-motion he played Alfred Hitchcock's film so that it lasted an entire day. He chose this well-known film because most people would have some preconception of what they would be seeing. As the slow-motion frames set up tensions and narratives not previously visible, any memory or expectation of the film is perplexingly discredited. Gordon has commented on this 'schizophrenic' effect: 'The viewer is pulled back into the past in remembering the original, then pushed into the future in anticipation of a preconceived narrative that will never appear fast enough. In the middle of this

is a slowly changing present – engaging in itself, but "out of time" with the rest of the world around it' (unpublished letter from Douglas Gordon to Michael Newman, 27 July 1995, p.4).

In all of his film pieces Gordon manipulates the act of looking. *24 Hour Psycho*, for example, is rear-projected on a screen installed in the middle of the room, so that people can walk around and behind the moving images, an intimacy denied at the cinema: 'When I was younger, I always believed that another reality existed behind the surface of the screen. I wanted to use this childish idea as a device to move the viewer around the space and to avoid the traditional cinematic "fixed perspective"' (ibid., p.3).

Slow-motion has been used strategically by film-makers engaged in critical film theory. However, Gordon's use of this device reflects the way in which video cameras are used domestically. He has commented:

As a teenager, any girl or guy can sit in their bedroom and run and rerun a video of their current obsession and watch the whole thing in slow-motion. This is not an academic exercise. This is about sex. This is about a human drive of real desire to see what shouldn't be seen. It's like being taken from the academy to the bedroom, and then ending up somewhere else altogether' (Blocnotes interview with Stephanie Moisdon, pp.5–6).

Following *24 Hour Psycho* Gordon produced a number of works involving medical films recording psychological malfunction, in which he investigates sadism and voyeurism as perceptual responses. *Hysterical*, for example, is a fragment of a medical demonstration film of 1908 documenting techniques for the treatment of hysteria. In an unconvincing interior, two male doctors violently restrain a masked woman as she experiences an hysterical fit. Gordon hints that the film is phoney by projecting the image on two adjacent screens, one projected from the front and one from the rear, the latter in slow-motion. Mirroring the screens in this way creates the impression that things are not as they might first appear. The incident appears staged, reminiscent of early Hollywood comedy (as implied by the artist's title).

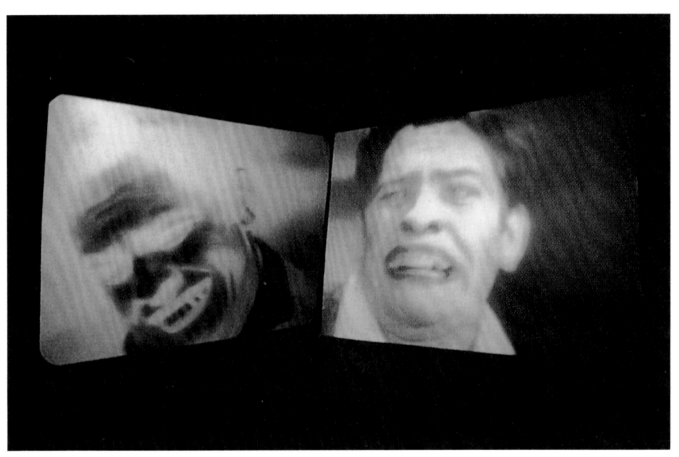

Douglas Gordon
*Confessions of
a Justified Sinner*
(detail) 1995

Craigie Horsfield
1949 Born in Cambridge
1972–9 Lived in Poland
1979 Returns to Britain

But at the same time the brutality of the footage is shocking. Gordon felt that the enacted scene became far more sinister when slowed-down.

In *Confessions of a Justified Sinner* (1995), which was the central piece in Gordon's Turner Prize display, the artist further explores the coexistence or 'hybridisation' of such apparent opposites as fantasy and truth, good and evil. *Confessions* comprises clips taken from an early film version of R.L. Stevenson's novel *The Strange Case of Dr Jekyll and Mr Hyde*, starring Frederic March as the doctor who attempts to liberate the human soul from its evil, bestial impulses. Unfortunately, his scientific dabbling has the reverse effect, with irrevocable and fatal results. Gordon amalgamates three clips enacting the fantastic transformation of saintly Jekyll into monstrous Hyde. Enlarged, slowed down and projected onto two separate screens, one negative, one positive, the selected clips emphasise and prolong the tortuous struggle between good and evil. But through slow-motion and video looping the expressions of the man turning into the monster are ambiguous – the distinction between good and evil is momentarily blurred.

The title of the piece refers to James Hogg's *The Private Memoirs and Confessions of a Justified Sinner*, published in 1824. Set in Scotland during a period of intense conflict within the Church, Hogg's chilling tale exposes the religious fanaticism that leads a devout youth to be seduced by the devil into killing his brother. The youth first meets the devil disguised as himself. In German folklore a meeting with one's own apparition or shadow soul, known as a *doppelgänger* (literally, 'double-goer') is a sign that death is imminent. In the book the narrative account of events is followed by the imagined confessions of the youth, which document his schizophrenic breakdown.

Gordon's work challenges us to be more conscious of how we perceive the world, and our place in it. We are frequently and uncomfortably prompted to play a game of 'truth or dare' in which we have to accept the rules and live with the outcome. As one critic has observed: 'Gordon's minimal means keep him at a distance, but he invites us – without

pronouncing judgement or offering any form of consolation – to plunge into some of the most difficult and distressing areas of the human psyche' (quoted in Angela Kingston, *Frieze*, no.21, March–April 1995, p.61).

Craigie Horsfield

Craigie Horsfield has said: 'The work I make is intimate in scale but its ambition is, uncomfortable as I find it, towards an epic dimension, to describe the history of our century, and the centuries beyond, the seething extent of the human condition' ('Craigie Horsfield: A Discussion with Jean-François Chevrier and James Lingwood', *Craigie Horsfield*, exh. cat., ICA 1991, p.28). His work is predicated on a philosophical position concerning the current crisis in European cultural, social and political life. In the late twentieth century we face the breakdown of rationalist and absolutist modes of thought which have dominated society since the Enlightenment. These omnipotent ideologies are now discredited – a belief in the idea of progress is no longer tenable. The notion that man could 'know all' and 'control all' has reached its threshold and we are crippled by a sense of an inability to act upon the forces of history which have brought us to this point of disintegration.

Through art Horsfield attempts to establish an understanding of history that involves the specificity of the present, challenging the notion of history as mythical past or inexorable future, divorced from human experience of the here and now. Using photography, with its residual trace of the real world, his work draws attention to the simultaneity and singularity of history.

Aware of the need to think and act new models of perceiving the world, Horsfield has based his project on human exchanges between individuals and communities. His black-and-white photographs record the environment around him and people he knows. The titles of his works record both the date of the photograph and the final print, emphasising the connectedness of past and present. He has written: 'It is an impossibly painful thing to realise that the lives, the very existence of people one loves are of the same matter as their fathers and mothers,

Craigie Horsfield
Carrer Muntaner,
Barcelona, Març 1996
1996

Craigie Horsfield
Pau Todó i Marga Moll,
carrer Muntaner,
Barcelona, Març 1996
1996

Gary Hume
1962 Born in Kent
1985–8 Goldsmiths'
College, University of
London

and generations before. This is not an easy thing to live with' (ibid., p.13).

The works shown in the Turner Prize exhibition were selected from a group of almost fifty images exhibited at the Fundacio Antoni Tapies in Barcelona. They were made as part of a collaboration over three years between Horsfield, Manuel Borja-Villel, and Jean-François Chevrier. The project involved several other groups working in and for Barcelona, and many individuals played an active part in its development. Within the project the city of Barcelona is seen not as different from other cities but as a paradigm of the changes occurring across Europe today. The collaboration was to describe this place and had a specific political purpose in developing an instrument and a model of communal action, and a sense of the network of relations that constitute a community. Horsfield has said: 'If we are to survive, if we are to resist death, [we] must work to understand the relation that we have at once to each other and the phenomenal world' (Craigie Horsfield, *Witte de With 1992: The Lectures*, Witte de With, Rotterdam 1993, p.83).

Gary Hume

In the late 1980s Gary Hume came to prominence with a series of sophisticated monochrome paintings which replicated the measurements of swing doors in St Bartholomew's Hospital, London. The paintings also incorporate the geometric features (circles, squares and rectangles) that are the windows and panels of hospital doors – they appear to be abstract, while literally representing real doors. Hume's use of gloss housepaint further enhanced the resemblance of his paintings to real doors. The resulting reflective surfaces of such paint also changed the experience of viewing the work. Hume continued to develop the series by using an increasing variety of colours and multi-panel parts until, at the end of 1992, he surprised the art world by abandoning them completely. Hume had felt trapped. The freedom afforded by critical and financial success was also stifling his creativity. He commented:

I just wanted to continue to create. The limitations of abstract geometric

paintings were of no interest. The recent paintings are not so closed down and give you more to think about. The door paintings were solid, whereas now the subject matter is more fluid (Gregor Muir, *Vague Art + Text*, no.51, May 1995, pp.41).

In 1995 Hume exhibited his new work in solo shows at White Cube and the Institute of Contemporary Arts, London. The new paintings are often deliciously coloured and unashamedly sensual. His subjects, which he describes as 'embarrassingly personal', have included feet, flowers, animals, toys, women and such media celebrities as Tony Blackburn. They are chosen, Hume says, 'for their ability to describe beauty and pathos'. Derived from fashion magazines and other mass-media sources, the subjects are familiar, yet, transformed by the artist, who uses the mediated image as a starting point, they become volatile and confusingly evasive.

The new paintings are contoured with immaculately applied layers and ridges of gloss paint. Working on the floor, he first builds up the painting in white to produce a variety of surface levels. This determines the outlines of dominant motifs and defines which areas touch or overlap.

Innocence and Stupidity, included in the Turner Prize exhibition, comprises two large panels butted together, one echoing the image of the other. Layers of paint also sit side by side, forming pools of pastel colour suggesting an aerial view of a topographical terrain. This seemingly abstract painting depicts two rabbits, amoebic lilac shapes representing their eyes. Hume derived the image of the rabbit from a medieval French tapestry, *La Dame et la Licorne*. Although his images are usually appropriated from specific sources, Hume resists literal interpretation of his work. His primary concern is to give pleasure, rather than to explain or fix meanings. Ultimately he is 'searching for that art moment', a sublime moment of 'supreme humanity' that happens occasionally in front of art, the kind of moment he experienced on seeing an astonishing portrait of a girl by the fifteenth-century painter Petrus Christus.

Gary Hume
Whistler 1996

Gary Hume
Innocence and
Stupidity 1996

Simon Patterson
1967 Born in
Leatherhead, Surrey
1985–6 Hertfordshire
College of
Art and Design,
St Albans
1986–9 Goldsmiths'
College, London

Simon Patterson

Simon Patterson is fascinated by the information that orders our lives. Using a variety of media he humorously dislocates and subverts such sources of given information as maps, diagrams and constellation charts. By transforming authoritative data with his own associations he challenges established rationales. Patterson's seemingly random, personal logic suggests that there are many different ways in which systems can legitimately work, and even the most obscure reference can find an audience, since his own knowledge of history, science and culture is shaped within a social context: 'There is no code to be cracked in any of my work. Meanings may not be obvious, you may not get a joke, but nothing is really cryptic – I'm not interested in mystification. I like disrupting something people take as read' (Sarah Greenberg, *tate: The Art Magazine*, no.4, Winter 1994, p.47).

Maps and diagrams function to convey reliable data about the 'real' world, translating putative 'fact' into abstract visual form. Patterson's best-known use of a map is *The Great Bear*. Within a few years of its making, this variation of the London Underground Journey Planner, or 'tube map', was lauded as 'an icon of Nineties art'. Patterson intended to print his version as a poster for the Underground. Understandably, as he had substituted station names with those of philosophers, film stars, explorers, saints and other celebrities, past and present, *The Great Bear* was deemed too confusing for commuters. Some new connections seemed appropriate, others nonsensical. Pythagoras as Paddington, for example, forms a neat triangle between the District and Circle, Metropolitan and Bakerloo lines. But what links Balham and Cher?

The relationship between language and objects was the focus of Patterson's work in the mid-1990s. At the Lisson Gallery in 1996 he exhibited a number of sculptures, including fabricated sliderules, kites and giant abacuses, which set out to explore the literal and metaphysical potential of three-dimensional things. The centrepiece of the show, later included in the Turner Prize exhibition, was an untitled work comprising three white yachting sails rigged on metal stands, each bearing the name and dates of a literary figure. Raymond Chandler (1888–1959), Currer Bell – the pseudonym of Charlotte Brontë (1816–1855) – and Laurence Sterne (1713–1768). In selecting these names Patterson implies a range of associations, not least the fact that as words they belong to the world of sailing, the ship's chandler, bell and stern. For Patterson the white sails suggest the artist's canvas: 'They are about the artist contemplating the blank canvas, and about the problems of making art' (Mel Goodling in Conversation with Simon Patterson at the Lisson Gallery, *Audio Arts Magazine*, vol.15, no.4, 1996). Indeed, the sails strain to race with the wind, to reach their destination, but the airless gallery denies them this satisfaction. On another level they refer literally to the traditional picturesque subject of marine painting.

Commenting on Patterson's lightness of touch in handling serious issues, David Lillington has written: 'His is a social art, addressing a society which puts faith in individualism. It sends the mind in several directions at once, and in this it is both funny and perceptive' (David Lillington, *Time Out*, 27 March–2 April 1991, p.43).

Simon Patterson
The Great Bear 1992

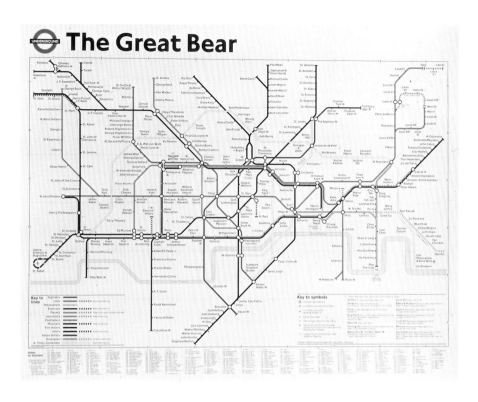

Simon Patterson
Untitled 1996

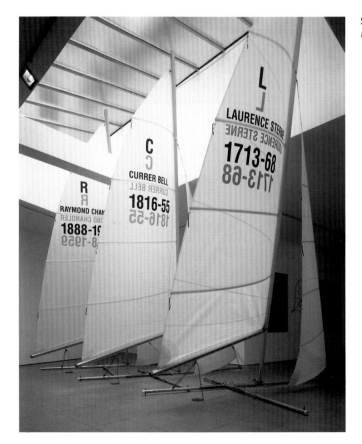

Gillian Wearing 1997

Winner
Gillian Wearing

Shortlisted artists
Christine Borland for her exploration of the language of forensic science as seen in her *From Life (Berlin)* project included in *Material Culture* at the Hayward Gallery and also in her solo exhibition at the Lisson Gallery
Angela Bulloch for her inventive use of a wide range of media and approach to exhibition making, as seen in *life/live* at the Musée d'Art Moderne de la Ville de Paris and in her solo show at Robert Prime Gallery, London
Cornelia Parker for her exhibition, *Avoided Object*, at the Chapter Gallery, Cardiff, in which she showed her continuing exploration of the secret lives of objects and materials both ordinary and strange
Gillian Wearing for the sustained development of her work in this year as seen in *The Cauldron*, at the Henry Moore Studio, Halifax; in *Full House*, at the Kunstmuseum Wolfsburg; and most recently for her video *10–16* at the Chisenhale Gallery, London

Jury
Penelope Curtis
Curator at the Henry Moore Institute, Leeds
Lars Nittve
Director of the Louisiana Museum, Humlebaek, Denmark
Marina Vaizey
Writer, art critic and lecturer
Jack Wendler
Representative of the Patrons of New Art
Nicholas Serota
Director of the Tate Gallery and Chairman of the Jury

Exhibition
29 October 1997–18 January 1998
Prize of £20,000 presented by the Rt Hon. Chris Smith, Secretary of State for Culture, Media and Sport, 2 December 1997

In 1997 the first all-woman shortlist provoked accusations of political correctness from some quarters. But most acknowledged that the shortlist genuinely reflected the achievements of British women artists. Following the presentation of the prize to Gillian Wearing, Waldemar Januszczak wrote: 'Much has been made of the all-female shortlist for 1997. But I honestly believe it was inevitable. Young women artists are making much of Britain's best work at the moment and they are mainly doing it in a new voice: the loud, boozy, confident chatter of the single urban female' (*Sunday Times*, 7 December 1997). The surprise for many critics, however, was that the shortlist had not included some of Britain's so-called 'bad girl' artists such as Sarah Lucas and Tracey Emin. When the exhibition opened, Martin Coomer, writing in *Time Out* (5–12 November 1997, p.48), commented on what he felt was an evenly matched competition: 'The jury has done its job impeccably; four artists, all worthy of individual merit, all well known, but not too famous, all female – yikes – but not the obvious choices. Rumours that Sarah Lucas declined her nomination, plus the omission of Tracey Emin, Georgina Starr and Sam Taylor-Wood have yielded a closer competition than we are used to'.

The prize and the art on display continued as in previous years to attract criticism. Brian Sewell, for example, declared: 'This year's Turner Prize is, without doubt, the silliest yet' (*Evening Standard*, 30 October 1997, p.29). Sewell expressed the view that the Turner Prize, which had not been won by a painter for over a decade, was 'the disreputable instrument of propaganda for the Serota Tendency ... Soon, under its mephitic influence, no one below the age of 40 will have the slightest notion of what separates an art gallery from an infant school, a freak show, a toy shop, and boring television'.

Marina Vaizey, a juror in 1997, commented on the criticism that the Turner Prize inspired, from both traditionalists and those supporting new developments in art: 'Is the knocking copy that the Turner attracts harmful? Those prizes that are not much criticised, or even scrutinised, are not perhaps taken all that seriously either. The non-reverential atmosphere does at least engage some of the audience to come and see what the fuss is about. It also ensures an annual provision at the Tate of a didactic exhibition of absolutely current art. I do not think it is time to stop knocking the Turner. Knock all you want, but remember it is an open door. Come and see for yourself what is within' (*Sculpture*, Autumn 1997, p.10). Indeed, more visitors attended the exhibition than in previous years. One of the most admired works on display was Cornelia Parker's *Mass (Colder Darker Matter)*, described by John McEwen in the *Sunday Telegraph* (2 November 1997, p.12) as a 'show-stopper'. But for Richard Dorment, also reviewing the exhibition, Gillian Wearing's video *60 Minutes Silence* stole the show (*Daily Telegraph*, 5 November 1997, p.22). The subsequent award of the prize to Gillian Wearing, felt Colin Gleadell, 'rammed home something that was not fully grasped after last year's award to Douglas Gordon. Like it or not, accept it as art or not, video art is now "institutionally correct"' (*Daily Telegraph*, 8 December 1997, p.18).

Gillian Wearing

Gillian Wearing is fascinated by people. Using photographs and video she has collaborated with members of the public, young and old, to produce a body of work that yields insights, both funny and disturbing, into the complexities of everyday life at the end of the twentieth century. Her desire to scratch beneath the surface of appearances was kindled early on by fly-on-the-wall television documentaries of the 1970s. She has said (in *Brilliant!*, exh. cat., Walker Art Center, Minneapolis 1995, p.81):

> I think my most important influence has been documentaries. I really enjoyed the 1970s 'fly-on-the-wall' documentaries that were made in Britain. There was a programme called *The Family*, where they went in someone's home and filmed the family. Documentary was still fresh then, and these programmes felt very spontaneous.

Wearing's subjects tend to highlight

Gillian Wearing
60 Minutes Silence
1996

the friction between public and private, between individual impulse and established norms of behaviour. Using carefully thought out methods and strategies, she presents a kaleidoscopic view of human experience, its pleasure, pain and ambiguities: 'There's elements of humour and then there's humility as well. I'm interested in every emotion being part of the work. Some of my work is very depressing, and then there's other stuff that's funny' ('Gillian Wearing interviewed By Ben Judd', *Untitled*, no.12, winter 1996–7, p.4).

All of her work involves a degree of complicity with ordinary people, mostly from South East London where she lives, an area that has become, in effect, her studio. In 1992 she began *Signs that say what you want them to say and not signs that say what someone else wants you to say*, a series of photographs of people holding placards upon which they had spontaneously written what they were thinking or feeling when the artist approached them on the street. The results are amusing, poignant and surprisingly honest for a nation noted for its lack of candour. In *Dazed & Confused* (no.25, 1996, pp.53, 54) the artist has commented:

> People gave so much of themselves, which is not expected of the British public, who are generally perceived as being reserved ... I wanted to find out what makes people tick. A great deal of my work is about questioning handed-down truths ... I'm always trying to find ways of discovering things about people, and in the process discover more about myself.

It has been noted that Wearing's work, which seems to depend on our 'vicarious voyeurism' for its effects, could be seen as exploitative of her human subjects (Adrian Searle, 'Gillian Wearing', *Frieze*, no.18, Sept.–Oct. 1994, p.62). But her collaborators are always consenting and Wearing, aware of her own fallibility, is never patronising or judgemental, often including herself in a work to prove the point. In *Dancing in Peckham*, for example, a video piece of 1994, she spent twenty-five excruciating minutes dancing in a shopping centre, the music of Gloria Gaynor and Nirvana playing only in her

head, while a worryingly unperturbed public trudged past her gyrating body and flailing limbs. Wearing has said (in *Dazed & Confused*, no.25, 1996, p.55):

> There are some things you can't ask of the public. For instance, the original idea for *Dancing in Peckham* stemmed from seeing this woman dancing wildly in the Royal Festival Hall. She was completely unaware that people were mocking her ... Asking her to be in one of my videos would have been patronising, so I decided to do it myself.

A method of eliciting collaboration consistently used by Wearing is that of placing an advert in the personal column of *Time Out* magazine. In 1994 she recorded the confessions of ten people who dared to respond to *Confess all on video. Don't worry you will be in disguise. Intrigued? Call Gillian* ... Aware of the confessional nature of many popular television chat shows, the artist offered participants the chance to confide their secrets to the camera, as if it were a modern Catholic confessional box. Besporting an array of wigs and masks and with varying degrees of relish or regret they disclose their 'perpetrations', which include betrayal, sexual perversion, stealing, and revenge. One man, the only victim, gives a desperately sad account of how witnessing his brother 'snog' his two sisters has subsequently destroyed his life.

Much of Wearing's work deals with the themes of deviancy and control. In *60 Minutes Silence* of 1996 the viewer is presented with what appears to be a life-size group photograph of twenty-six policemen and women. Suddenly there is movement within the frame. The picture is in fact a video projection: like a living sculpture it returns our gaze – we are being watched by the law. Wearing persuaded the participants to remain still for a punitive hour of silence under the scrutiny of her camera. Gradually, the shuffling increases, tension mounts. When the time is up, one officer releases a yelp of anger and relief. Lesley Garner (in the *Daily Express*, 2 August 1996) has commented:

> This video is not a photograph, and the

Gillian Wearing
1963 Born in Birmingham
1985–7 Chelsea School of Art, London
1987–90 Goldsmiths' College, London

Gillian Wearing
Sacha and Mum 1996

Gillian Wearing
10–16
1997

longer I looked the more I saw other figures move; nothing dramatic, just the normal shifts and coughs of people made to hold a silent pose for an hour.

It's mesmerising. There is a great sense of tension from all that suppressed energy, and the longer you looked the more individuals emerge. Gillian Wearing has made a career from using video to bring out humanity and individuality and this seemingly simple piece is compellingly effective.

As well as examining modes of behaviour in public spaces, Wearing has also attempted to unmask the ambivalent emotions underpinning personal relationships. *Sacha and Mum* of 1996 shows intimacies between a mother and daughter at home. But their embraces become struggles, the mother using a towel to mask and restrain the younger woman, clad only in bra and pants. Wearing has choreographed their movements, and by running the stark black-and-white film backwards, creates a disquieting scenario in which horseplay turns into coercion, bordering on violence.

A more recent film commissioned by the BBC, *Two into One*, records a mother and her two eleven-year-old sons talking about their relationship. Wearing met them through a friend and quickly realised that they had strong views about each other. They agreed to lip-synch edited interviews with the artist, so that the dynamics of their relationships are thrown into relief. This device, also used in *10–16*, exhibited at the Chisenhale Gallery in 1997, draws attention to the emotional and psychological realities belied by outward appearance. In *10–16* adults lip-synch to the recorded interviews of children aged between ten and sixteen. *Two into One* shows children lip-synching to their mother's voice, and she to theirs. As they speak, deadpan, to the camera, the shadowy borderlands between love and hate compellingly unfold.

Christine Borland

Christine Borland's work asks us to consider the ways in which social systems and institutions exploit and devalue life. She has said, for example, 'I think the ways that we are forced to be institutionalised or compartmentalised by the institutions surrounding the body – health, medicine, birth and death – is an important subject and one which we must try to repersonalise (unpublished interview, Kari J.Brandtzaeg, May 1997).

Her installations exploring the traditional theme of mortality are both seductive and repellent, exerting a morbid fascincation. Like an archaeologist or historian she conducts research, often seeking out expertise within a particular field of enquiry, opening doors that are normally closed.

The Dead Teach the Living, shown in the Turner Prize exhibition, points to how science has legitimised the dehumanisation of racial groups. On a visit to the Anatomical Institute in the faculty of medicine at the Westfälische Wilhelms-Universität in Münster, Borland was immediately struck by a display case of heads – death masks from people of different ethnic groups, shrunken heads, artists' portraits and fragments of heads. The department's records were mostly destroyed during the Second World War so Borland could only speculate as to whether these items had served as teaching tools. However, further research enabled her to establish a historical context for the specimens: she discovered that during the 1920s and 1930s the faculty had been an important centre for so-called Rassenhygiene ('racial hygiene') and eugenics. Many of its professors had promulgated National Socialist theories of race, a fact that Borland felt unable to ignore: 'Although I wanted the project in its eventual form to be historically non-specific, this knowledge provided a crucial perspective for me ... my struggle to deal with this history ... reflected the medical faculty's own desire to move forward while dealing with the past honestly and respectfully' (*Sculpture: Projects in Münster*, 1997, p.75). Borland made copies of these heads using the latest technology. The heads, she explains:

were scanned in many different positions by a laser and this information built up into computer

Christine Borland
1965 Born in Darvel, Ayrshire
1983–7 Glasgow School of Art
1987–8 University of Ulster, Belfast

Christine Borland
The Dead Teach the Living (detail) 1997

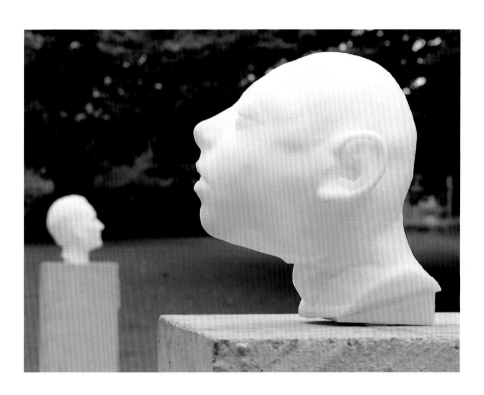

Christine Borland
Phantom Twins (detail) 1997

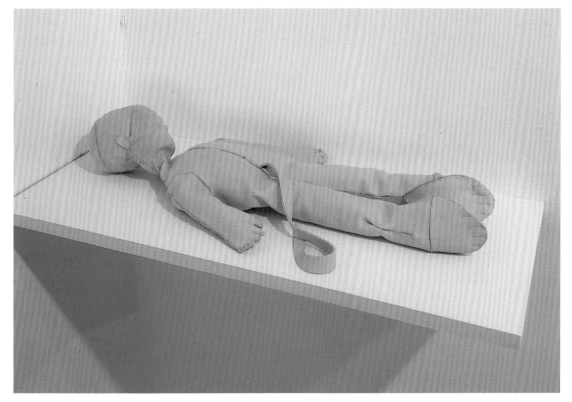

data. In the next process the data was converted and painstakingly rebuilt in three-dimensionally molten ABS plastic, by machine.

The resulting piece is necessarily removed from the emotive originals, the new material inviting curiosity and interaction [ibid., p.76].

On occasion Borland seems to be playing with the role of Mary Shelley's doctor-scientist, Frankenstein. In 1997, for example, she made *Phantom Twins* based on two leather 'dolls' used in the eighteenth century to demonstrate childbirth to medical students. The original 'dolls' contained real foetal skeletons –beneath the stretched leather their skulls are clearly visible. Although Borland used plastic replica skulls obtained from an osteological supplier, her 'dolls' nevertheless convey, at one step removed, the poignancy and uniqueness of the tiny lives buried under the leathery carapace.

Angela Bulloch

Angela Bulloch makes cool, immaculately fabricated mixed-media sculptures often including functional elements that are activated by the viewer, or modified by the passing of time. In an interview with Liam Gillick in *Documents sur l'art* (no.8, spring 1996, p.30) she has said:

I am interested in how things evolve, or shift their meaning when you move them into various different contexts. I am also involved in a consideration of time-scale as a framework, rather than assuming a fixed perspective ... I like the apparent contradiction of defining something which is always subject to change.

The human presence is crucial to the possible meanings of her work. Based on systems or structures that limit the parameters of human choice, her sculptures are nevertheless continually redefined in relation to those choices. As David Bussel has observed, 'The viewer becomes the activator, making an intervention of some kind through the structure provided by the work itself within the context of the gallery. As

such, the work becomes a kind of democratic collaboration of action and choice between Bulloch and her audience ('Angela Bulloch', *Frieze*, June–Aug. 1997, p.85).

Bulloch's real interest lies in how systems influence our preferences and exert control over our behaviour or potential for action. Using a variety of means, including modern technology, light, sound and fabricated 'furniture', her work effortlessly subverts such binary opposites as on-off, order-chaos, pleasure-pain, opposites that we might encounter in our daily experience of the world.

Since the early 1990s Bulloch has been making drawing machines, such as *Betaville* (1994). Typically, the artist sets up a system whereby the presence of the viewer, detected by infra-red sensors, sound- or pressure-sensitive switches, triggers the movement of a mechanically operated pen on the wall to produce a continuous line drawing.

Intrigued by the idea that sculptures can function as places of social interaction, Bulloch has more recently made sculptures that have potential use as furniture. A recurring type has been the comforting 'Happy Sack' which Bulloch uses as an individual piece or as an element in other sculptures. She has commented: 'If somebody wishes to view the work or to be part of it, s/he has to be more-or-less lying down, or together with other people on the same structure. Basically I see the 'Happy Sack' as a piece of furniture, but in another way it's a social structure (ibid.).

Another group of works, the *Rules Series*, begun in 1993, makes visible the rules and regulations that mechanise our behaviour. Displaced from their original contexts, and writ large on a gallery wall or some other location, her lists of rules, covering activities as diverse as bungy-jumping, stripping, and debating in the House of Commons, are themselves subjected to critical scrutiny. The *Rules Series*, like many of Bulloch's inventions, conveys the feeling that all life is interconnected, that individual action impacts on others and vice versa. As with all her works, one is left with the view that, for the individual, coerced by social convention, self-

Angela Bulloch
1966 Born in Ontario, Canada
1985–8 Goldsmiths' College, London

Angela Bulloch
Betaville 1994

Angela Bulloch
Vehicles, an exhibition
at Le Consortium,
Dijon in 1997

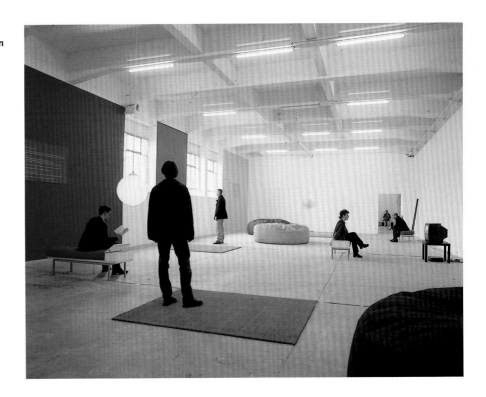

Cornelia Parker
1956 Born in Cheshire
1975–8 Wolverhampton
Polytechnic
1980–2 Reading
University

determination may be merely an illusion.

Cornelia Parker

There are no absolute truths in Cornelia Parker's universe. Such is the intensity of her imaginative investigation into the nature of matter that 'She can convince you that the living room is the ocean, that buildings can breathe and that the universe can be turned inside out, like a glove' (Adrian Searle, *Cold Dark Matter: An Exploded View*, exh.cat., Chisenhale Gallery London 1991). Her approach to making sculpture has been described as that of a 'particle physicist', yet Parker's sensibility is poetic, shot through with an erudite and witty use of language and an understanding of the complexity of human experience. She tests the physical properties of substances and things, at the same time playing on their public and private symbolic meaning and value. Her methods of exploration have included suspending, exploding, crushing and stretching, and have involved the assistance of such unlikely collaborators as the Colt Firearms Factory in Connecticut and H.M. Customs and Excise.

Parker revels in the real and imaginative transformations wrought by destructive forces both natural and man-made. A pivotal piece in Parker's artistic career is *Cold Dark Matter: An Exploded View*, first installed at the Chisenhale Gallery in 1991. A garden shed, housing familar domestic objects culled from car boot sales, was blown up for the artist by the British Army. The residual scorched and mutilated fragments were then hung in a cluster around a single light bulb, where they appeared as a dematerialised form resembling an alternative solar system or eccentric 'parallel universe'. 'Cold dark matter' is a scientific term used to describe the substance that exists in the universe, yet remains mysterious and unquantifiable. For Parker it points to nature's resistance to being categorised, measured and fixed.

In 1997, during her residency at ArtPace in San Antonio, Texas, Parker produced a more ethereal installation, *Mass (Colder Darker Matter)*. Chunks and splinters of charcoal are suspended from the ceiling to form the illusion of a cube, dense at the centre, thinning at the edges. Parker had been in Texas for four days when she heard that a Baptist church had been struck by lightning. *Mass* is made from the charred remains. Parker reincarnated the pieces of charcoal, already resonant with meaning, as a formal arrangement of found objects. All of Parker's work is flush with linguistic and cultural associations. Here the church, symbolic of spiritual certainty and social order, has been 'killed off' by a natural force which could be interpreted by some as an 'act of God'.

The found object plays a key role in Parker's art practice. Two exhibitions have explored the idea of the found object in different ways. In 1995 she was invited by the actress Tilda Swinton to collaborate in the making of *The Maybe* at the Serpentine Gallery, London. From museums Parker selected curiosities associated with historical figures, all deceased, and displayed them alongside Swinton, who slept in a glass vitrine.

In a more recent exhibition held at the Chapter Gallery in Cardiff, Parker developed the idea of the 'avoided object' The idea grew partly out of the larger installations which always produced a discarded 'fall-out, a debris or a residue'. Parker began to focus on seemingly worthless by-products, that we 'avoid psychologically', such as tarnish, the swarf from grooves made in a lacquer 'master' record, or 'the negative of words – the little scraps left when somebody engraves a piece of silver'.

Cornelia Parker *Twenty
Years of Tarnish
(wedding presents)*
1996

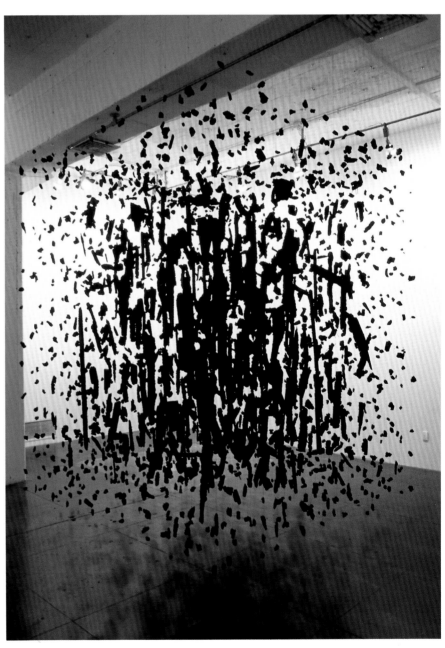

Cornelia Parker *Mass
(Colder Darker Matter)*
1997

Winner
Chris Ofili

Shortlisted artists
Tacita Dean for her solo exhibition at the Frith Street Gallery and other presentations of her work in the UK and Europe, in which she demonstrated her versatility in the use of a wide range of media, including drawing and film, to create imaginative narratives of her chosen themes
Cathy de Monchaux for the growing complexity and richness of her sculpture and for her sensuous use of materials as displayed in her solo exhibition at the Whitechapel Art Gallery and her striking contribution to *Wounds* at the Moderna Museet, Stockholm
Chris Ofili for the inventiveness, exuberance, humour and technical richness of his painting, with its breadth of cultural reference, as revealed in his solo exhibition at Southampton City Art Gallery and in *Sensation* at the Royal Academy, London
Sam Taylor-Wood for her prize-winning presentation at the Venice Biennale and her solo exhibitions at the Kunsthalle, Zurich, and Louisiana Museum of Modern Art, Denmark, in which were seen her acutely perceptive explorations of human relationships through photography and video

Jury
Ann Gallagher
Exhibition Officer at the British Council
Fumio Nanjo
Curator and critic
Neil Tennant
Representative of the Patrons of New Art
Marina Warner
Author and critic
Nicholas Serota
Director of the Tate Gallery and Chairman of the Jury

Exhibition
28 October 1998–10 January 1999
Prize of £20,000 presented by agnes b., 1 December 1998

Chris Ofili
Afrodizzia (2nd Version)
1996

For many critics 1998 was a memorable year. Painters had always featured on Turner Prize shortlists; in fact, such celebrated artists as Sean Scully, Peter Doig, Callum Innes and Gary Hume had all been recent contenders. But this was the first time a painter had won the prize since 1985. However, odds-on favourite Chris Ofili, whose vibrant, gorgeous paintings, embellished with and propped up on resin-coated elephant dung, proved a problematic choice for critics who hankered after a more traditional mode of painting. Dubbed the 'Rembrandt of Dung', Ofili prompted the inevitable tabloid headlines – the *Express*'s 'Dung-ho art tops the Turner', for instance, and the *Sun*'s 'Artist dung great'. Brian Sewell, as so often, offered the strongest objection: 'If anything is to be said for these pictures it is only that all the damned dots and spots are mind-numbing triumphs of idiot industry, and their concentrated tedium is in no way relieved by the random application of pachydermal turds ... I am sick of shit in art: has no one in authority the courage to resist it and the infantilism that promotes it?' (*Evening Standard*, 8 October 1998).

There were also accusations of 'political correctness' when Ofili won the prize: not only was he the sole male artist on the shortlist, he also happened to be black. Following the announcement of the award, Adrian Searle defended the jurors' choice: 'Chris Ofili has proved popular with a black audience which, it is often assumed, feels alienated by contemporary art. Ofili is truly popular, and also highly respected among artists ... unlike an earlier generation of black artists in Britain, he is not interested in the polemics of political correctness, preferring beguilement and a self-consciously over-the-top exoticism to outright political statement ... Chris Ofili truly deserves the prize' (*Guardian*, 2 December 1998).

Raeka Prasad commented thoughtfully on the significance of Ofili's triumph for black Britons: 'Contemporary art galleries in Britain do not attract a large black audience. Visual art is still more clubby that contemporary music or even theatre. The Tate and National Portrait Gallery show work by black artists, but permanent displays are largely of European and western art. Most black artists are shown in temporary exhibitions – here, but not

forever and always. Ofili says: "I'm black and it's a very important part of what I am. I'm not embarrassed about it. I try to bring all that I am to my work and all that I experience. That includes how people react to the way I am – the prejudice and the celebrations. I now know I didn't win the Turner Prize only for me. I just hope that when black people look at me they don't see someone superhuman. They see themselves." ... Although art can touch people irrespective of race, the excitement at seeing someone who looks like you making art and featured in it, is still a novelty for black people in Britain' (*Guardian*, 5 December 1998). Ofili's *No Woman, No Cry*, a tribute to the family of murdered black teenager Stephen Lawrence, was widely admired by the press.

Judging by the amount of copy, many critics, whether for or against, felt compelled to analyse the success of the prize in the light of the huge audiences for the exhibition. In just one year attendance had increased by almost fifty per cent. Iain Gale, for example, queried the stated aim of the prize: 'The Turner may be a way of bringing "art" to a wider public, but it is equally dangerous for perpetuating the sad myth of art as outrage and playing into the hands of a dumbed-down press who happily prey upon the worst prejudices of a repressed and under-informed audience. The prize has now become more important than the art it shows. It has become a jamboree of indulgence, of opportunism and bigotry which may, in fact, be doing more harm than good to British art' (*Scotland on Sunday*, 15 November 1998). By contrast, Philip Hensher celebrated the spectacle engendered by the prize: 'From slightly fusty beginnings, it has turned into by far the most enjoyable and interesting of British prizes, and serves a genuinely useful purpose ... As all prizes should, the Turner gives the appearance of awarding achievement, when what it is really doing is luring in the unsuspecting audience with outrage, spectacle, fun and something amazingly new' (*Independent*, 30 October 1998). Others, including Adrian Searle, acknowledged the growing international reputation of the prize. Searle conceded that the Turner Prize had increased public awareness of contemporary art, but his guarded praise raised questions about the level of

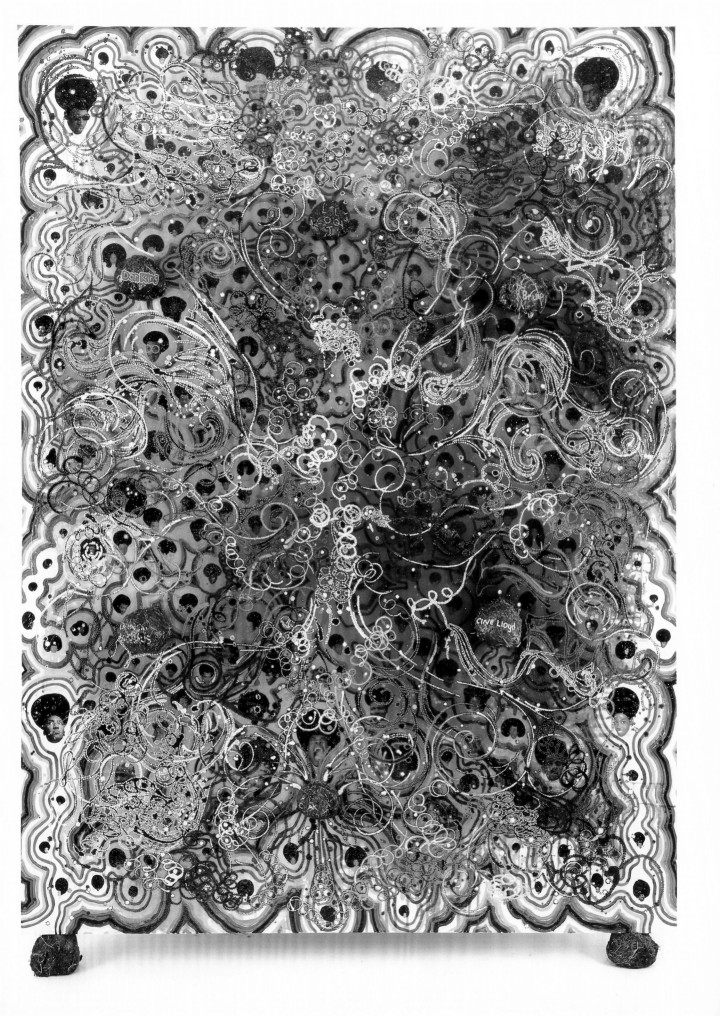

Chris Ofili
1968 Born in
Manchester
1988–91 Chelsea
School of Art, London
1991–3 Royal College
of Art, London

engagement with the works of shortlisted artists: 'There's a danger that the British public is actually getting comfortable with contemporary art. Writers no longer feel obliged to explain what installations are, what conceptual art is, or why films and videos can be art. The Turner must take some credit for this accommodation to the avant-garde, but it's debatable whether familiarity is the same things as serious interest' (*Guardian*, 28 November 1998).

Chris Ofili

Chris Ofili's paintings are notable for their technical innovation and complexity, their vibrancy, funkiness, humour, irreverence and sheer delight in the act of painting. In his words: 'My work and the way that I work comes out of experimentation, but it also comes out of a love of painting, a love affair with painting.' Like the hip hop music that he listens to, Ofili samples and mixes a wide range of cultural and popular references, from the Bible to pornographic magazines, from 1970s comics to the work of artists like William Blake, producing work that challenges stereotypes of black culture, identity, exoticism and sexuality.

Ofili's approach to painting is characterised by a desire to experiment with the traditional confines of the medium, something which he does in part by incorporating seemingly extraneous elements, such as lumps of elephant dung, into his work. While at art school he gradually came to realise that 'you can do anything, there are no rules, and even the ones you set for yourself can be temporary – they're just for the moment'. For him, the introduction of elephant dung is a means by which to establish a dynamic between the increasingly beautiful paint surfaces of his paintings and the perceived ugliness of dung. He is insistent, however, that his use of dung is not intended as an assault on painting, rather a friendly challenge and an embellishment. To this end, he frequently adorns it with coloured map pins and uses it as the very means by which to support his paintings in the gallery environment, rather than hanging them on the wall.

Between 1993 and 1995 Ofili's paintings were essentially abstract, although there were suggestions of flowers, foliage and other organic motifs within the swirling traceries of dots and pools of colour that covered their surfaces. Ofili gradually extended his imagery to incorporate figurative elements, peopling his canvases with the tiny collaged heads of black personalities which he had cut out from magazines. The increasing technical complexity of the paintings, with their multiple layers of paint, resin and collage, provides a visual parallel for the ever-growing multiplicity of reference and meaning within Ofili's work as a whole. As his paintings became increasingly figurative, they also became increasingly urban in feel, rooting themselves more and more in the street culture of hip hop and the lyrics of 'gangsta rap'. Ofili has drawn an analogy between his painting technique, in which layer after layer is gradually built up until the overall picture is formed, to the 'laying down', one instrument at a time, of the different parts of a musical track.

It is in this context that his two versions of the painting *Afrodizzia* can be viewed. The title alludes to the stereotype of black sexual potency, while also describing the dizzying patterning and colours of the paintings. Ofili presents us with a pantheon of black celebrities from the worlds of music and sport, some of whom are singled out for special consideration by having their names emblazoned in coloured map pins across their own ball of dung. This is Ofili's own form of the 'namechecking' which is a characteristic feature of hip hop and rap performance. Ofili gives each of his characters a 1970s Afro hairstyle, a device which raises questions of black identity although in a highly ambiguous fashion. The Afro can be read both as a symbol of pride and unity, serving to highlight the individuality of each face it adorns, and as a means of sucking all that individuality out, sustaining the cliche that all black faces look the same. Typically, Ofili refuses to take a fixed stance: 'In some ways [the work] is a criticism of the absurdity of making work about identity, but in some ways it *is* about identity, to the point of overload'. *Afrodizzia* has both the exuberance and the sting in the tail that characterises much contemporary black music. This essential dichotomy in the work has been described by Terry Myers: '*Afrodizzia* is the perfect word to describe the hallucinatory celebration at

Chris Ofili
The Adoration of Captain Shit and the Legend of the Black Stars (Part 2)
1998

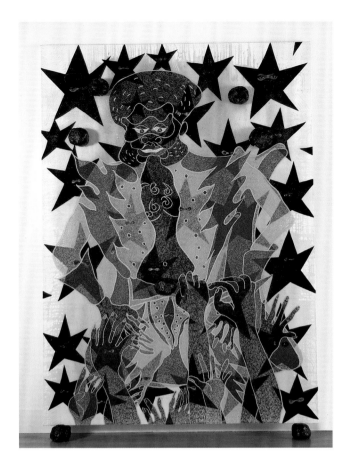

Chris Ofili
No Woman, No Cry
1998

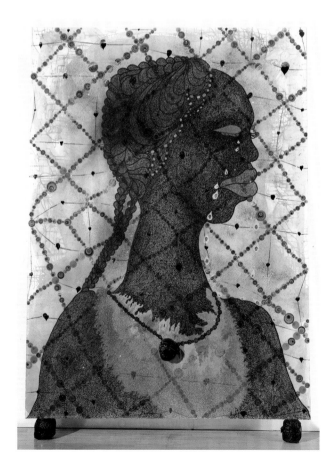

work in these paintings – art objects meaningfully labour-intensive yet mindful, it seems, of the thin line between dreams and delusions, or the large obstacles between dreams and the struggle to meet them' (*Art/Text 58*, 1997, p.38).

In 1996 Ofili began a series of paintings featuring Captain Shit, a 'slightly comical saviour of the day' (*Chris Ofili*, exh. cat., Southampton City Art Gallery, Serpentine Gallery, London 1998, p.8). Inspired in part by the character of Luke Cage Power Man from the 1970s Marvel comics, Captain Shit is a somewhat flawed superhero, whose red and yellow spandex suit, lipstick, nail varnish, and dungball belt-buckle seem to undermine his invulnerability. He does, however, appear to have been endowed with at least one superpower, namely the ability to glow in the dark thanks to the phosphorescent paint that Ofili has used in these paintings. In *The Adoration of Captain Shit and the Legend of the Black Stars (Part 2)*, Ofili presents us with one of his classic remixes of art-historical quotation, biblical reference and musical parallel. Just as the 'interludes' on hip hop concept albums make reference to the actual process of consumption of the music itself, so for Ofili this painting is as much an ironic comment on the 'adoration' of his paintings as an actual adoration of his superhero.

Captain Shit is typical of the humour that Ofili often brings to more serious issues of sexual and racial stereotyping. 'My project is not a p.c. project ... It allows you to laugh about issues that are potentially serious' (ibid., p.83). This refusal to censor himself is perhaps most evident in Ofili's use of pornography as source material. A recent portrait, *Rodin – The Thinker* (1997), takes inspiration directly from a photograph published in a pornographic magazine, as well as from Rodin's famous sculpture of the same title. The confrontation of base subject matter with sheer decorative beauty lies at the heart of much of his work. His is truly an 'irresolvable art that is intellectually provocative, visually luxurious and confounding' (ibid., p.13).

Tacita Dean

When she trained as a painter Tacita Dean was constantly dividing her canvas into squares, unable to make just one image. This compulsion to resist the single viewpoint has found expression in her method of working, which often combines film, primarily 16 mm, with a variety of other media. Inhabiting the borderlands between truth and concealment, history and myth, her work takes the form of imaginative investigations, often triggered by chance encounters or discoveries. Typically documentary in style, her stories remain enigmatic, perhaps hinting at the various ways in which our experience of reality is filtered through knowledge, expectation and belief.

Dean is preoccupied with notions of time, and the relationship between history and the present is a recurring theme in her work. Many of her works also feature the sea, both as a backdrop for human drama and as a symbol of psychological and physical isolation. Her hypnotic and highly evocative film *Disappearance at Sea*, shown in the Turner Prize exhibition, records the fading light at nightfall refracted inside the St Abb's Head lighthouse beacon in Berwickshire. The rhythmic clunking of the rotating beacon, like the hum of the projector, contrasts with the atmospheric sound of seagulls and sea. Edited to fourteen minutes, the film cuts between a shot looking inwards to the bulb and a view out to sea, ending with the lighthouse beam panning the darkened coastline. The formal structure of the film, achieved using an anamorphic lens, seems to enhance the viewer's sense of space and the passage of time, notably in the way that the movement of the light itself seems to be progressively slowed as the film unfolds.

Disappearance at Sea is one of several works inspired by the tragic story of Donald Crowhurst, the amateur yachtsman who died in 1969 whilst participating in the first ever solo non-stop round-the-world yacht race. Realising that he could not complete the race, yet unable to admit his failure, Crowhurst began exaggerating his progress and concealing his real position. His anxiety about this huge deceit began to distort his sense of reality until, losing all sense of time and location, he drifted off course. His trimaran was found abandoned a few

Tacita Dean
1965 Born in Canterbury, Kent
1985–8 Falmouth School of Art, Cornwall
1989–90 Supreme School of Fine Art, Athens
1990–2 Slade School of Art, London

Tacita Dean
Still from
Disappearance at Sea
1996

Tacita Dean
Still from *Gellért*
1998

hundred miles from the coast of Britain. For Dean, Crowhurst's story is 'about human failing; about pitching his sanity against the sea, where there is no human presence or support system left on which to hang a tortured psychological state'. In *Disappearance at Sea* image and sound induce a trance-like state, and a sense of disorientation that perhaps echoes Crowhurst's 'time-madness' (*Tacita Dean: Missing Narratives*, Frith Street Gallery, London 1997, p.17).

Alongside *Disappearance at Sea* the artist exhibited a new film, *Gellért*, shot in the thermal baths of the Hotel Gellért, Budapest, and *The Roaring Forties*, a series of blackboard drawings comprising a sequence of seven 8-feet-square blackboards which she completed in one week. Dean has produced such drawings since the early 1990s . In many ways they point to the relationship between the process of drawing and that of film-making, both of which rely heavily on editing. The Roaring Forties is a notoriously rough zone in the southern Atlantic. Using old photographs for reference Dean depicts what appear to be scenes from a maritime adventure. The luminous white chalk marks on black grounds give the boards the appearance of photographic negatives. The reference to cinematic storyboards is further emphasised by captions, hand-written in chalk as part of the drawing, such as 'Aerial view' and 'Out of frame'. Unlike a film still, which reads as a single moment, the cinematic storyboard, like a drawing, is full of potential, leaving interpretation more to the viewer's imagination.

Cathy de Monchaux

Cathy de Monchaux's world is a place of dreams and fantasies. Her sculptures have a highly individual visual language and yet seem strangely familiar. They appear to retain the vestiges of some functional object while having no identifiable practical application. As she describes it: 'They remind you of something you once saw somewhere else, as you passed it by in the street or in a dream.'

De Monchaux's work draws on a wide gamut of cultural references which she reinterprets within her own idiom. 'In a way I see all my work as a form of cultural plundering in an attempt to evoke a culture of my own. I suppose it's a kind

of world' (*Tate: The Art Magazine*, Summer 1997, p.61). Her work combines visual references that range from the religious to the secular, the sexually explicit to the chaste, the industrial to the domestic, the manufactured to the organic, the ugly to the beautiful. Frequently they are set against each other in a balance of opposites that attempts to act as 'a metaphor for the dialogue between all those opposing sides of the human psyche who are having their own shootout in your head all the time, as you struggle to appear to be a balanced human being'.

De Monchaux's earlier work seemed to hint at the darker side of eroticism. More recently she continues to investigate the contradictions of the human condition, and in particular of human sexuality and gender difference, but in a way which she describes as 'more psychologically dramatic, rather than sexually dramatic' (*Art Newspaper*, June 1997, p.14).

For the Turner Prize she combined a range of new and existing works to create a discrete world of objects within the gallery space. In her floor sculpture *Never forget the power of tears* rectangular, human-scale slabs suggested gravestones, cemeteries and human mortality. Twelve 'tombs' made of lead flanked a central 'backbone' composed of endlessly repeated organic-looking motifs. This exposed spine looked like an exotic *vagina dentata* or a giant Venus flytrap which, instead of feeding off insects, consumes human beings.

The arrangement of *Never forget the power of tears* was mirrored in a new work, *Fretting around on the brink of indolence*, comprising two lightboxes either side of an elaborate central section. Despite incorporating photographic images, which by definition have some roots in reality, the piece presented an ambiguous, dreamlike view of a world beyond the gallery. Like so much of de Monchaux's work it suggests anxiety, possibly about the state of the world we live in but also, in its combination of natural order and chaos, about all those 'irrational, emotional, repressed fears' with which our minds are clouded from time to time.

De Monchaux has also continued to work on a smaller scale in wall-mounted pieces like *Making a day for the dead ones*

Cathy de Monchaux
1960 Born in London
1980–3 Camberwell School of Art, London
1985–7 Goldsmiths' College, London

Cathy de Monchaux
*Never forget the power
of tears* (detail) 1997

Cathy de Monchaux
*Making a day for the
dead ones* 1997

149

Sam Taylor-Wood
1967 Born in London
1989–90 Goldsmiths'
College, London

(1997), *Cogent shuddering* (1997) and *Don't touch my waist* (1998). Many of her works have the feeling of quasi-religious artefacts, something which the artist encourages by distressing their surfaces and coating them with a unifying layer of chalk dust which gives them 'a patina of age and belonging'. It comes as little surprise that she cites among her visual sources Roman Catholic reliquaries and shamanistic ritual objects. While each work has a strong individual character, de Monchaux situates them within a larger whole, constructing an environment which conveys 'that sense of a very special place where the atmosphere is about the work and the viewer, a contemplative space' (*Make*, April–May 1997, p.21). This is her world with its own internal logic, but it is a world in which, as a viewer, one is given free reign for one's own imaginings.

Sam Taylor-Wood

Using film, video and photography Sam Taylor-Wood has produced a body of work that focuses on a range of such fundamental human emotions and states of mind as expectation, desire, anger, loneliness and boredom. Working with professional actors, amateurs and friends, she loosely orchestrates scenarios, often lingering on the moments of tension created when opposites collide. Through her work she draws attention to the role of the mass media, particularly film, as an echo-chamber for all our expressions and gestures, both original and acquired. Even in works depicting more than one protagonist she seems to emphasise the solitary nature of human existence.

With a few exceptions, Taylor-Wood shoots her work on film rather than video. Although she draws on diverse sources from the history of art and popular culture, it is the cinema and the subversion of its conventions that has largely given her work its structure.

For the Turner Prize Taylor-Wood exhibited *Atlantic*, a highly acclaimed three-screen projection, in which the artist dwells on the well-worn subject of the breakdown of a relationship between a man and a woman. In the artist's words: 'On the wall in front of you is a panoramic projection of a restaurant. On the left-hand wall is a projection of a woman in her thirties ... She's angry, yet resilient and calm. On the right-hand side there are a pair of man's hands ... He nervously fidgets with a pack of cigarettes or picks at the label of a wine bottle. The whole piece is synchronised ... and simultaneously you'll see the couple in the background in the panoramic view of the restaurant' (*Untitled*, no.13, Spring 1997, p.8). Shot in real time, the action is seen from three different vantage points. As in life, the viewer is faced with fragments of experience rather than the kind of narrative sequence constructed typically by film.

In this work Taylor-Wood concentrates on body language as key evidence for the viewer to decode. Perceiving the scene from a distance, the viewer is drawn to the spectacle. The intriguing dialogue, almost submerged in the ambient sound of the busy restaurant, sucks the viewer deeper into the action on screen. But as with much of her work, only shreds of the story are disclosed and we are left to make our own conclusions. Her interest seems to lie, as Michael O'Pray has commented, in 'the gesture of emotion itself, as an element of representation' (*Sam Taylor-Wood*, exh. cat., Chisenhale Gallery, London 1996, p.6).

Also shown in the exhibition were three works from *Five Revolutionary Seconds,* a series begun in 1995 in which the artist further explores the idea of dysfunctional narrative. In these extraordinarily elongated photographs she has succeeded in creating an almost cinematic effect. Shot with a camera that takes five seconds to pan the 360 degrees of a room, these panoramic images capture incidents of human interaction. Although an accompanying soundtrack records the conversations and background noise relating to the scene portrayed, the various plots remain ambiguous and unexplained.

Not unlike Renaissance paintings that depict sequences from the life of a saint in one continuous image, these photographs allude to the variety of states of being, the split persona of self, laid bare in one complete scene. Most of the lives portrayed appear to be unresolved and unfulfilled: the characters talk, argue, gaze out of windows, have sex, but ultimately seem oblivious to one another, dissipated by an atmosphere of ennui.

Sam Taylor-Wood
Atlantic (detail) 1997

Sam Taylor-Wood
*Five Revolutionary
Seconds XI* (detail) 1997

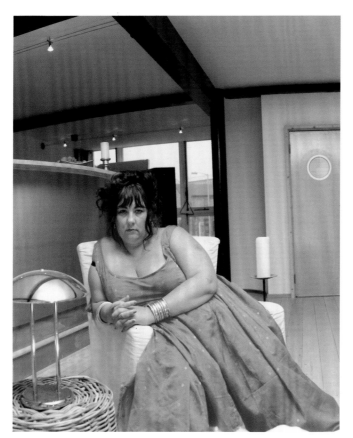

Tracey Emin
1963 Born in London
1983–6 Maidstone College of Art
1987–9 Royal College of Art, London

Tracey Emin

The art of Tracey Emin embraces the full range of media available to the late twentieth-century practitioner: she paints, she draws, she is a printmaker, she makes sculptural constructions, she works in performance and installation, film, video, embroidery-collage, neon, and written text. She has devised for her art, and incorporated as part of the work itself, unusual marketing strategies.

Tracey Emin has become notorious as one of the baddest of the so-called bad girls of contemporary British art, but commentators have also not failed to note the wistfulness, poetry, humour and honesty that underpin the harrowing frankness and unreserved sexual revelation of her obsessively confessional oeuvre. But although she deals so relentlessly with the minutiae of her own life she touches largely on issues that are common to all, not least sexuality, mortality and the creation of meaning in life. She also shares with prominent artists of the past a preoccupation with what it is to be an artist.

Tracey Karima Emin was born in London in 1963, one of non-identical twins (her sibling was a boy), and grew up in Margate, where her father and mother ran a hotel. At the age of thirteen she was raped, an experience which provided the culminating event of her book *Exploration of the Soul*. At about the same time, 'nebulously bored' by school, she dropped out, spending the next two years on the disco scene in Margate and London and systematically seeking sexual experiences, which she saw as a way of gaining knowledge of the world: 'I had this attitude that you'd learn more about different places by sleeping with someone than you would do by actually travelling'.

At fifteen she moved to London and had a succession of jobs before beginning to attend the Sir John Cass School of Art one day a week studying printmaking. At twenty she gained a place at Maidstone College of Art, getting in on what she wryly described as 'the genius clause'. She graduated in 1986 and went on to study at the Royal College of Art. At this stage, she was a painter and printmaker. In 1990 she had an abortion, after which 'the whole

meaning of creativity changed. I gave up art completely in 1991'.

She emerged from this crisis period in 1992, when she invited around eighty people to invest in her future as an artist: in return for £10 they each received three letters from her. Then, at the beginning of 1993, she teamed up with the artist Sarah Lucas in opening *The Shop* in the East End of London, where they sold small works directly to visitors. One of these was the gallerist Jay Jopling, owner of White Cube. He offered her a solo exhibition. It took place from November 1993 to January 1994 under the title *My Major Retrospective* because, Emin said, she thought she would never have another.

Emin's remarkable marketing of herself and her art continued in 1995 when she opened the *Tracey Emin Museum* in a shop at 221 Waterloo Road in London. Until the venture ended in 1998 Emin was creator and curator, museum and gallery, artist and gallerist, creating a total living interactive artwork.

In the same year she opened the museum, Emin made *Everyone I Have Ever Slept With 1963–95*, a work that has become an icon of contemporary British art. It is a small tent embroidered on the inside with the names of everyone Emin had slept with, including her twin brother in the womb, parents and comatose friends, as well as lovers.

Recently Emin has been focusing on her desire to make ambitious large-scale sculptural works, such as *My Bed* (1999), an installation based on her own bedroom. This work graphically illustrates themes of loss, sickness, fertility, copulation, conception and death – almost the whole cycle of human life that has its locus in the place where we all spend what are ultimately our most significant moments. As confrontational as anything Emin has ever made, it reminds us of one of the central tenets of art in the twentieth century, well summarised by Emin herself when she said 'There should be something revelatory about art. It should be totally new and creative, and it should open up doors for new thoughts and new experiences.'

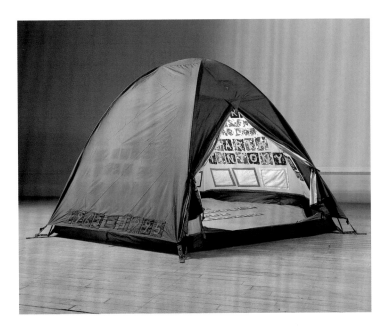

Tracey Emin
*Everyone I have Ever
Slept With 1963–95*
1995

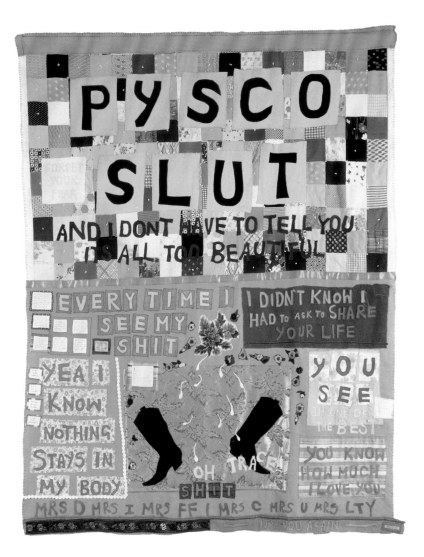

Tracey Emin
Psyco Slut 1999

Steve McQueen
1969 Born in London
1989–90 Chelsea
School of Art, London
1990–3 Goldsmiths'
College, London
1993–4 Tisch School
of the Arts, New York
University

Steve McQueen

Steve McQueen works in a variety of media – film, photography and sculpture – but the language of film is at the essence of his work. He made his first films at Goldsmiths' College and after graduating he was awarded a place at the Tisch School of the Arts in New York, a forcing ground for independent American film directors. However, once there he soon realised that learning to be a professional film-maker was too prescriptive and he left after a year, frustrated by the lack of freedom to experiment. He later commented 'they wouldn't let you throw the camera up in the air' and since that time he has amply demonstrated that there are no limitations on what can be done with a camera.

Until recently McQueen worked only in black and white, using 16 mm or 35 mm film, without sound. In all his work he uses the rudimentary elements of film language, distilling film to its most basic form to gain a greater sense of immediacy and impact. McQueen deliberately shuns any elaborate narrative structure or character development, but chooses extremely simple filmic propositions. This pared-down approach gives the films an elegant, highly formal, uncluttered quality.

The use of extreme and unexpected camera angles has become a trademark of McQueen's films. 'The idea of putting the camera in an unfamiliar position is simply to do with film language … Cinema is a narrative form and by putting the camera at a different angle … we are questioning that narrative as well as the way we are looking at things. It is also a very physical thing. It makes you aware of your own presence.'

For McQueen, working in black and white was a means of working as directly as possible with his medium without the distraction that the use of colour might involve. In *Deadpan*, McQueen uses a famous stunt from the film *Steamboat Bill Jr* of 1928, where comedian Buster Keaton remains standing as a house collapses around him. In its original form it was a slapstick, throwaway moment, but McQueen's version is humourless, and completely deadpan. We see McQueen standing in front of a timber house, a simple A-frame structure with a single window frame. The camera focuses on his feet, and then the window frame, and we watch from various angles as the wall falls around him, over and over again. He hardly flinches, he stares straight ahead. The artist has taken a moment of silliness, a cinematic cliche, and given it powerful resonance.

It is easy to be absorbed by McQueen's films, to be gripped by the content while equally captivated by the rich, sensuous quality of the film: the bold, chiaroscuro light effects, and the graininess of the projected image. However, McQueen's films have a stronger effect on us by way of their presentation. McQueen has a clear strategy for their installation. The image is projected in an enclosed space, on a scale way above human proportions. 'Projecting the film onto the back wall of the gallery space so that it completely fills it from ceiling to floor, and from side to side, gives it this kind of blanket effect. You are very much involved with what is going on. You are a participant, not a passive viewer.' This is particularly effective in *Deadpan*, where the enclosed space makes the viewer feel as if the wall will fall in on them as well as the artist. The silence is also key: 'The whole idea of making it a silent experience is so that when people walk into the space they become very much aware of themselves, of their own breathing … I want to put people in a situation where they're sensitive to themselves watching the piece.'

McQueen is attracted to the physical dimension of film-making, and the theme of travelling and movement – and its disorienting and dislocating effect – links many of his works. In *Drumroll*, the first work where he combined colour and sound, McQueen installed video cameras at either end of an oil drum, with one in its curved surface, and rolled it through the streets of Manhattan. A microphone recorded the ambient sounds of the journey, a cacophonous accompaniment to the whirling, circular images that show his route along New York's busy streets and sidewalks. The resulting films are presented in triptych format, and watching them is an awesome, nausea-inducing experience.

Steve McQueen
Deadpan 1997

Steve McQueen
Drumroll
1998

1999

Steven Pippin
1960 Born in Redhill
1982–5 Brighton Polytechnic
1987 Chelsea School of Art, London

Steven Pippin

Between 1982 and 1991 Steven Pippin's work consisted of photographs. These were not taken with conventional cameras, but made by converting pieces of furniture, architectural spaces and diverse objects into optical devices. Since 1991 Pippin has also made sculptural machines. Most of these have interconnected moving parts that spin, flip or rotate in different axes, as in a gyroscope, around a stable central point which houses an image or object. A characteristic of Pippin's photographic and sculptural works is that the function of the camera or sculptural object relates closely to the artistic subject each depicts. A fridge converted into a camera is used to photograph food and a wardrobe made into a camera photographs clothes. Several of Pippin's recent sculptural machines are based on models of the moon circling the earth and of the planets orbiting the sun. Some have at their centre a television screen which transmits the image of a spinning globe. These televisual rotations are countered by a physical movement of the television in the sculpture, which keeps the globe in precise equilibrium.

In the mid-1980s Pippin began to make self-portraits. His most notable early ones were those in which he turned an ordinary bathtub into a camera with which to photograph his own naked body, and a self-portrait standing in a London street taken from a photobooth converted into a camera. Pippin created what he described as 'an intimate meeting of different technologies', by using the photobooth with its sophisticated colour processing facility as a makeshift pinhole camera. His own role as operator and subject was both public and embarrassing. He recalls that 'standing almost to attention in amongst the normal coming and going of pedestrians became a perplexing ordeal and seemed more problematic than the actual conversion of the booth itself'.

Among Pippin's most celebrated photographic works are those made using washing machines as cameras. After his first experiment in 1985, in 1991 he made a series of works, *Laundromat Pictures*, in which he converted machines in public

laundromats into cameras. Pippin drew an analogy between the technical processes of cleaning clothes and of developing photographs. After making an exposure through a shutter device placed in the recessed glass door of the washing machine, he used the wash, rinse and spin cycles to develop, fix and dry the photographic negative. Operating in public, Pippin noted the embarrassment felt by people as their dirty washing was exposed to public view. The attention he drew to himself by his eccentric activity was countered by donning a suit. Pippin created what he called 'a means of protection, an acceptable uniform' behind which he felt 'secure and respectable, even in the most squalid of situations'. Wearing a suit had practical uses too. Pippin used sewn-in magnets in the jacket to fix it over the front of the washing machine while, pushing his arms back through the sleeves, he loaded the drums with light sensitive film.

His *Laundromat-Locomotion* photographs of 1997 mark the ambitious culmination of Pippin's washing machines project. Using a bank of twelve machines triggered by trip wires, the artist created sequences of images. These were of himself and in one case a horse and rider, moving along in front of the line of machines. They pay homage to *Animal Locomotion*, the pioneering photography of Eadweard Muybridge, which analysed motion for the first time. As a wry comment on Muybridge's less scientific studies of naked women getting in and out of bed, Pippin's sequences include one of a naked woman and another of a naked man walking with a full erection.

Cosmological investigations and the laws of physics are subjects of fascination for Pippin. They are central to several of his machines, which he began making in 1991 as a separate activity from his photographic works. A recent group of them are based on models of the solar system.

Pippin has never exhibited his sculptures and photographs together, yet some intriguing and complementary characteristics link these discrete bodies of work. Each work appears technically innovative and inquisitively speculative, inventively exploring ways of learning about the world.

Steven Pippin
*The Continued Saga of
an Amateur
Photographer* 1993

Steven Pippin
*Laundromat-Locomotion
(Horse & Rider)* 1997

157

Jane Wilson
1967 Born in
Newcastle
1986–9 Newcastle
Polytechnic
1990–2 Goldsmiths'
College, London

Louise Wilson
1967 Born in
Newcastle
1986–9 Duncan of
Jordanstone College of
Art, Dundee
1990–2 Goldsmiths'
College, London

Jane and Louise Wilson

Using film, photography and sculpture, Jane and Louise Wilson have created a series of highly theatrical and atmospheric installations that investigate the darker side of human experience. Since they first began working together in 1989 – the year they famously produced identical degree shows – the Wilson twins have been fascinated by the power of the unconscious mind, creating a body of work which probes collective anxieties and phobias, arouses unwanted memories, and seeks to reveal that which is usually repressed.

The Wilsons explore this subterranean world in highly charged psychodramas, acted out using the tools of the mass media: film and photography. The Wilsons are only too aware of the allure of the cinema, and they consciously borrow its narratives and imagery, as well as its technologies, to create films which are visually enticing. Seeming to adhere to cinematic convention, these films poignantly demonstrate the power of its influence.

The Wilsons create environments of moving image, sound and space where reality and artifice collide. Although moving images take prominence in their work, these are characteristically exhibited with large-scale, filmic photographs and physical props that allude to, and are relics of, the unfolding drama. Early films such as *Crawl Space* (1995) and *Normapaths* (1995) were presented in this way, transporting the viewer into a no-man's land bordering the real and the imagined. In these works, the Wilsons sought out anonymous locations – old warehouses, derelict hotels – and drew out their latent, sinister meaning, making manifest our unconscious associations with such places.

In their work, the Wilsons have become increasingly sensitive to how certain kinds of architecture have powerful effects on human emotions. They have now begun to film well-known locations, whose notoriety is ensured by events in recent political history, 'buildings where there is a pathology attached'. *Stasi City*, the first of these works, was filmed in Berlin, in the abandoned headquarters of the former German Democratic Republic Intelligence Service, the Staatssicherheitsdienst, and in a former Stasi prison. It is in this work and more recently in *Gamma* (1999), filmed in the decommissioned American missile base at Greenham Common, that the Wilsons probe the architectural uncanny.

In *Stasi City* the camera pans through interrogation rooms and offices, scanning empty corridors. We catch sight of a figure, opening a door or standing in a paternoster lift, but for the most part we are alone. There is a feeling of ominous dread. The clicking of a hidden camera makes reference to acts of covert surveillance, the sound of slamming doors and the humming of the harsh neon lights add to the sense of menace. *Gamma* has a similar atmosphere of secrecy and fear, surveillance and paranoia.

Through swift camera movement and sharp edits a powerful tension is achieved in these films, and the Wilsons use complex devices to heighten the drama within the actual installation. The images are presented on two sets of double corner projections placed opposite each other in the same room. These twin projections offer similar perspectives on the unfolding drama, sometimes only slightly out of sync but occasionally completely juxtaposed, which has a disorientating effect on the viewer. The scale of the images, projected floor to ceiling, is also crucial – there is an elision between real and depicted space.

Having created such a highly charged physical and psychological language of space in *Stasi City* and *Gamma*, the Wilsons turned to other locations where the architecture is saturated with meaning, focusing on such diverse spaces as the Palace of Westminster and Caesar's Palace in Las Vegas. For *Las Vegas, Graveyard Time* (1999) the Wilsons chose to film inside casinos, which, unlike the locations of other recent works, are very public spaces, accessible to everyone. They filmed at 'graveyard time', in the early hours of the morning, and the sense of emptiness makes these interiors sinister and alienating. The work demonstrates how certain emotions are not purely the property of self-evidently sinister locations such as those found in *Stasi City* and *Gamma*, but are also present in places supposedly associated with pleasure.

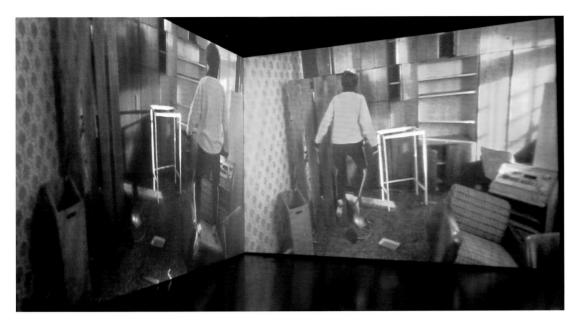

Jane and Louise
Wilson
Stasi City 1997

Jane and Louise
Wilson
*High Roller Slots,
Caesar's Palace*
1999

Art & Language
p.48 Photo Charles Harrison;
p.49 Lisson Gallery, London

Terry Atkinson
p.38 Tate Gallery;
p.39 Gimpel Fils, London

Gillian Ayres
p.72 the artist;
p.73 Photo Prudence Cuming Associates, courtesy Gimpel Fils Ltd, London

Christine Borland
p.136 Gautier Deblonde;
p.137 (top) Photo Thorsten Arendt and Christine Dilger, courtesy Lisson Gallery, London;
p.137 (bottom) Photo Jean Luc Fournier, courtesy FRAC Languedoc-Rousillon

Angela Bulloch
p.138 Fiona Rae;
p.139 (top) Fredrik Nilson; p.139 (bottom) André Morin

Victor Burgin
p.48–9 the artist

Patrick Caulfield
p.58 Tate Gallery;
p.59 Photo Prudence Cuming Associates, courtesy Waddington Galleries/DACS

Helen Chadwick
p.58 Photo Zelda Cheatle;
p.59 ICA, London

Hannah Collins
p.98 Photo Antoni Bernad;
p.99 the artist

Tony Cragg
pp.40–1, 64 Lisson Gallery, London;
p.63 Tate Gallery

Ian Davenport
p.81 (top) Waddington Galleries, London;
p.81 (bottom) and p.82 Tate Gallery

Grenville Davey
p.87 Photo Hugo Glendinning, courtesy Lisson Gallery, London;
p.88 Photo Chris Felber, courtesy Lisson Gallery, London

Richard Deacon
pp.32, 56 Tate Gallery;
p.33 British Council Collection;
pp.55, 57 Lisson Gallery, London

Tacita Dean
p.146 Photo Andrew Dunkley, Tate Gallery;
p.147 Frith Street Gallery, London

Cathy de Monchaux
p.148 Photo Hugo Glendinning;
p.149 Photo FXP, courtesy of the artist

Willie Doherty
p.106 Photo Marcella Leith, Tate Gallery;
p.107 Photo Edward Woodman, courtesy Matt's Gallery

Peter Doig
p.108 Photo Marcella Leith, Tate Gallery;
p.109 (top) Victoria Miro Gallery;
p.109 (bottom) Tate Gallery

Tracey Emin
p.152 Photo Johnie Shand-Kydd;
p.153 (top) Lehmann Maupin, New York;
p.152 (bottom) courtesy Jay Jopling

Ian Hamilton Finlay
p.40 Tate Gallery;
p.41 the artist

Lucian Freud
p.65 The Bridgeman Art Library;
p.75 Tate Gallery

Gilbert and George
pp.32, 46 Photo Nigel Maudsley, courtesy Anthony d'Offay Gallery, London;
p.33, Tate Gallery (left);
p.33 (right) and p.47 Anthony d'Offay Gallery, London

Douglas Gordon
pp.123, 125 Photo Stephen White, courtesy Lisson Gallery, London;
p.124 Photo Simon Starling

Antony Gormley
pp.104–5 Photo Marcus Leith, Tate Gallery

Richard Hamilton
pp.64–5 Courtesy Anthony d'Offay Gallery/DACS

Mona Hatoum
p.116 Tate Gallery;
p.117 Musée national d'art moderne, Centre Georges Pompidou

Damien Hirst
pp.89, 113, 115 Courtesy Jay Jopling, London;
pp.90, 114 Photo Stephen Lovell-Davis

Howard Hodgkin
pp.34, 38 Tate Gallery;
pp.35, 37, 39 Anthony d'Offay Gallery

Craigie Horsfield
p.126 Photo Marcella Leith, Tate Gallery;
p.127 (top) Frith Street Gallery;
p.127 (bottom) Photo Lluis Bovar, courtesy Frith Street Gallery

Shirazeh Houshiary
p.110 Photo Marcella Leith;
p.111 (top) Photo Marcus Leith, Tate Gallery;
p.111 (bottom) Photo Peter White, courtesy Lisson Gallery, London

Gary Hume
p.128 Photo Marcella Leith, Tate Gallery;
p.129 (top) Matthew Marks, New York;
p.129 (bottom) Photo Stephen White, courtesy Jay Jopling

Callum Innes
p.118 Photo H. Kosaniuk, courtesy Frith Street Gallery;
p.119 Frith Street Gallery

Derek Jarman
p.50 Photo Howard Sooley courtesy Richard Salmon;
p.51 estate of the artist

Anish Kapoor
p.79 Lisson Gallery, London;
p.80 Photo Philip Sayer, courtesy Lisson Gallery, London

Richard Long
pp.34, 60, 66, 72 Photo Denny Long, courtesy Anthony d'Offay Gallery;
pp.35, 61, 67, 71 Anthony d'Offay Gallery, London

Declan McGonagle
p.60 Tate Gallery

Stephen McKenna
p.50 the artist;
p.51 the artist, courtesy Edward Totah Gallery

Steve McQueen
p.154 Photo Denis Darzacq;
p.155 Anthony Reynolds Gallery, London and Marian Goodman Gallery, New York

David Mach
pp.66–7 the artist

Malcolm Morley
pp.31–2 Tate Gallery

Chris Ofili
pp.143, 145 Victoria Miro Gallery, London;
p.144 Photo Jane Bown

Thérèse Oulton
p.60 Photo Roger Hammond;
p.61 Marlborough Fine Art (London) Ltd

Cornelia Parker
p.140 Photo Gautier Deblonde;
p.141 (top) Photo Edward Woodman, courtesy Frith Street Gallery;
p.141 (bottom) Ansen Seale, courtesy Frith Street Gallery

Simon Patterson
p.130 Photo Marcella Leith, Tate Gallery;
p.131 (top) Tate Gallery;
p.131 (bottom) Photo Stephen White, courtesy Lisson Gallery

Vong Phaophanit
pp.100, 101 (top) Tate Gallery;
p.101 (bottom) Killerton Park, Exeter, Devon

Steven Pippin
p.156 Photo Steve Davies;
p.157 Gavin Brown's enterprise

Fiona Rae
p.83 (top) Waddington Galleries, London;
p.83 (bottom) and p.84 Tate Gallery

Paula Rego
p.74 Photo Jane Bonn;
p.75 Marlborough Fine Art (London) Ltd

Sean Scully
p.76, 102 Photo Terence Donovan;
pp.77, 103 Tate Gallery

Sam Taylor-Wood
p.150 Photo Phil Pointer;
p.151 (top) Photo Justin Westover, courtesy Jay Jopling, London;
p.151 (bottom) courtesy Jay Jopling, London

David Tremlett
p.91 Hester van Royen

John Walker
p.42 Tate Gallery;
p.43 the artist courtesy Nigel Greenwood Gallery, London

Mark Wallinger
p.120 the artist;
p.121 (top) Anthony Reynolds Gallery;
p.121 (bottom) Photo Marcus Leith/ Mark Heathcote, Tate Gallery, courtesy the Anthony Reynolds Gallery

Gillian Wearing
p.134 Photo Johnnie Shand-Kydd;
p.133, 135 the artist, courtesy Maureen Paley/Interim Art

Boyd Webb
p.68 Photo Heini Schneebeli, courtesy Anthony d'Offay Gallery;
p.69 Anthony d'Offay Gallery

Rachel Whiteread
pp.84, 96 Tate Gallery;
p.85 (top) Karsten Schubert Ltd, London;
p.85 (bottom) The Saatchi Gallery, London;
p.95 Tate Gallery;
p.97 Anthony d'Offay Gallery

Alison Wilding
p.68, 92 Photo Marcella Leith, Tate Gallery;
p.69 Karsten Schubert Ltd, London;
p.93 Photo John Webb

Jane and Louise Wilson
p.158 Photo Gautier Deblonde;
p.159 (top) Photo Theo Coulombe, courtesy Lisson Gallery, London;
p.159 (bottom) courtesy Lisson Gallery, London

Richard Wilson
pp.68, 76 Photo Robin Klassnik, courtesy Matt's Gallery;
pp.69, 77 Photo Edward Woodman courtesy Matt's Gallery, London

Bill Woodrow
p.52 the artist;
p.53 Lisson Gallery, London

Copyright Credits

Except for those listed below, all works are © the artist or the estate of the artist

Patrick Caulfield: ©Patrick Caulfield/ DACS 1998

Richard Hamilton: ©Richard Hamilton/ DACS 1998

p.16 © Solo/Evening Standard

p.17 © Express Newspapers plc

p.23 © Peter Clarke/Guardian 1984

Back cover © Peter Brookes/The Times 1993

Errata

pp.18 (n.5) and 30 Waley-Cohen not Whaley-Cohen

pp.20, 30 and 112 McEwen not McEwan

pp.32 and 56 Richard Deacon served as a Trustee from 1991–6, not 1989–96

p.54 Richard Shone, Associate Editor of the *Burlington Magazine*, was a jury member in 1987

p.62 Nicholas Serota, then Director Elect of the Tate Gallery, was chairman of the jury in 1988

p.108 Peter Doig became a Trustee in 1995, not 1994

p.112 Gary Garrels, Curator of Contemporary Art at the San Francisco Museum of Modern Art, was a jury member in 1988

Art & Language
*Incident in a Museum,
Madison Avenue* 1986
Oil and mixed
media on plywood
on oil and mixed
media on plywood
243.8 × 379.7 cm
The artist, *page 49*

Terry Atkinson
*Art for the Bunker 4:
The Stone Touchers 1
Ruby and Amber in the
Gardens of their Old
Empire History Dressed
Men* 1985
Acrylic on board
120.7 × 90.2 cm
The artist, courtesy of
Gimpel Fils, London,
39

Gillian Ayres
Dido and Aeneas 1988
Oil on canvas
274 × 305 cm
Gimpel Fils Ltd,
London, *73*

Christine Borland
*The Dead Teach the
Living* 1997
Plastic, wood, text
Dimensions variable
The artist and
Westfälisches
Landesmusem,
Münster, *137*

Christine Borland
Phantom Twins 1997
Leather, sawdust,
replica foetal skulls
Dimensions variable
The artist and Lisson
Gallery, London, *137*

Angela Bulloch
Betaville 1994
Private Collection, *139*

Angela Bulloch
Works in the
Vehicles exhibition at
Le Consortium, Dijon,
1997, *139*

Victor Burgin
Office at Night 1986
from a series of nine
triptychs comprising
black-and-white
photographs and
plastic film
182.8 × 243.8 cm
The artist, *49*

Patrick Caulfield
Interior with a Picture
1985–6
Acrylic on canvas
205.7 × 243.9 cm
Tate Gallery, *59*

Helen Chadwick
Of Mutability 1986
Photocopies and
assorted media
Dimensions variable
The Board of Trustees
of the Victoria and
Albert Musuem, *59*

Hannah Collins
Signs of Life (section)
1992
Silver gelatin print
mounted on linen
250 × 600 cm
The artist, *99*

Hannah Collins
The Truth 1993
Silver gelatin print
mounted on cotton
166 × 130 cm
The artist, courtesy
Gallery Joan Prats, *99*

Tony Cragg
On the Savannah 1988
Bronze
225 × 400 × 300 cm
Tate Gallery, *63*

Tony Cragg
Still Life Belongings
1985
Mixed media
172 × 170 × 270 cm
Private Collection,
USA, *41*

Ian Davenport
Untitled 1989
Household paint on
canvas
213.4 × 213.4 cm
Collection Lockhart,
81

Ian Davenport
Untitled (Drab) 1990
Oil on canvas
213.5 × 213.5 cm
Tate Gallery, *81*

Grenville Davey
HAL 1992
Two parts
Steel
244 × 122 cm each
Private Collection, *87*

Richard Deacon
Boys and Girls 1982
Vinyl and plywood
91 × 152 × 21.3 cm
British Council
Collection, *33*

Richard Deacon
Feast for the Eye
1986–7
Galvanised steel
with screws
100 × 80 × 350 cm
The artist, *55*

Richard Deacon
Fish out of Water 1987
Laminated hardboard
245 × 350 × 190 cm
Hirshhorn Museum
and Sculpture Garden,
Washington, *55*

Richard Deacon
*For Those Who Have
Ears No.1* 1983
Laminated wood and
galvanised steel
with rivets
366 × 152.5 × 229 cm
Prada Milano Arte,
Milan, *57*

Richard Deacon
Troubled Water 1987
Wood and galvanised
steel with rivets
and screws
310 × 100 × 140 cm
Private Collection,
London, *55*

Tacita Dean
Disappearance at Sea
1996
16 mm anamorphic
film
Dimensions variable
Tate Gallery, *147*

Tacita Dean
Gellért 1998
16 mm film
Dimensions variable
The artist, Frith Street
Gallery, London and
Marian Goodman
Gallery, New York, *147*

Cathy de Monchaux
*Making a day for the
dead ones* 1997
Brass, copper, leather
and chalk
110 × 61 × 4 cm
Joel and Zoë Dictrow,
New York, courtesy
Sean Kelly Gallery,
New York, *149*

Cathy de Monchaux
*Never forget the power
of tears* 1997
Lead, rusted steel,
leather and chalk
700 × 425 × 20 cm
Courtesy Sean Kelly
Gallery, New York,
149

Willie Doherty
Border Incident 1993
Cibachrome print
mounted on
aluminium
122 × 183 cm
Matt's Gallery, *107*

Willie Doherty
*The Only Good One is
a Dead One* (detail)
1993
Double-screen video
projection with sound
Dimensions variable
Weltkunst
Foundation, *107*

Peter Doig
Cabin Essence 1993–4
Oil on canvas
230 × 360 cm
Private Collection, *109*

Peter Doig
Ski Jacket 1994
Oil on canvas
295 × 351 cm
Tate Gallery, *109*

Tracey Emin
*Everyone I have Ever
Slept With 1963–95*
1995
Appliquéd tent,
matress and light
122 × 245 × 214 cm
Saatchi Collection,
London, *153*

Tracey Emin
Psyco Slut 1999
Appliqué blanket
244 × 193 cm
Lehmann Maupin,
New York, *153*

Ian Hamilton Finlay
(with Nicholas Sloan)
*The Present Order
is the Disorder of the
Future* 1983
Stone
700 × 600 × 35 cm
The artist, *41*

Lucian Freud
Painter and Model
1986–7
Oil on canvas
159.6 × 120 cm
Private Collection, *65*

Lucian Freud
Standing by the Rags
1988–9
Oil on canvas
168 × 138 cm
Tate Gallery, *75*

Gilbert and George
Coming 1983
242 × 202 cm
Anthony d'Offay
Gallery, London, *45*

Gilbert and George
Death Hope Life Fear
1984
Four panels, each
60.5 × 50.3 cm
Tate Gallery, *33, 47*

Douglas Gordon
*Confessions of a
Justified Sinner* 1995
Video installation,
two parts, each
300 × 400 cm
Fondation Cartier
pour l'art
contemporain, Paris,
125

Douglas Gordon
*Something Between My
Mouth and Your Ear*
1994
Cassette deck,
amplifier,
loudspeakers, blue
paint, light filters
Dimensions variable
Private Collection,
London, *122*

Antony Gormley
Testing a World View
(detail) 1993
Cast iron, five pieces,
each 112 x 47 × 118 cm
The artist and Jay
Jopling, London, *105*

Richard Hamilton
Lobby 1985–7
Oil on canvas
175 × 250 cm
Private Collection, *65*

Mona Hatoum
Corps étranger 1994
Video installation
350 × 300 × 300 cm
Musée national d'art
moderne, Centre
Georges Pompidou,
117

Mona Hatoum
Light Sentence 1992
Mixed media
Dimensions variable
Musée national d'art
moderne, Centre
Georges Pompidou,
117

Damien Hirst
Amodiaquin 1993
Gloss household paint
on canvas
208.3 × 198.1 cm
Private Collection, *115*

Damien Hirst
The Asthmatic Escaped
1992
Mixed media
221 × 426.7 × 213.4
cm
Private Collection, *89*

Damien Hirst
*I Want You Because
I Can't Have You* 1992
MDF, melamine,
wood, steel, glass,
perspex cases, fish
and formaldehyde
solution
2 parts, each
121.9 × 243.8 × 30.5
cm
Private Collection, *89*

Damien Hirst
*Mother and Child,
Divided* 1993
Steel, GRP
composites, glass,
silicone sealants, cow,
calf, formaldehyde
solution
Dimensions variable
Astrup Fearnley
Museum, Oslo,
2, 112

Howard Hodgkin
Son et Lumière 1983–4
Oil on wood
66.7 × 74.3 cm
Private Collection, *35*

Howard Hodgkin
*A Small Thing But
My Own* 1983–5
Oil on wood
44.5 × 53.5 cm
Private Collection, *37*

Howard Hodgkin
Still Life 1982–4
Oil on wood
32.1 × 34 cm
Private Collection, *39*

Craigie Horsfield
*Carrer Muntaner,
Barcelona, Març 1996*
1996
Unique photograph
265.7 × 263 cm
The Saatchi
Collection, *127*

Craigie Horsfield
*Pau Todó i Marga
Moll, carrer Muntaner,
Barcelona, Març 1996*
1996
Unique photograph
140 × 136.3 cm
The artist and Frith
Street Gallery,
London, *127*

Shirazeh Houshiary
*The Enclosure of
Sanctity* 1992–3
Lead, copper, silver
leaf and gold leaf,
five parts, each
100 × 100 × 100 cm
Tate Gallery, *111*

Gary Hume
Whistler 1996
Enamel on paint on
aluminium panel
210 × 160.5 cm
Private Collection, *129*

Gary Hume
*Innocence and
Stupidity* 1996
Gloss paint on
aluminium panel,
two panels, each
170 × 221 cm
Bonnefantenmuseum,
Maastricht, *129*

Callum Innes
*Exposed Painting,
Cadmium Orange* 1995
Oil on canvas
110 × 100 cm
Frith Street Gallery,
London; Collection
Harry Handelsman,
119

Callum Innes
Monologue 1994
Oil on canvas
210 × 190 cm
Kunsthaus Zurich,
119

Derek Jarman
*Michael Gough as
St Jerome* 1986
Film tableau after
Caravaggio's *St Jerome
in his Study, 51*

Anish Kapoor
Void Field 1989
Sandstone and
pigment
Dimensions variable
The artist and the
Lisson Gallery, *79*

Richard Long
Chalk Line 1984
71 × 1028 cm
The artist, courtesy
Anthony d'Offay
Gallery, London, *35*

Richard Long
Red Walk 1986
Printed text (red)
158 × 109 cm
Anthony d'Offay
Gallery, London, *61*

Richard Long
Untitled 1988
River Avon mud on
paper 50.8 × 39.1 cm
Anthony d'Offay
Gallery, London, *67*

Richard Long
White Water Line
1990
China clay and water
solution
Installed at Tate
Gallery, London
3 October 1990–6
January 1991,
70

Stephen McKenna
Clio Observing the Fifth Style 1985
Oil on canvas
200 × 280 cm
Private Collection, *51*

Steve McQueen
Deadpan 1997
16 mm black and white film, video transfer, silent
4 min 30 sec
The artist, courtesy Anthony Reynolds Gallery, London and Marian Goodman Gallery, New York, *155*

Steve McQueen
Drumroll 1998
Colour video projection, triptych, with sound
22 min 1 sec
The artist, courtesy Anthony Reynolds Gallery, London and Marian Goodman Gallery, New York, *155*

David Mach
101 Dalmatians
101 plaster dogs and assorted household objects
Dimensions variable
Temporary installation at the Tate Gallery 14–28 March 1988, *67*

Malcolm Morley
Farewell to Crete 1984
Oil on canvas
203.2 × 417 cm
Private Collection, *31*

Chris Ofili
The Adoration of Captain Shit and the Legend of the Black Stars (Part 2) 1998
Acrylic, oil, resin, paper collage, glitter, map pins and elephant dung on canvas with two dung supports
243.8 × 182.8 cm
Warren and Victoria Miro, *145*

Chris Ofili
Afrodizzia (2nd Version) 1996
Acrylic, oil, resin, paper collage, glitter, map pins and elephant dung on canvas with two dung supports
243.8 × 182.8 cm
Warren and Victoria Miro, *143*

Chris Ofili
No Woman, No Cry 1998
Acrylic paint, oil paint, polyester resin, paper collage, map pins, elephant dung on canvas
243.8 × 182.8 cm
Victoria Miro Gallery, *145*

Thérèse Oulton
Pearl One 1987
Oil on canvas
238.8 × 213.4 cm
Marlborough Fine Art (London) Ltd, *61*

Cornelia Parker
Mass (Colder Darker Matter) 1997
Charcoal retrieved from a church struck by lightning, Lytle, Texas, USA
366 × 320 × 320 cm
The artist and Frith Street Gallery, London, *141*

Cornelia Parker
Twenty Years of Tarnish (wedding presents) 1996
Two silver-plated goblets, each
13 × 6.5 × 6.5 cm
The artist and Frith Street Gallery, London, *141*

Simon Patterson
The Great Bear 1992
Lithograph on paper
108.5 × 134 cm
Tate Gallery, *131*

Simon Patterson
Untitled 1996
Dacron, aluminium, steel and mixed media, three parts, each
550 × 380 × 272 cm
Lisson Gallery, *131*

Vong Phaophanit
Litterae Lucentes 1993
Nine Laotian words in red neon on 50 × 4.5 m wall installed at Killerton Park, Exeter, Devon, *101*

Vong Phaophanit
Neon Rice Field 1993
Neon and rice
1500 × 500 cm
The artist *14, 101*

Steven Pippin
The Continued Saga of an Amateur Photographer 1993
Photographs and video
Each photograph 50.6 × 8.1 cm
Tate Gallery, *157*

Steven Pippin
Laundromat-Locomotion (Horse & Rider) 1997
Twelve black and white photographs
76.2 × 76.2 cm
The artist and Gavin Brown's enterprise, New York, *157*

Fiona Rae
Untitled (yellow) 1990
Oil on canvas
213.3 × 198.1 cm
Tate Gallery, *83*

Fiona Rae
Untitled (yellow and black) 1991
Oil and charcoal on linen 213.4 × 182.9 cm
Collection the artist, courtesy Waddington Galleries, *83*

Paula Rego
The Maids 1987
Acrylic on canvas backed paper
213.4 × 243.9 cm
The Saatchi Collection, London, *75*

Sean Scully
Paul 1984
Oil on three canvases
259 × 320 × 24 cm
Tate Gallery, *77*

Sean Scully
White Window 1988
Oil on canvas
245.5 × 372.5 cm
Tate Gallery, *103*

Sam Taylor-Wood
Atlantic 1997
Three-screen laser disc projection with sound, shot on 16 mm film
Dimensions variable
The artist and Jay Jopling, London, *151*

Sam Taylor-Wood
Five Revolutionary Seconds XI (detail) 1997
Colour photograph on vinyl with CD
72 × 757 cm
Rebecca and Alexander Stewart, Seattle, WA, *151*

David Tremlett
Walls and Floors 1992
Wall drawing, pastel and masking tape
487.5 × 888 cm
Courtesy Hester van Royen, *91*

David Tremlett
Wall Drawings at Abbaye de St Savin, France 1991, *91*

John Walker
Form and Sepik Mask 1984
Oil on canvas
243.8 × 152.4 cm
The artist, *43*

Mark Wallinger
Brown's 1993
from the series of 42 works
Oil on linen, each
110 × 110 cm
The Artist, courtesy of Anthony Reynolds Gallery, London
Installed at the Tate Gallery 1 November–3 December 1995, *121*

Mark Wallinger
Half-Brother (Exit to Nowhere/ Machiavellian) 1994–5
Oil on canvas
230 × 300 cm
Tate Gallery, *121*

Gillian Wearing
Sacha and Mum 1996
Single channel video artwork in colour with sound
Tate Gallery, *135*

Gillian Wearing
60 Minutes Silence 1996
Video projection in colour with sound
Dimensions variable
Arts Council Collection, Hayward Gallery, *133*

Gillian Wearing
10–16 1997
Single channel video artwork in colour with sound
Tate Gallery, *135*

Boyd Webb
Pupa Rumba Samba 1986
unique colour photograph
123 × 154 cm
William College Museum of Art, Mass., *69*

Rachel Whiteread
Ghost 1990
Plaster on steel frame
269 × 355.5 × 317.5 cm
The Saatchi Collection, London, *97*

Rachel Whiteread
House 1993
Commissioned by Artangel Trust and Beck's (corner of Grove Road and Roman Road, London E3, destroyed 1994), *95*

Rachel Whiteread
Untitled (Amber Bed) 1991
Rubber
129.5 × 91.4 × 101.6 cm approx.
Fundacio la Caixa, *85*

Rachel Whiteread
Untitled (Sink) 1990
Plaster
107 × 101 × 86.5 cm
The Saatchi Collection, London, *85*

Alison Wilding
Assembly 1991
Steel and PVC
123 × 174 × 547 cm
Private Collection, *93*

Alison Wilding
Red Skies 1992
Patinated mild steel, acrylic, brass and bronze
217 × 99 × 86 cm
Private Collection, *93*

Alison Wilding
Stormy Weather 1987
Galvanised steel, oil paint and bronze
225 × 115 × 170 cm
Weltkunst Foundation, *69*

Jane and Louise Wilson
High Roller Slots, Caesar's Palace 1999
C-type print mounted on aluminium
180 × 180 cm
Lisson Gallery, London, *159*

Jane and Louise Wilson
Stasi City 1997
Two double wall projections, two sculptures and a series of photographic stills
Dimensions variable
Lisson Gallery, London, *159*

Richard Wilson
Sea Level 1989
Galvanised steel grilling, sheet steel and gas-fired space heater
Dimensions variable
Arnolfini Gallery, Bristol, *77*

Richard Wilson
20:50 1987
Used sump oil and steel
Dimensions variable
The Saatchi Collection, London, *69*

Bill Woodrow
Self Portrait in the Nuclear Age 1986
Shelving unit, wall map, coat, globe and acrylic paint
205 × 145 × 265 cm
Cordiant PLC, *53*